ONEWOMAN**100**FACES

Published in 2013 by Goodman
An imprint of the Carlton Publishing Group
20 Mortimer Street
London W1T 3JW

10 9 8 7 6 5 4 3 2 1

Photography, Text and Design © Francesca and Alberto Tolot, 2013
Makeup by Francesca Tolot
Photography by Alberto Tolot
Book Design by Cristiano Tolot

A CIP catalogue record for this book is available from the British Library.

ISBN 978 1 84796 068 9

Printed in China

ONEWOMAN 100FACES

GOODMAN

FOREWORD

"Francesca Tolot is the most extraordinary make-up artist of our time. I have the ultimate respect for her artistry. She approaches her work with expertly trained hands and critically honest eyes. She manages to make a woman look sophisticated, elegant, modern and feminine. Whether she is using neon colours, feathers, period make-up or natural make-up, she is the only artist I trust will bring out a beauty in me I didn't even know existed. She seeks and finds beauty in all things and the face is her perfect canvas. The images in this book speak volumes about the intimacy of the camera and the willingness of one woman to show all the many, exciting parts of herself."

BEYONCÉ KNOWLES *New York City 2013*

INTRODUCTION

Francesca Tolot is a make-up artist and true creative in every sense, finding inspiration at every turn and always on the lookout for new materials to fashion something out of, or unusual objects to incorporate into an image. Working as a make-up artist to high-profile celebrities, Francesca is respected for her artistry, expertise and ability to reveal the hidden beauty within every subject.

When she and her photographer husband Alberto moved from Milan to Los Angeles in the 1980s, they discovered a freedom of creative expression that led to productive collaborations and enduring friendships with several leading hairstylists and the model Mitzi Martin, who all shared the same passion and vision. Over the course of 22 years, Alberto has photographed Mitzi in endless fantastical guises, from otherworldly creatures to sculpture, suggesting every conceivable emotion and mood along the way.

The resulting book, *One Woman 100 Faces*, is a true labour of love. Like a photographic dream sequence, it takes you on a visual journey exploring the many facets of a woman's – every woman's – complex personality. The images together expose every part of her – her hopes, fears, strength, vulnerability and innocence as well as her deepest secrets and fantasies and, of course, her grace and beauty. Like a magician, she changes shape completely from image to image, leaving an indelible mark on the spectator's memory and making them wonder about her innocence, femininity, sexuality and mystery. It is a fascinating metamorphosis of a woman, a sort of personal mythology, a visual stimulation of dream and desire transformed into strong, palpable images.

The following questions and answers provide a fascinating insight into the thought processes, inspirations and artistry behind this unique collection of arresting and beautiful images.

Zia Mattocks *London 2013*

DIALOGUE

Can you sum up what this book means to you?

The project evolved from a long collaboration that started out professionally and transformed into friendship. So many beautiful images emerged that we needed to consolidate them into a single collection to narrate our journey. Make-up and hair, inextricably linked, create a powerful illusion that only survives in the photograph. With her beauty and gestures, Mitzi embodies and interprets each woman, each character we create for her, in a mesmerizing way. Alberto's masterful lighting and ability to capture that miraculous and fleetingly unexpected osmosis completed the circle. During the photo-shoots there were moments of uncertainty, amazement and laughter. I feel privileged to have worked with such a wonderful group of generous and talented friends – with the unified thread of having passion for what we do.

What is the main message that you want the reader to take away?

The book stands for a woman being able to be free to express herself without any fear. Through this fantasy tour of fairytale characters, they will recognize aspects of themselves that are usually suppressed. In this book every woman can discover one or multiple facets of herself, which seem simultaneously natural and impossible.

How did the long-standing collaboration with Mitzi Martin come about?

When Alberto and I first started working with Mitzi, it was for commercial projects. She was a stunningly beautiful girl of 17 and we found that we loved working with her – she was so open to our ideas and willing for me to experiment on her with make-up – so we kept on hiring her and our professional relationship soon developed into a friendship.

What is it about Mitzi that makes you love working with her?

Her face is a dream for a make-up artist; it's like a white canvas with the most piercing, amazing, beautiful eyes. When we first started working together she was so young, so she was rounder, softer and more innocent. Then she became a woman, a wife and a mother, and her face became stronger and chiselled. Her symmetrical features and the proportions of her face allowed me to transform her with almost no effort. She changes so much throughout the book that most people forget that it's actually the same woman – the only constant is her incredible eyes.

How have the images changed over the 22 years you've been working together?

The main differences for me are the things that have inspired me over the years. I've been through periods of extremism and theatricality. Other times, less is more and it's all about minimalism and paring back. In life and in growing up I don't think we've changed that much. When we get together to work it's all about creating and everything else disappears.

What inspires you?

Anything inspires me – books, paintings, movies, theatre, a piece of fabric or an unusual material that I can make into something unexpected, everyday life and the lucky coincidence of seeing something that catches my eye and sparks an idea. For instance, once when we were shopping, I found a dry palm leaf and it gave me the idea of wrapping Mitzi's nude body in palm leaves. I love to go to museums and art galleries and do so at every opportunity. Whenever I'm travelling for work, I always make a point of visiting the city's important museums or galleries – the Louvre, the Prado, the National Gallery in London and the Met and MoMA in New York. But whatever or whoever inspires me is only ever the starting point, not the end result. I always move the idea on from the original thought so that often the final image is a very different thing. It's always a journey.

Has your Italian heritage left its mark?

I grew up in a little medieval town outside Venice, so I was always surrounded by the most amazing buildings and churches filled with incredible paintings. I used to spend the summers in Venice and carnival time was a big event. As a child and then a teenager, I paid no attention to all the splendour and beauty around me. I didn't think about it consciously, but I couldn't help but soak it up. If, as I did, you move away from everything that was so much a part of you from a young age, aspects from your past inevitably surface somehow. Now I especially love the art of the Renaissance period, and Venetian masked balls are a huge inspiration for what I do – the magic of how a mask conceals and then reveals an identity.

You come from a family of artists and creatives – how did this affect you?

My mother made dolls from porcelain, papier-mâché and fabric, and she also made all my costumes for the carnival every year from scratch, from the wig to the shoes. My brother is a painter and my father could make or fix anything, so I grew up in a very hands-on environment and have always loved

making things; it's second nature to me. I always wanted to go to art school but my parents wouldn't let me go because it was too far from home.

Why did you decide to train as a make-up artist?

When I married Alberto we moved to Milan, where he worked as a photographer, and I met an amazing make-up artist, Diego Dalla Palma, who introduced me to the make-up world. He had just opened his own make-up school and I took his first class. Working on a photo-shoot for Italian *Vogue* opened my eyes to the potential of make-up as an exciting artform and I decided it was something I would love to do as a profession. Growing up, I was a tomboy, never interested in dolls or make-up, so it was funny to end up with a career in this field – life is full of surprises.

What's the appeal of using make-up as your artistic medium?

Make-up is so versatile – you can use a lipstick or an eyeliner, for example, in hundreds of different ways. You can completely transform a person with make-up or you can just use it to cover any imperfections to make them feel comfortable with themselves. You can use it give someone confidence and make them feel beautiful and fabulous. The additional thrill is to see how lighting changes everything. Through working with Alberto I have come to understand the relationship between make-up and lighting, how the two artforms work together. You can create a stunning make-up look, but if the lighting isn't right, it will destroy it. Conversely, good lighting can erase imperfections. When you achieve the right combination, the resulting picture will be spectacular.

Did the ideas often evolve as you worked?

In many cases they did, as one thing invariably led to another and the planned look that we started with would be the springboard for as many looks as we had time for. There were often moments of

drama, such as Mitzi feeling claustrophobic under a clay mask. On that particular shoot, the last one Alberto, Peter and I did, the original idea was to re-create an iconic image we first did in 1986 of a white statue with clay hair. As the day progressed, we remodelled the clay hair and painted her black. Then, as we deconstructed the look, we saw new characters emerging and began subtracting and adding elements and colours, leading to many more images. Being together with friends, exploring our own creative expression without the pressure of delivering for a client, gave us so much freedom and was always so much fun. If it worked out, it worked out, and if it didn't, we walked away and tried it differently another day. We always ended up with at least one good picture, but often, as we'd gradually deconstruct a look, Alberto found he could make many wonderful pictures.

Some of the images look as though they must have taken ages to complete.

Alberto loves to shoot in daylight, so for the more complex fabrications I would prepare materials ahead of time to ensure that we didn't spend too long putting the look together. That way we could make the most of the daylight and Mitzi's time. Other looks were so improvised that we didn't wait to book a studio but just seized the moment, carried away with our excitement, and shot at home or in the backyard.

How do the extreme and experimental looks you created for the book compare to the work you do with celebrity clients?

With Mitzi, it was all about experimentation. She has always been so amazing, letting us indulge our creativity on her face and body. She was uninhibited and collaborative, allowing us to create whatever we wanted, but sometimes it was physically hard on her. With my commercial work, there is often a concept that comes with a job – from the celebrity, the photographer or the director – but usually there is freedom for interpretation. When you work with professionals, you hire people for

their knowledge and experience and you have to trust them, because if one part doesn't fit into the puzzle, the resulting image won't be as strong.

Mitzi often seems to have been transformed into a living sculpture.

This pair of images (below) was inspired by Gundi Dietz, a Viennese artist whom I met through Peter. I wanted to create my own interpretations of her exquisite porcelain sculptures of women, so we covered Mitzi's hair with a bald cap and painted her white before drawing lines on her face and body, in keeping with Gundi's artistic style. In the first version she is ethereal, serene and submissive but not a victim. The second image is arresting and disconcerting – you wonder what has happened to her. I drew eyes on her eyelids, quickly and asymmetrically – even though her eyes are closed, she can "see" through her other senses. Her expression is like a silent scream, tense with emotion.

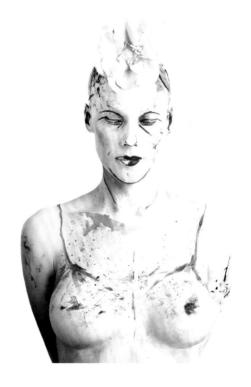 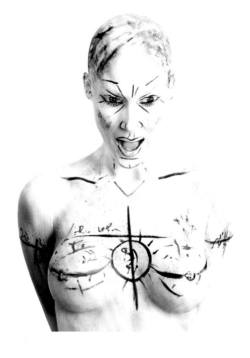

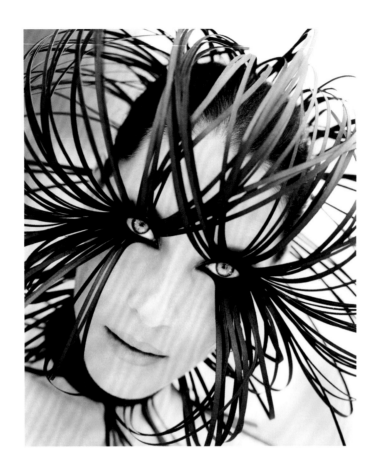

How did you conjure up these amazing eyelashes?

This image came to me in a dream and I had to figure out a way to make it happen. I found some paper that I could cut into long strips to create the effect I wanted. One end of the paper ribbons were glued around her eyelashes and then folded back and secured at her neck. The effect is like a cage around her head, implying that she's imprisoned by her own vanity.

These two images have a very theatrical feel.

They were created for a prospectus for the school of the performing arts at the University of California, Los Angeles (UCLA), and each image represented a different department – music, dance, drama – but in a non-literal way. The music one (left) is my favourite. I photocopied original sheet music and then printed it in reverse so the notes were white on a black background for a more dramatic effect. I folded and pleated the paper into different shapes and then started building them up on her body like a surrealist sculpture. In the other image, she is like a dark angel, dancing and performing, with a hat created from cut paper for a feathery effect.

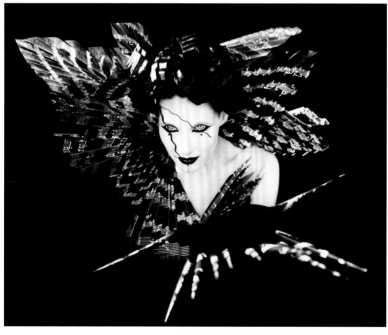 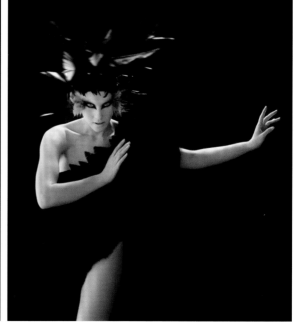

It's evident that you love to bring out the inner strength of a woman.

Strong women have always inspired me. For example, the Marchesa Maria Luisa Casati, who walked around with a panther on a leash, was glamorous, unique, creative and fearless for the time in which she lived, in the early part of the twentieth century. The original performance artist, and muse to countless designers, painters and photographers, she once declared that she wanted to become a living piece of art and in 1910 wore a slaughtered chicken on her shoulder. In the images I created in the early 1990s (opposite) – neither of which literally represent Marchesa Casati – she's outlandish, but she has such confidence and is so secure in who she is that she comes across as brave and powerful. For the top image, I randomly sketched around Mitzi's eyes using a fuchsia lip pencil and black eyeliner; for the other look I created smoky eyes with glossy black eyeshadow and then applied metallic particles in a somewhat irregular fashion. The overall effect is one of organized chaos.

You moved from Milan to Los Angeles in the 1980s. How was your work received Los Angeles at that time?

It was perfect timing because the industry was changing and that brought a freedom of expression. We were eager to try new things and we were lucky enough to meet other creatives, such as hairstylist Peter Savic, who arrived from Vienna at around the same time; it seemed we were all trying to import European experimentation to Los Angeles and it gave us the will and desire to push the boundaries farther than we'd done before. People became curious and then receptive to us – we were very innovative at that time, and coming up with the images for the book was something we all thrived on, enjoying the process as much as the result.

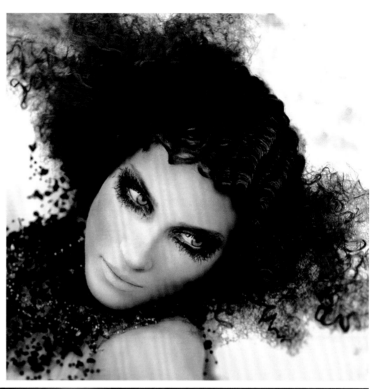
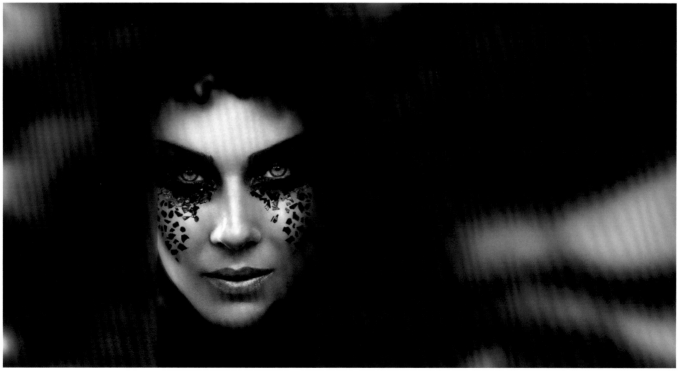

At what point did you have the idea of collecting all the images in a book?

Initially, we were just creating and experimenting. Mitzi was our muse – she was the perfect canvas for our creative expression. One day it just clicked in my mind: she was one woman with 100 faces. From that moment on, we kept shooting her with a book in mind.

Is this project a true collaboration?

It's all about teamwork – sometimes the initial idea was mine, sometimes one of the hairstylists we work with would come up with a concept and I would do the make-up to complement it. We are all creatives in our own fields and everyone brings something different to the mix. We're all friends, too, so it's always a joy when we come together to create something new. Ultimately, though, it's about interpretation. As the photographer, Alberto brings what we've created to life, assessing the lighting, the angles, the poses and the fleeting expressions, and turns it into a beautiful image. Often we don't need to discuss it in detail for him to share my vision. The image he produces always exceeds my expectations.

So the way your skills complement each other is key to this project's success?

Alberto started taking photographs before images could be manipulated by computer, so he learnt how to control lighting to make a woman look beautiful. He is also a jazz musician, which imbues him with the gift of improvisation. He has the ability to recognize the core of an idea and the key elements, and then make beautiful music or, in this case, magical images. He's always adaptable and versatile and his way of capturing always exceeds expectations. He is the zen energy in the madness of some chaotic photo-shoots.

You must have so much material – how did you choose which images to include?

We do have many more photographs, but as time progressed, a style progressed as well, and some didn't seem to fit anymore. There are images inspired by many different eras, as well as many fantasies, but we wanted the book to flow and to show a variety of images – with some more natural, softer and less extreme than others. We wanted that variety to illustrate the many different aspects of a woman. It wasn't hard to choose in the end and we all tended to agree – we're an amazing team, we have the same vision, and that is reflected throughout the project.

Zia Mattocks *London 2013*

MITZI MARTIN
the MUSE

I was 17 years old when Francesca and Alberto Tolot booked me for what would be the first of many photoshoots that would make me a privileged part of this incredible creative family.

Years of working together on ad campaigns in grand studios, European magazine editorials, and especially those inspired days of Francesca and Alberto's personal shoots in their own backyard, led to this most original body of work: *One Woman 100 Faces*.

The photographs in this book, taken over the course of my entire modelling career – first as a teenager, then as a single woman, a young wife, throughout my pregnancies, and now as a working mother of two children – imbued me with tremendous confidence. Francesca and Alberto not only made me look beautiful but more importantly, feel empowered and extraordinary.

One Woman represents the totality, yet ever-evolving landscape, of all women – our universal dreams and fantasies, being the individual object of unlimited creativity, and our emotional embrace of ultimate possibilities of fulfilment.

This stunning collection of images piques the curiosity and invites questions regarding the meticulous behind-the-scenes production. The props and materials used were all very real. The staging was as intense and intricate as the photographs reveal. My entire body was painted black, covered in glitter, clay, naked…

Francesca used feathers, plastic, paper, clay, glue, leaves, butterflies, lace, fabric, metal… an endless list of objects to create these works of art. I like to call it "guerilla art" because sometimes we only had minutes to get the shot before it all fell apart… or I fell apart. We were also fuelled by the most inspired hairstylists – Peter crocheted my hair, Enzo defied gravity, Robert turned silver ribbon into beautiful locks, along with Serena's masterful paper wig, and Yuki's sexy interpretations.

The application and removal of these materials from my face and body, my hair and skin was never easy but well worth the hours of preparation and deconstruction.

I am extremely fortunate to have worked with these great talents, such innovative hair stylists, Alberto's visionary photography, and most of all the amazing Francesca. They manifested the mood, created the most exciting surprises, and continue to be the best of their craft. They remind us that it is the process and collaboration that produces the art.

They are an inspiration and I feel blessed to be a part of this book.

Mitzi Martin *Los Angeles 2013*

"Illusion is the first of all pleasures"

Voltaire

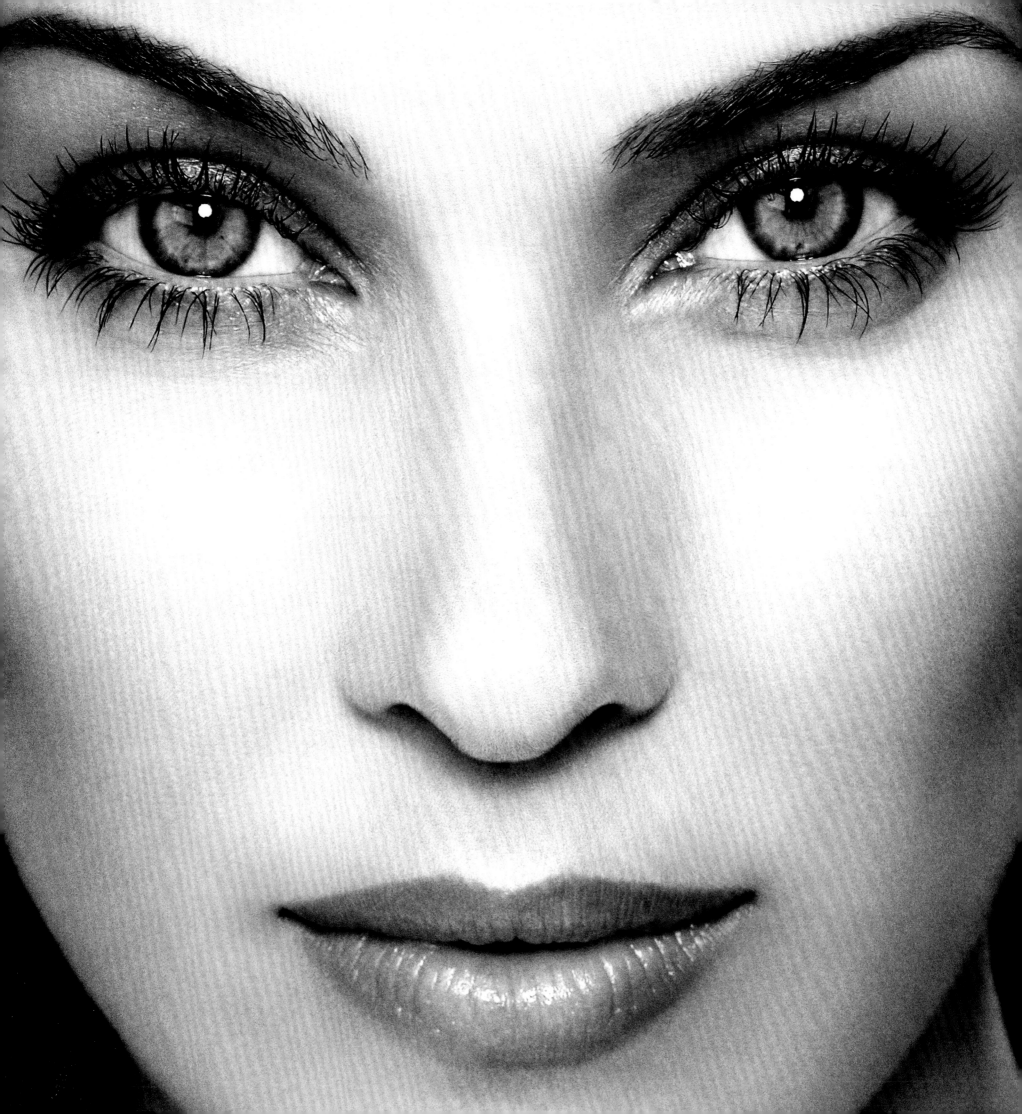

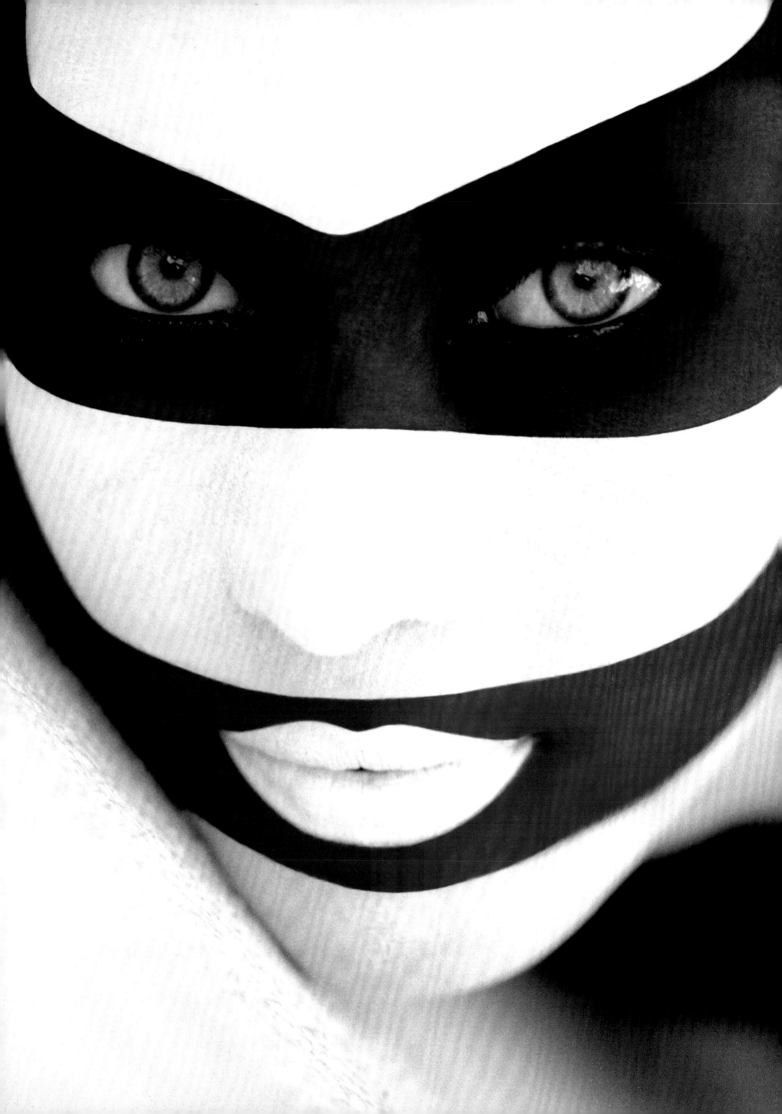

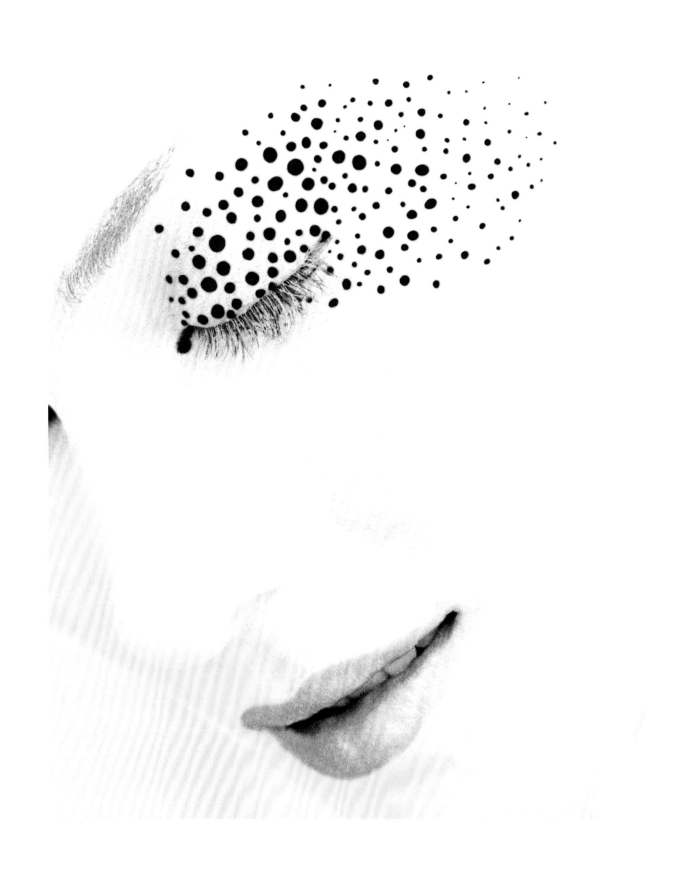

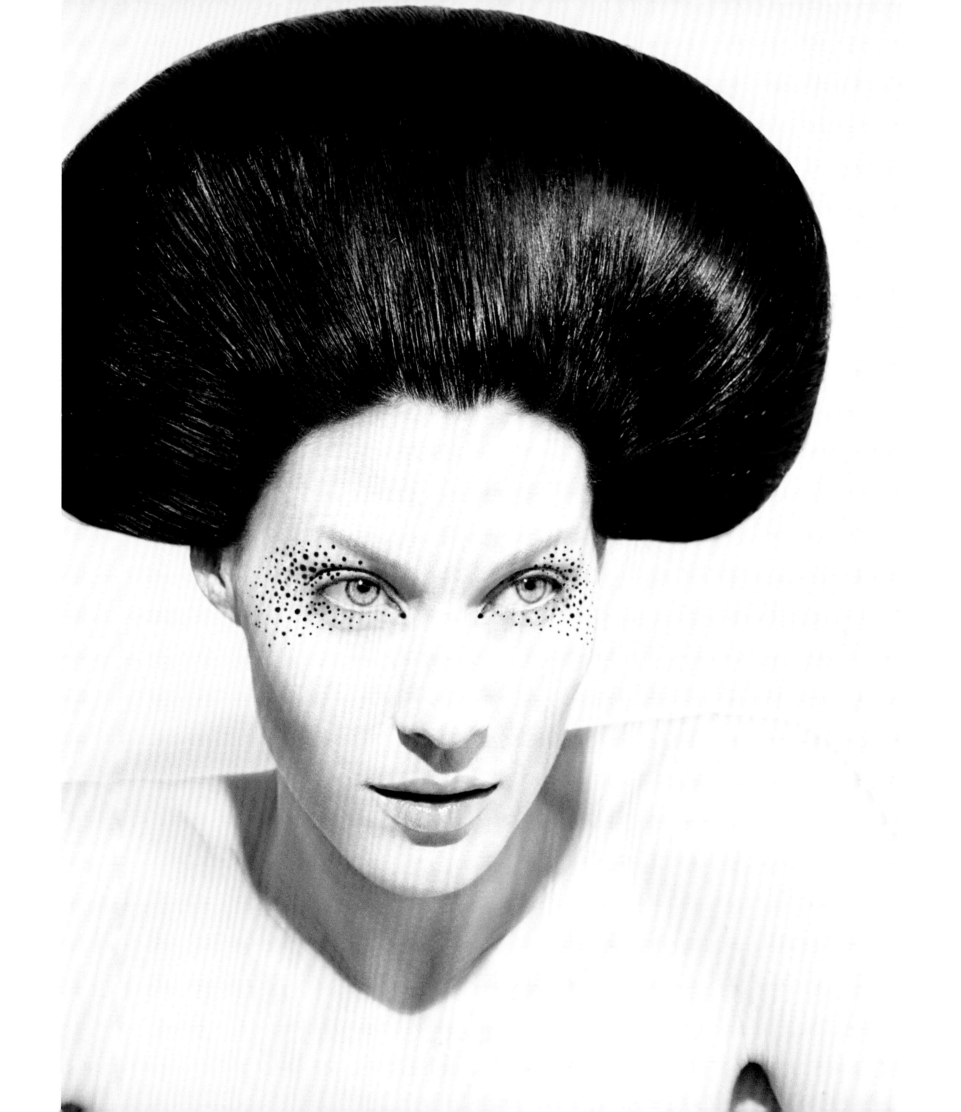

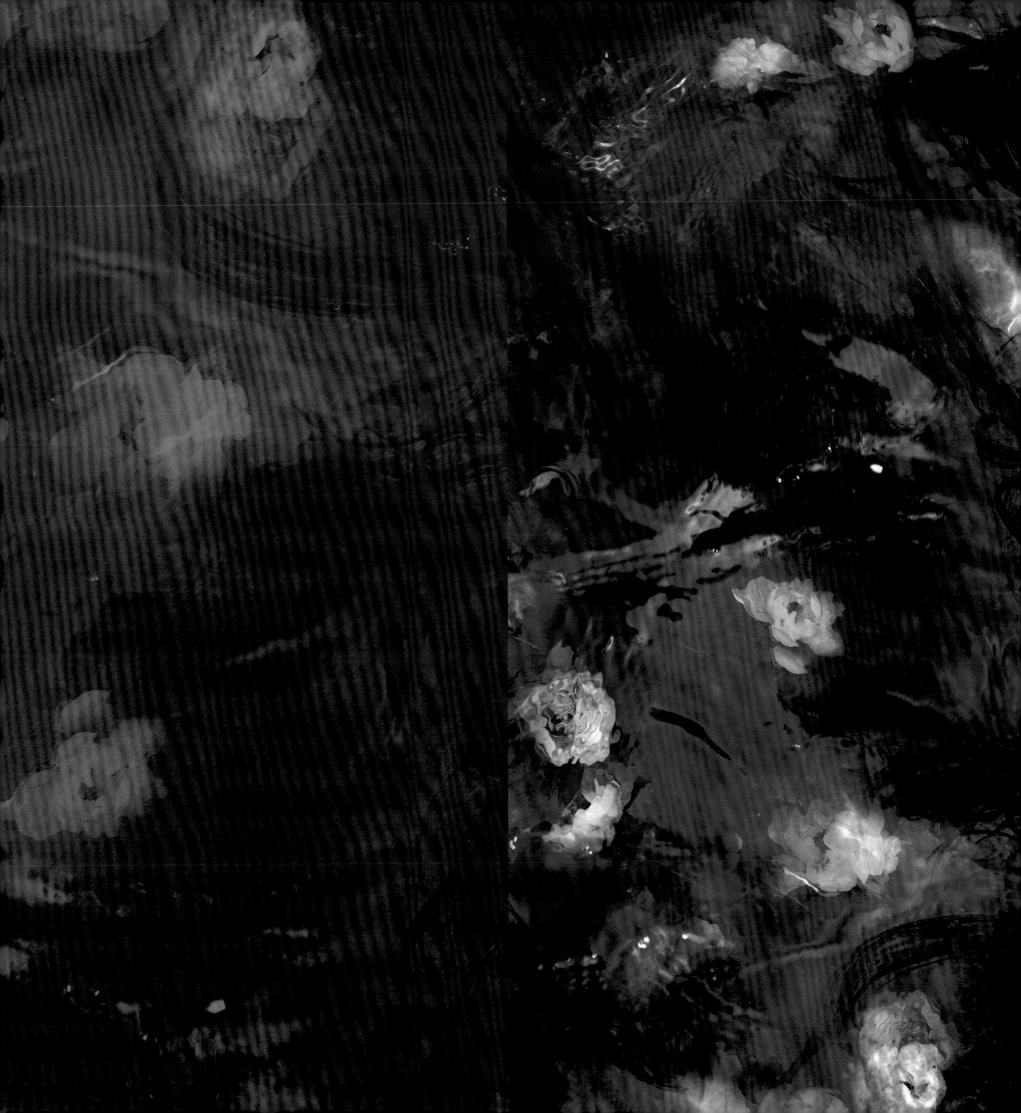

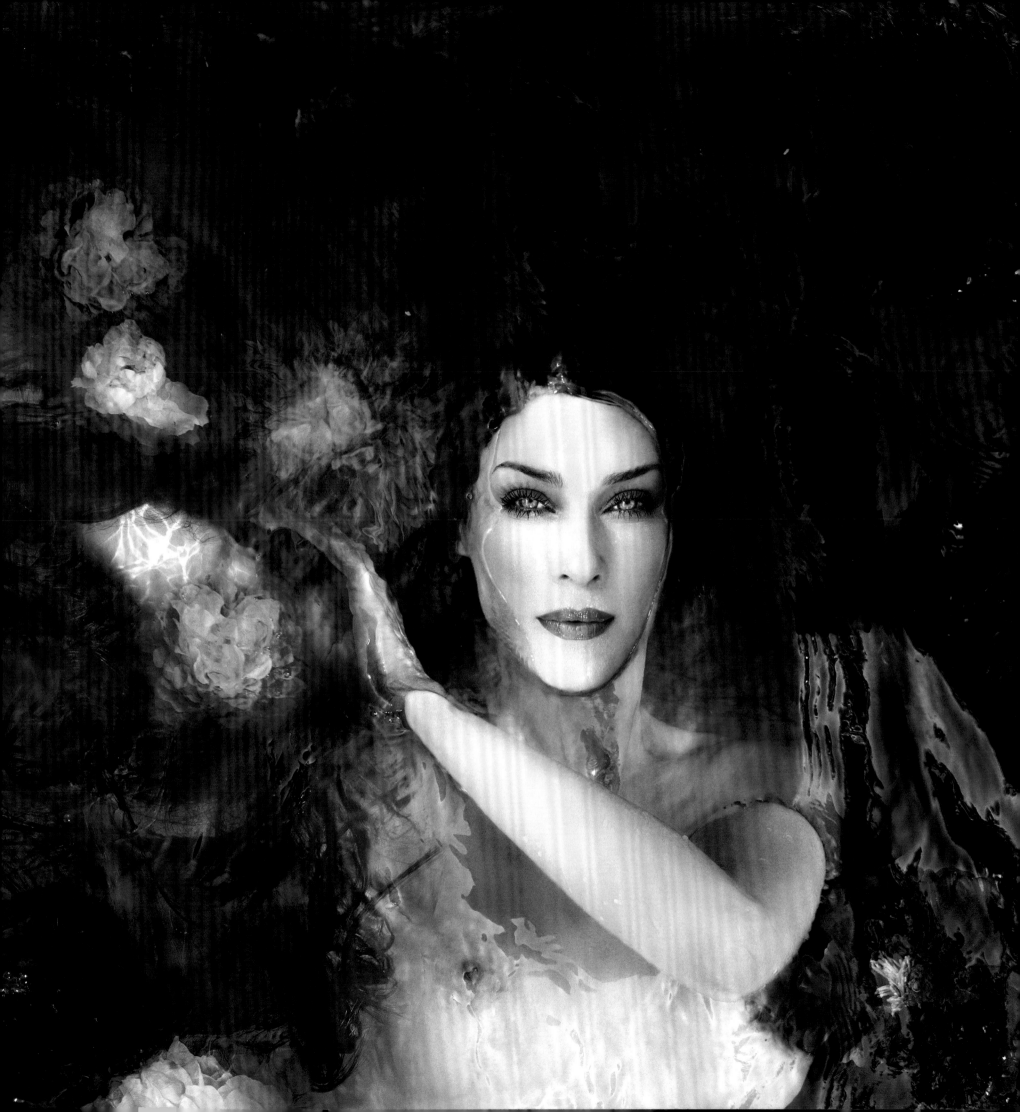

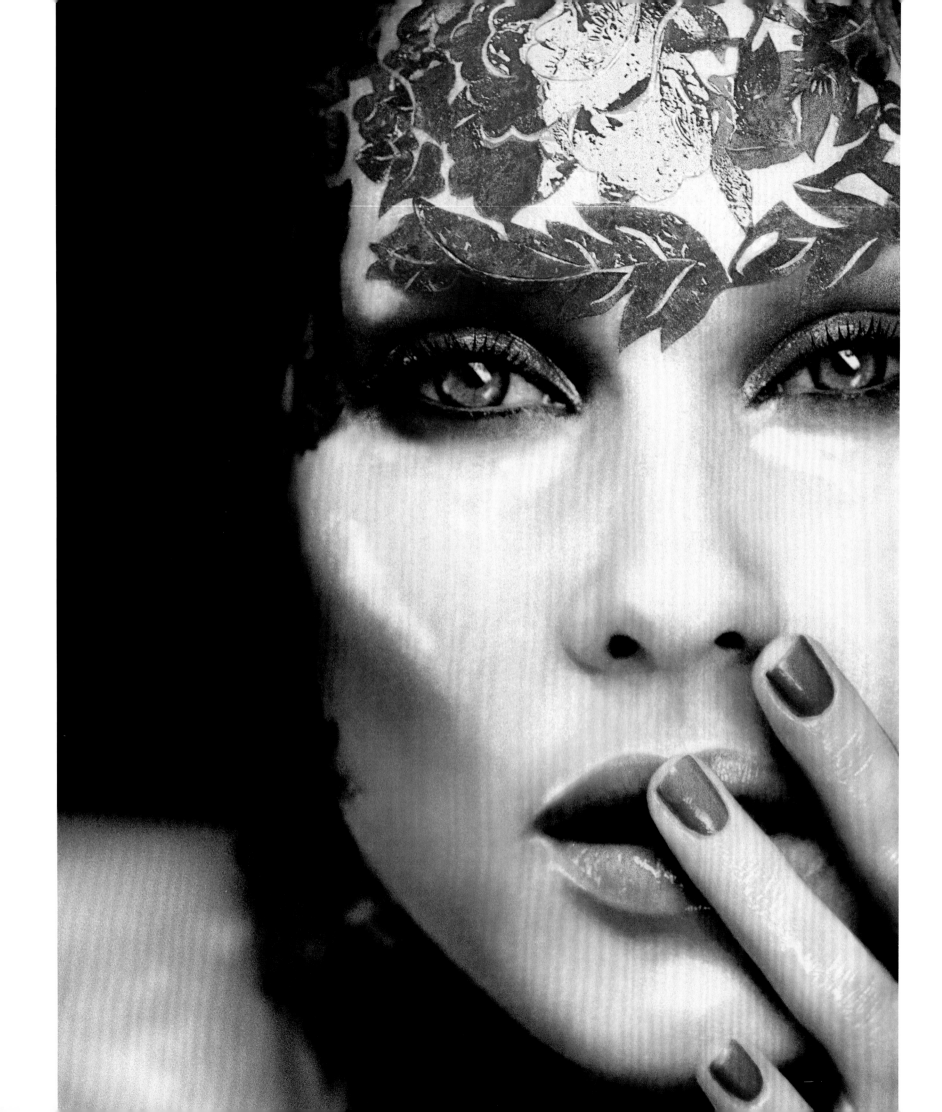

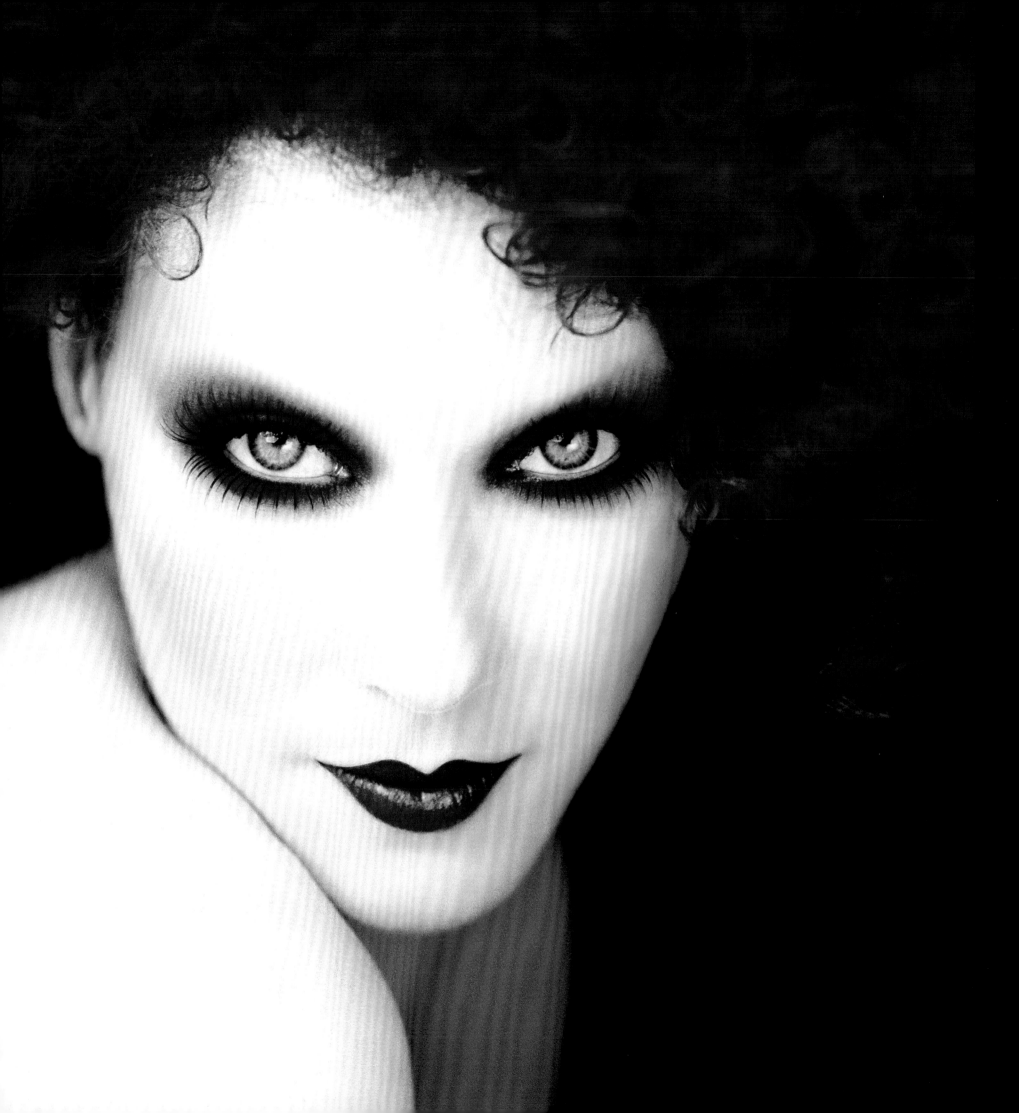

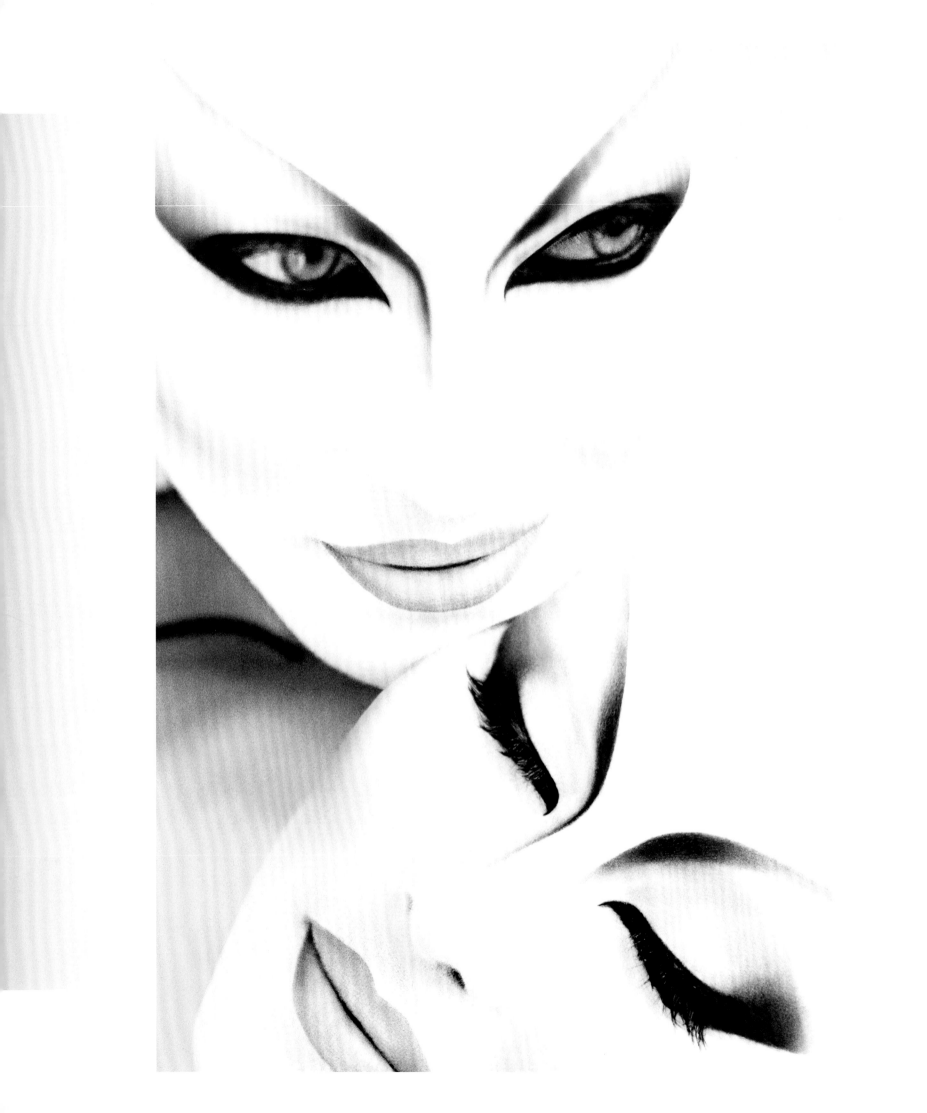

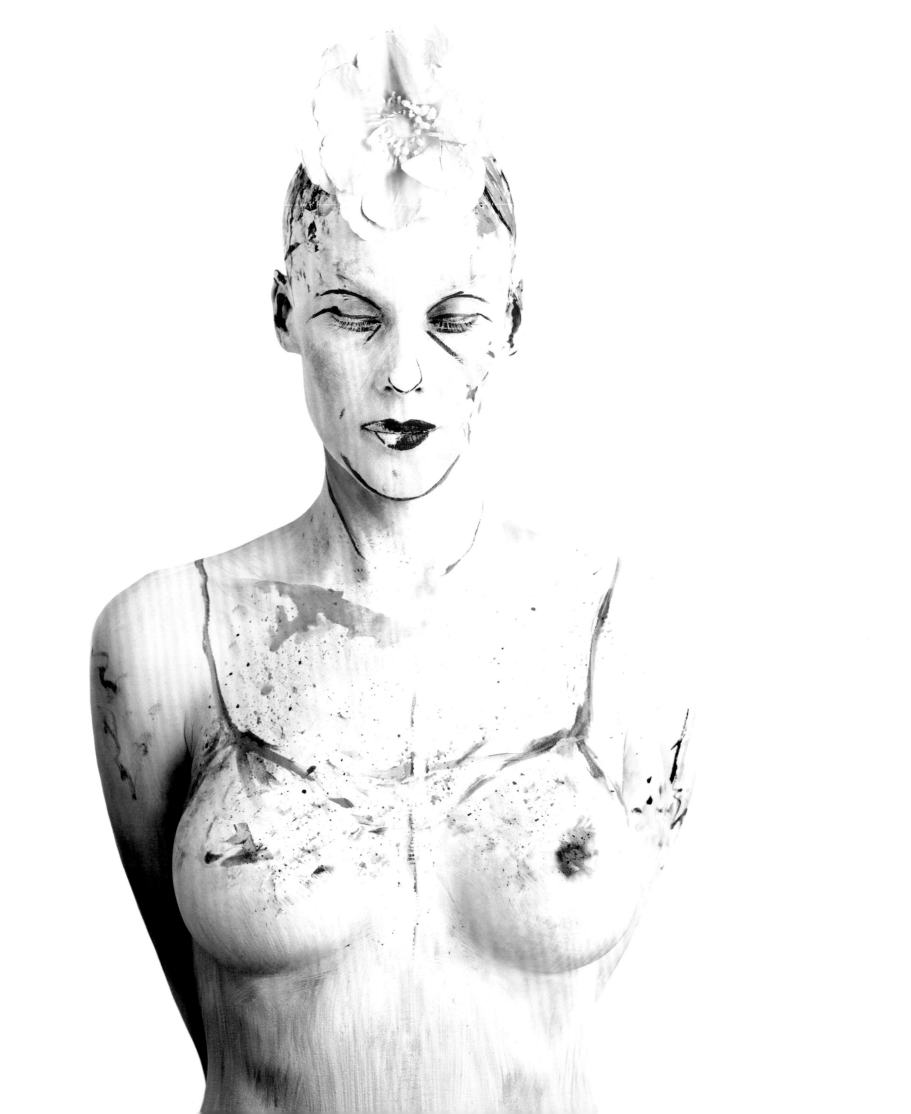

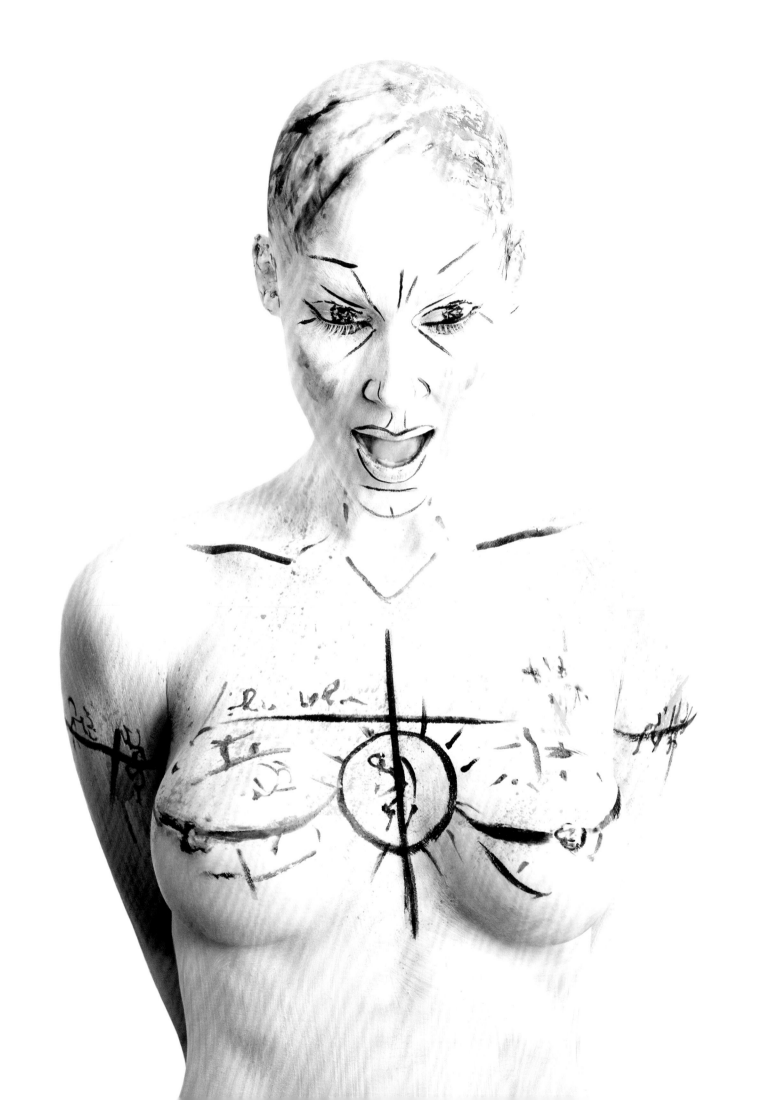

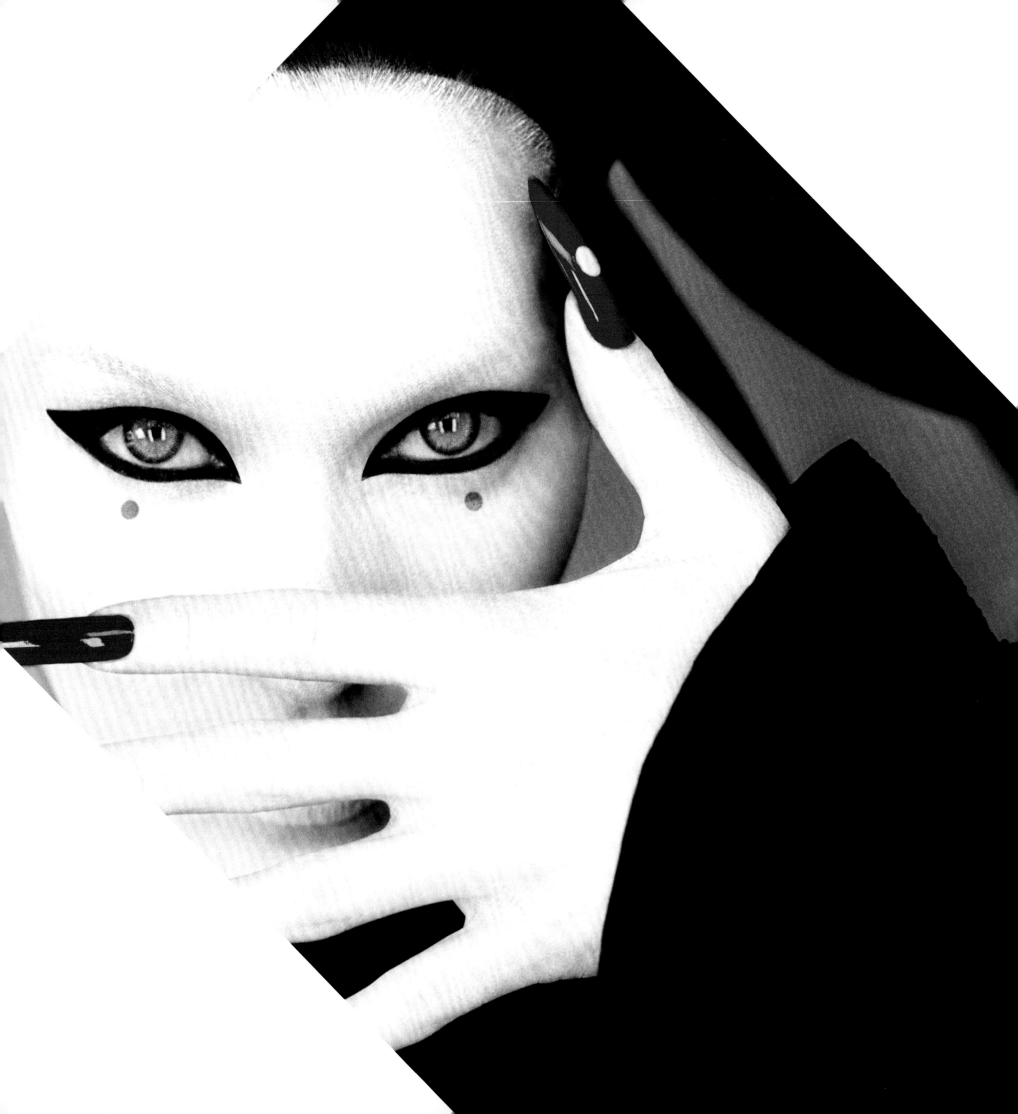

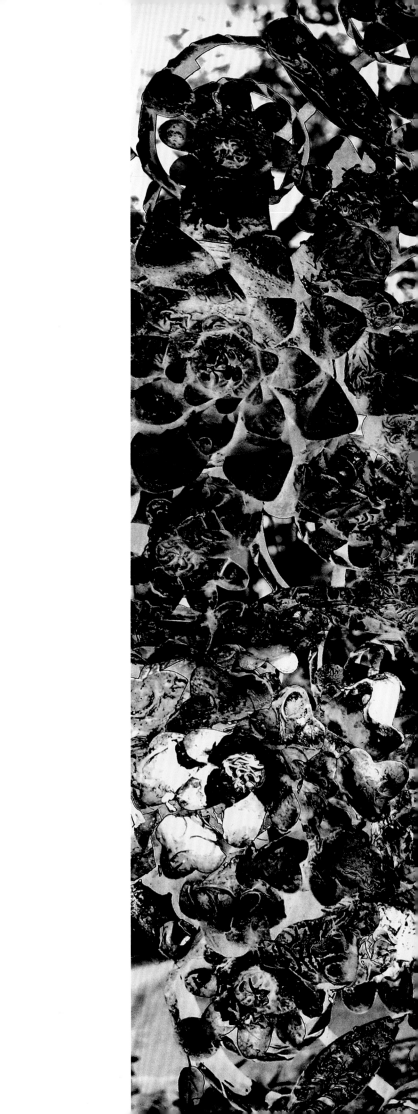

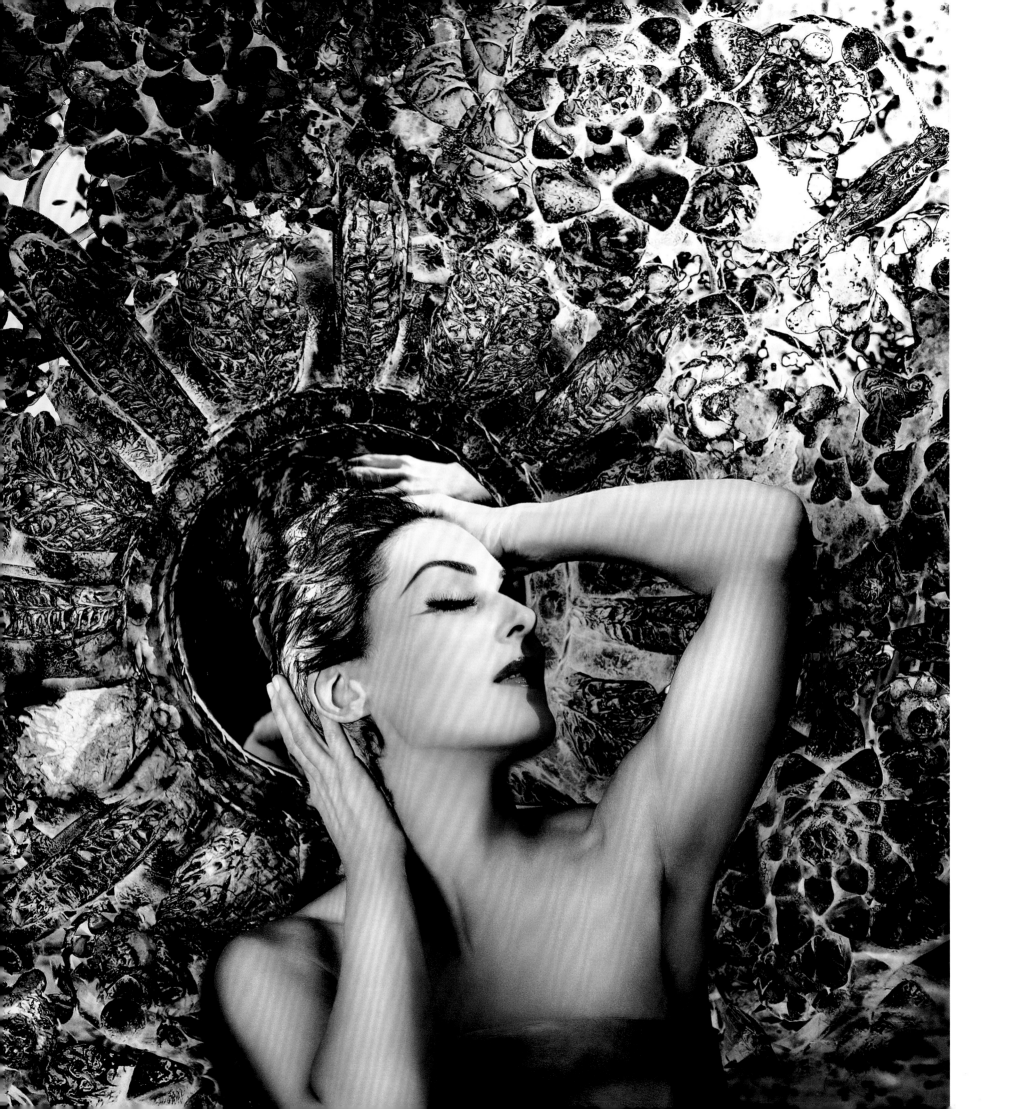

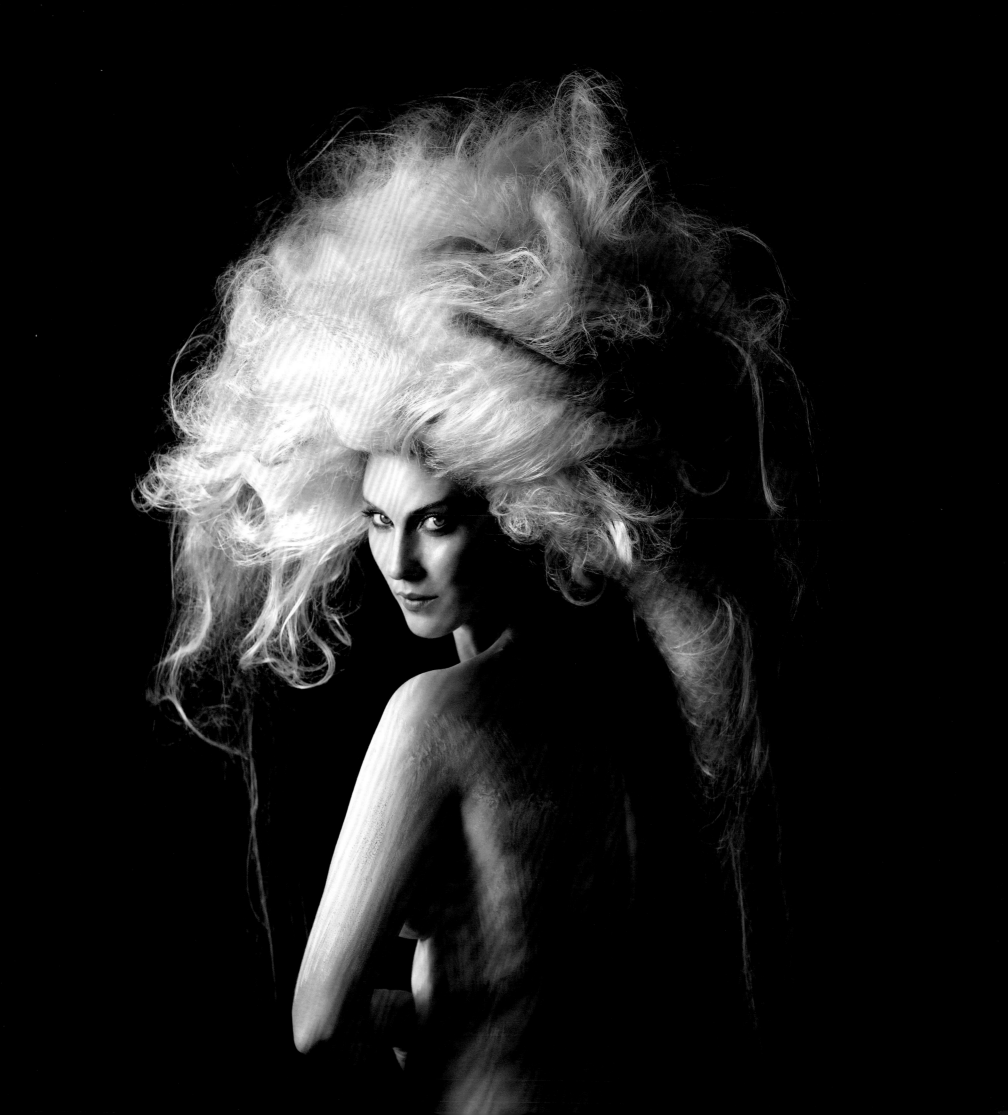

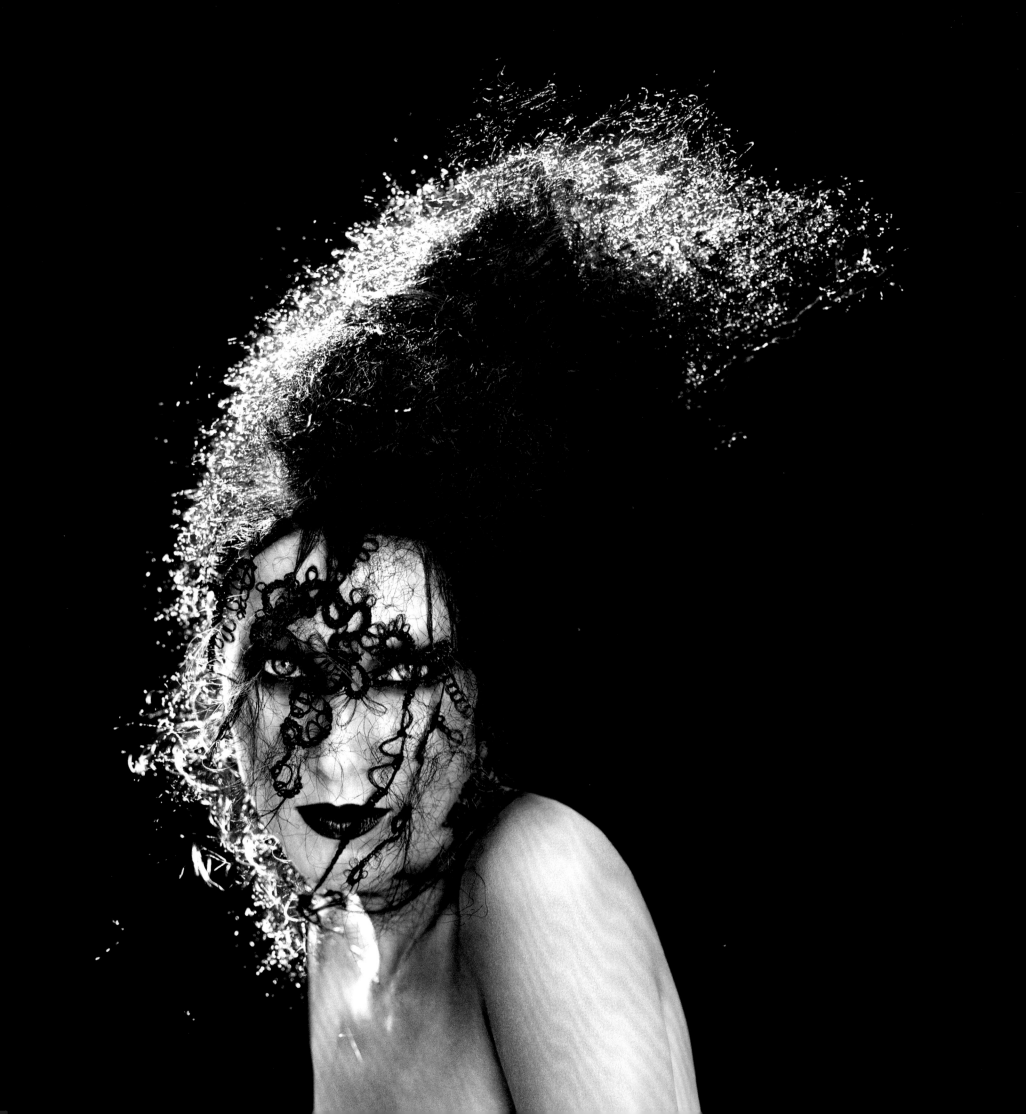

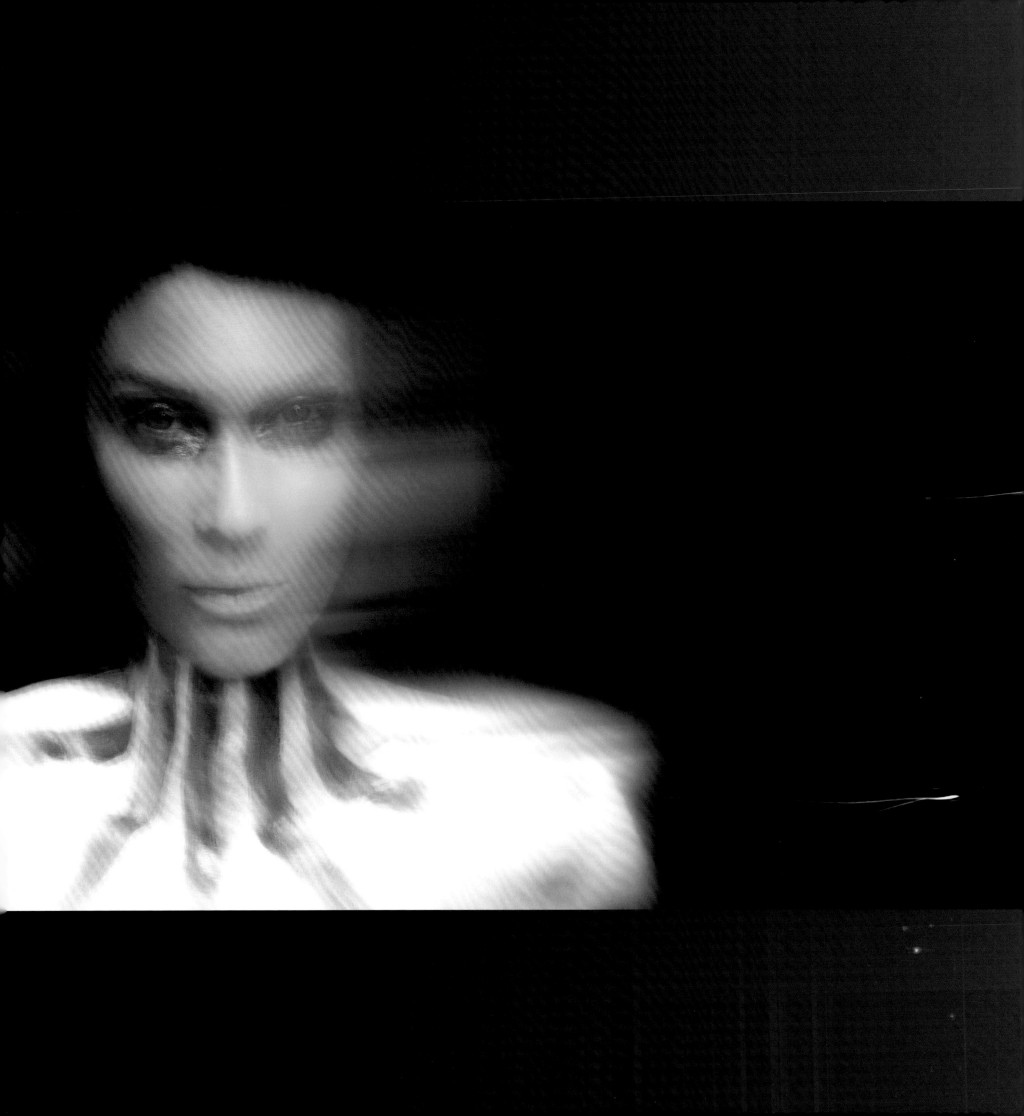

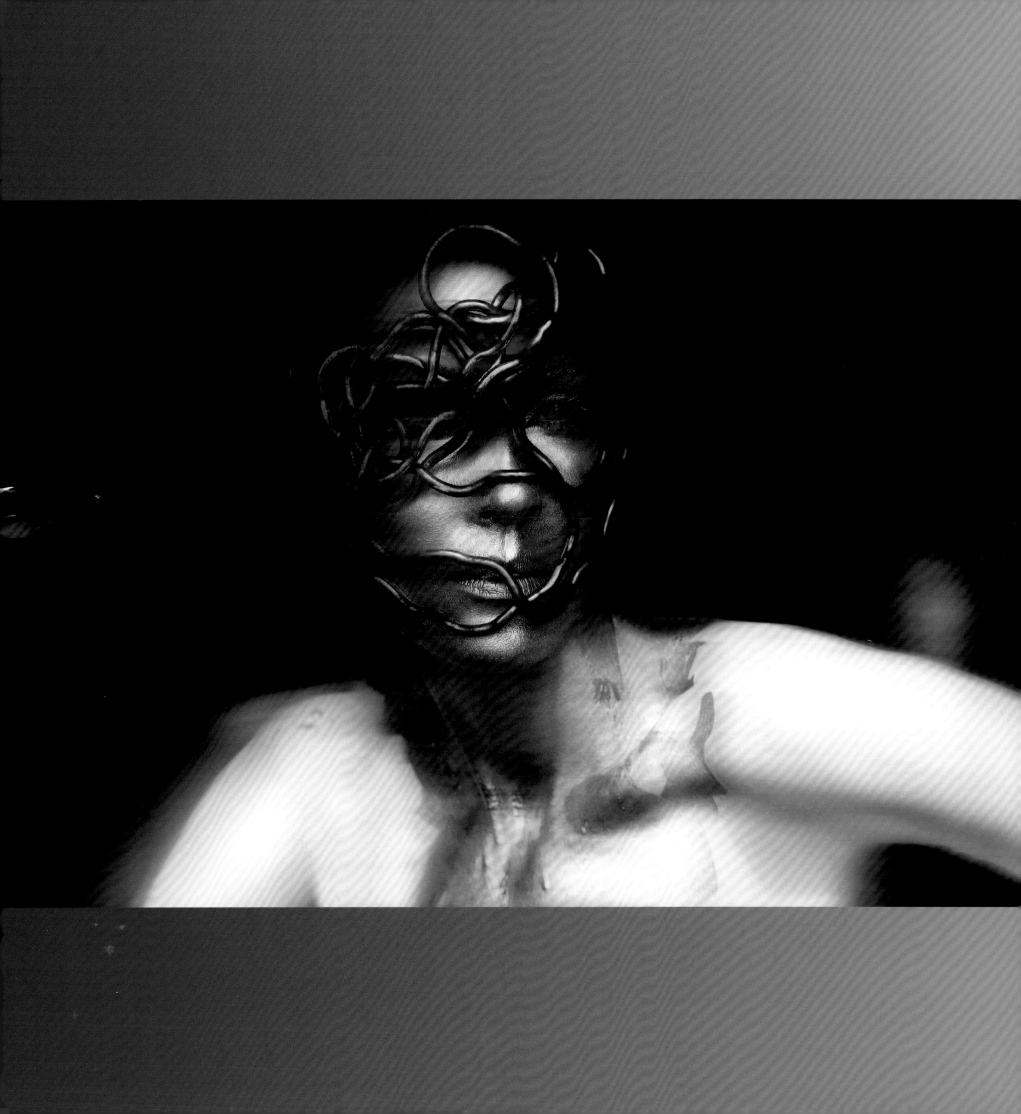

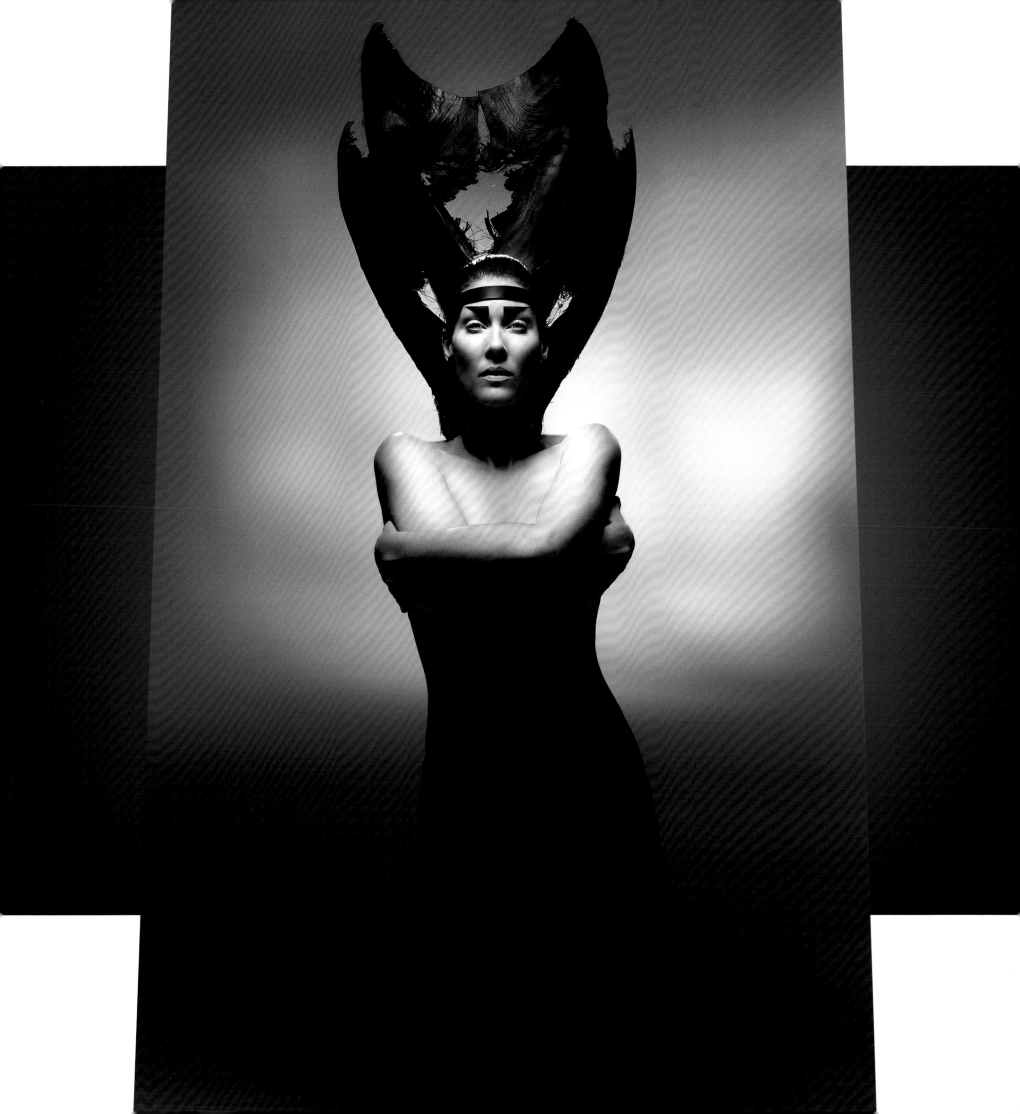

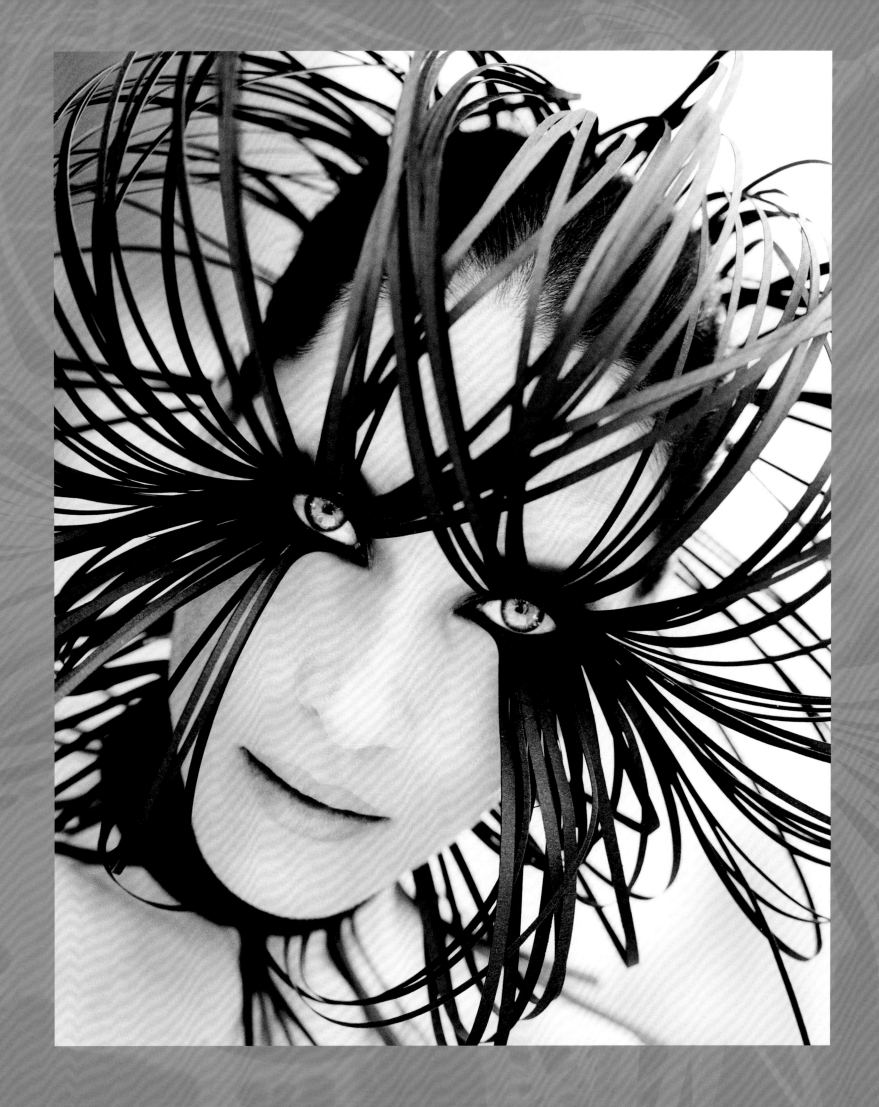

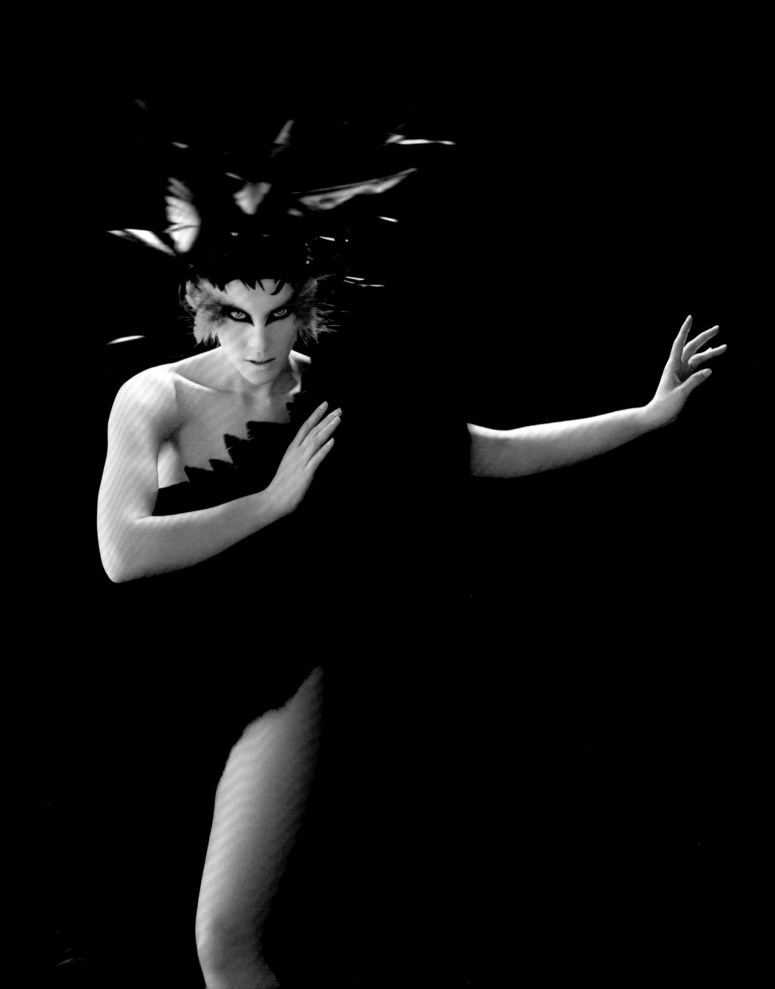

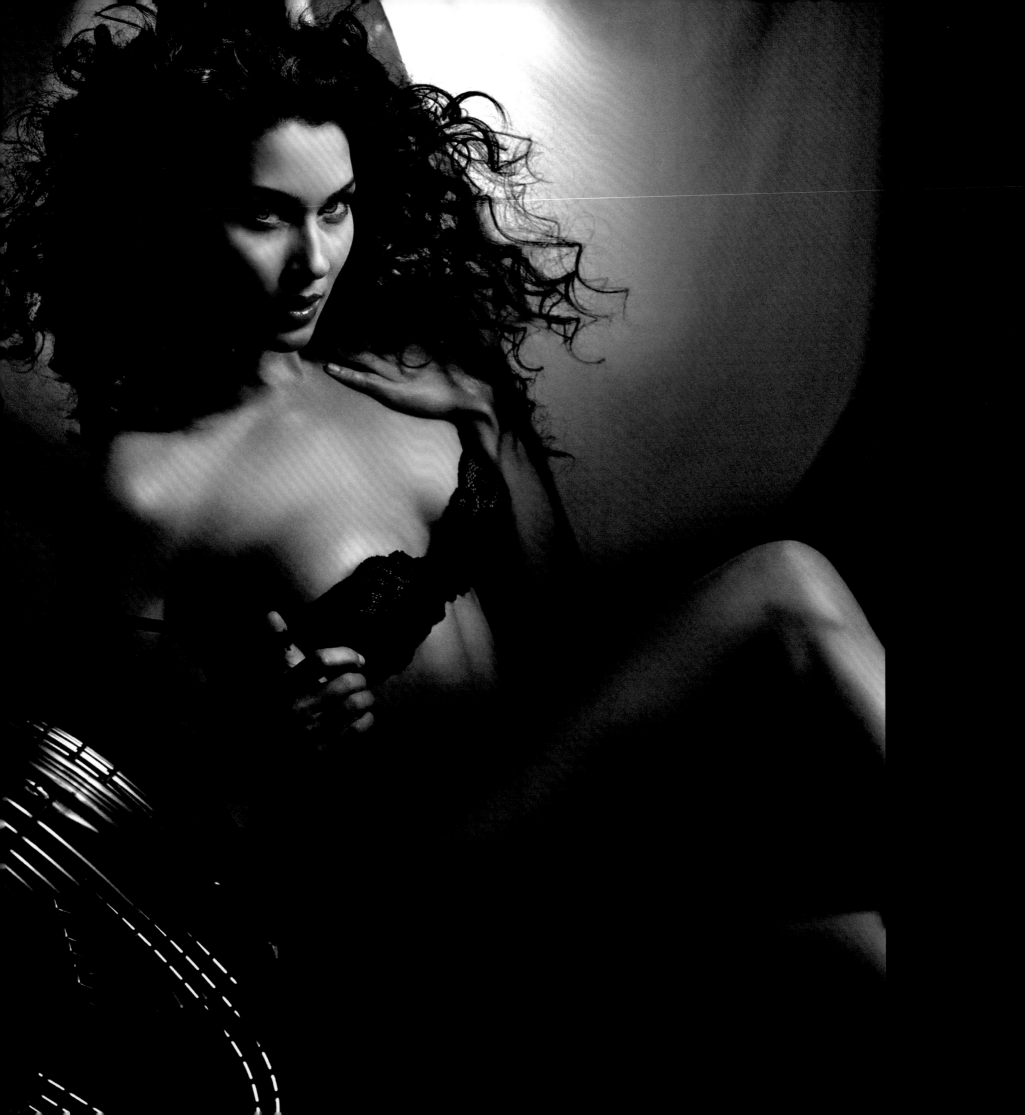

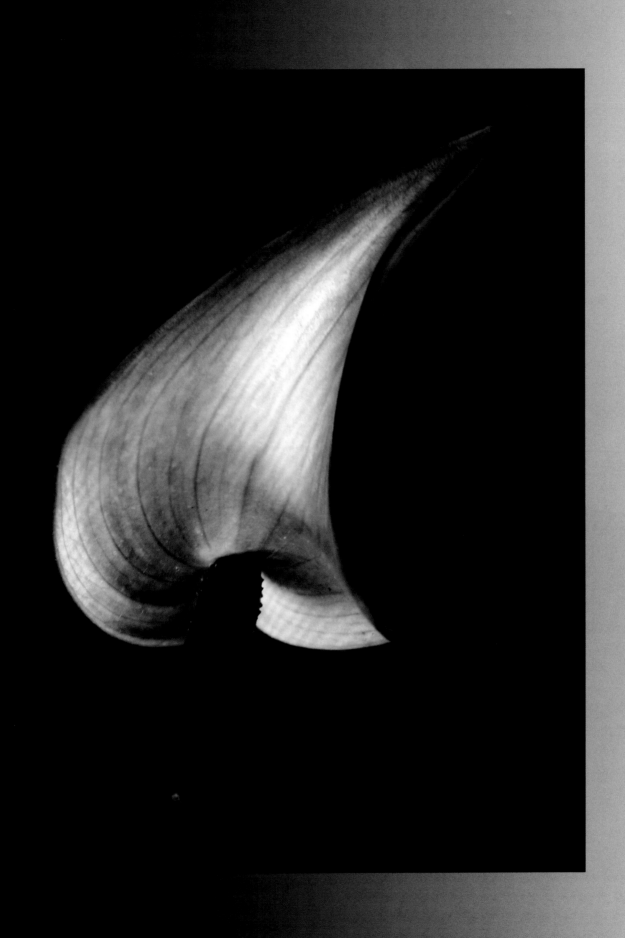

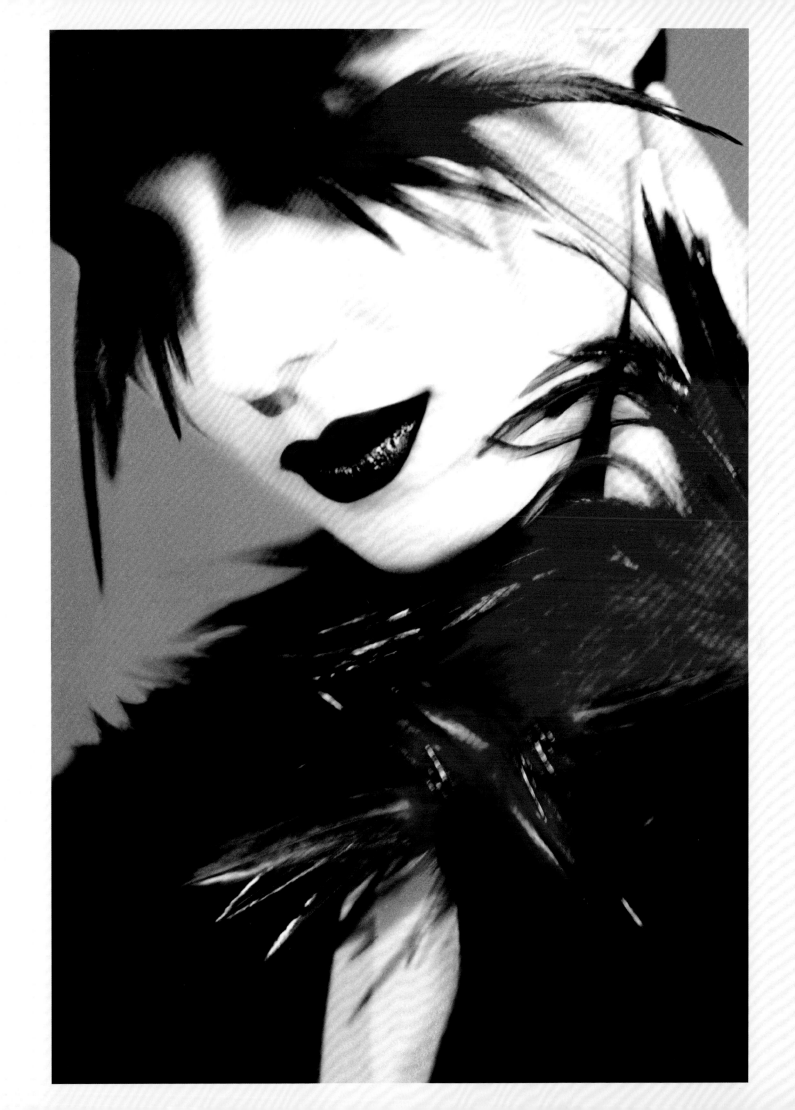

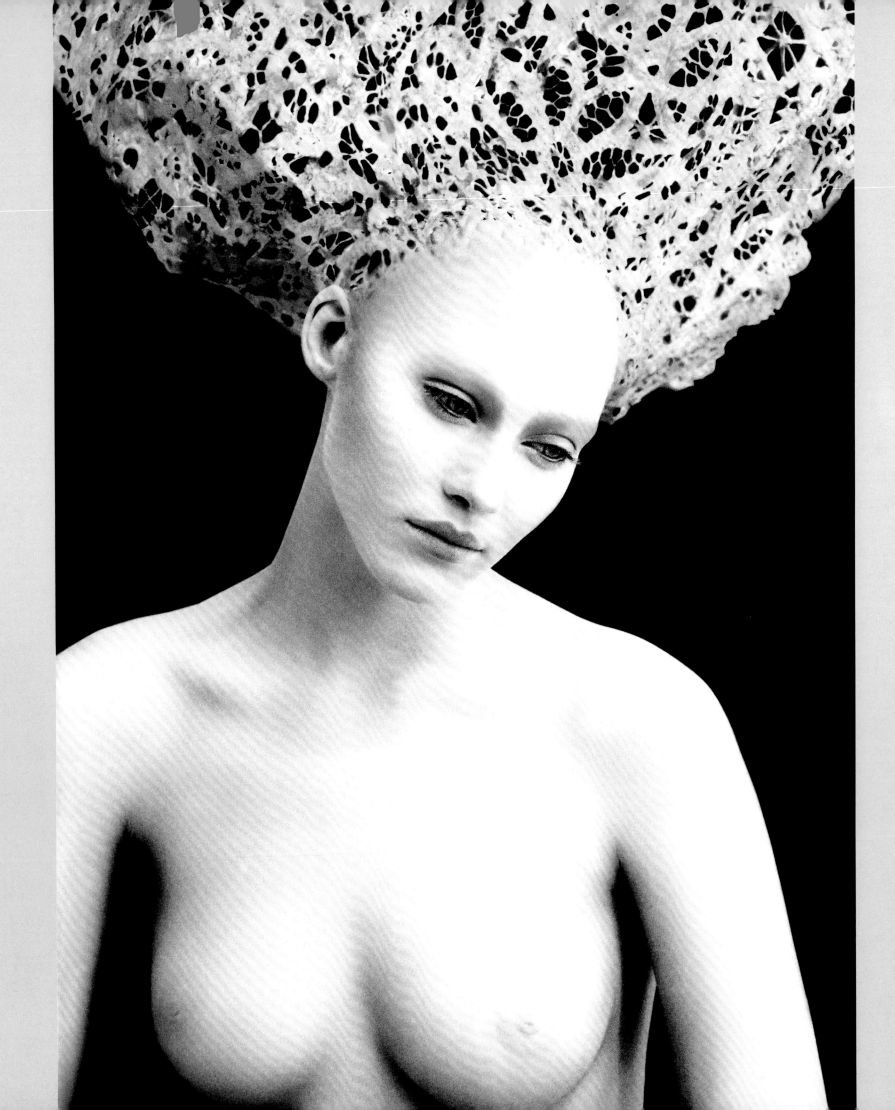

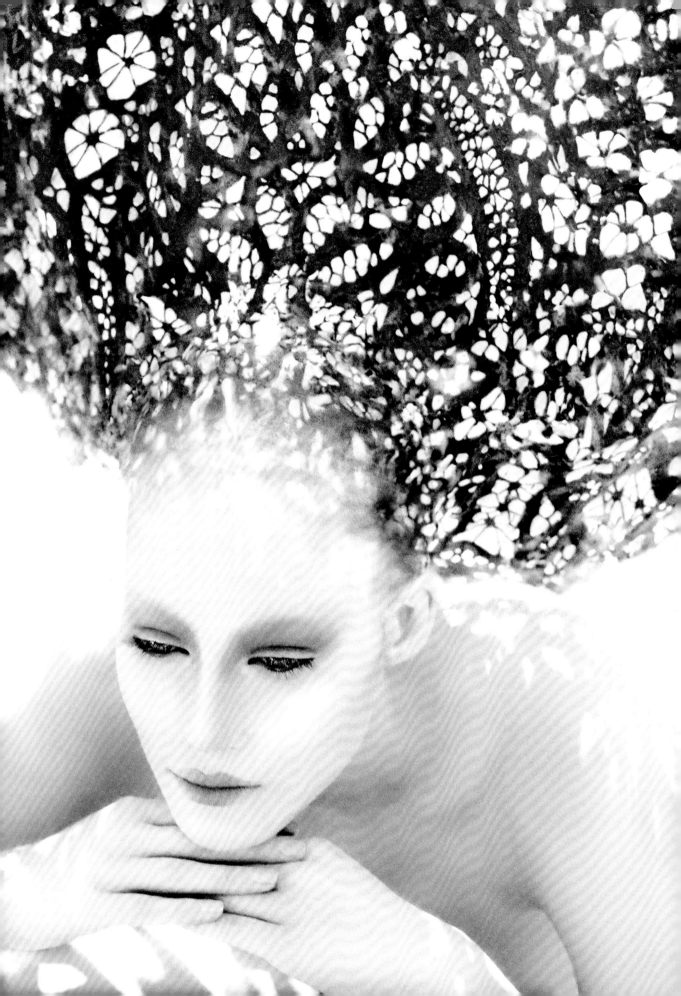

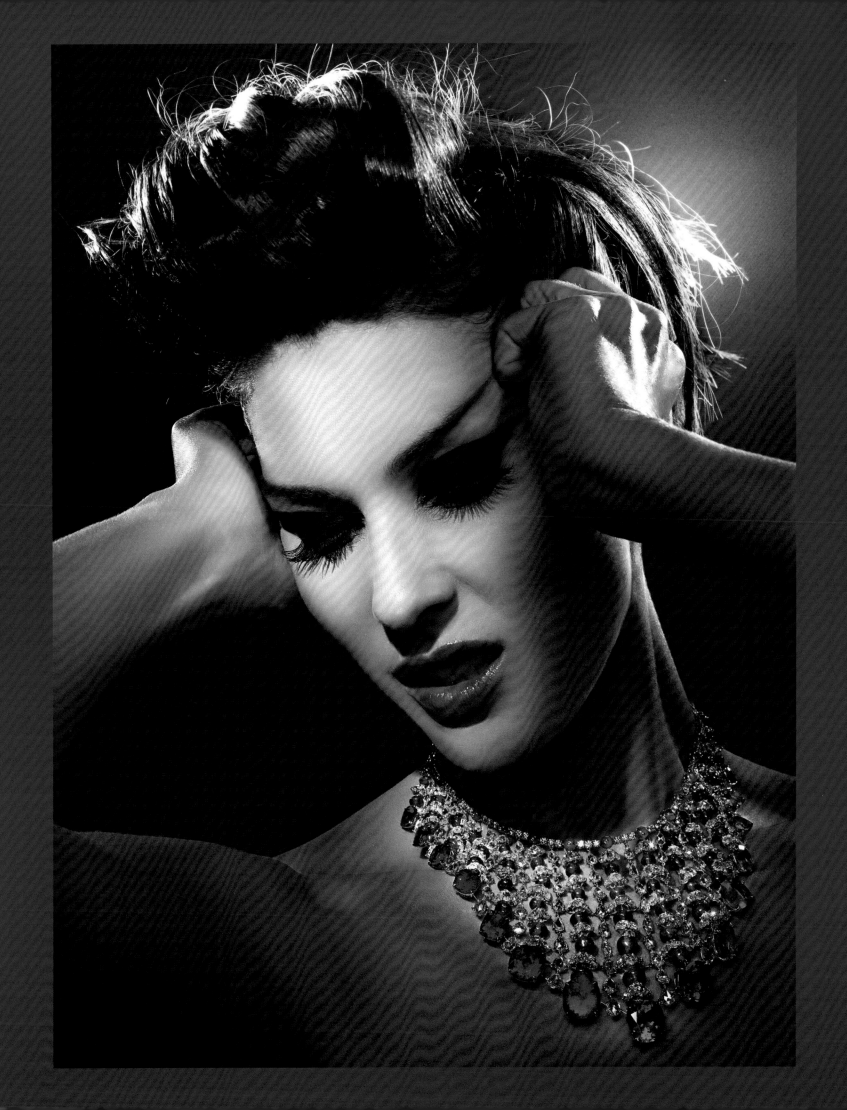

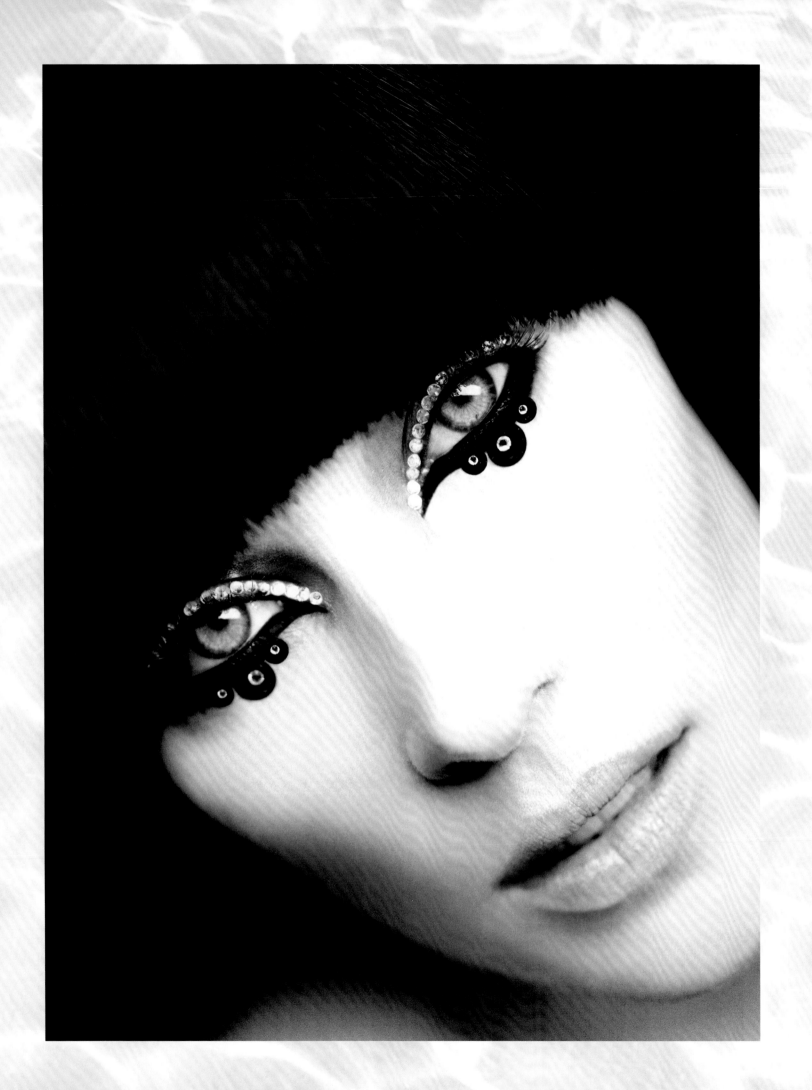

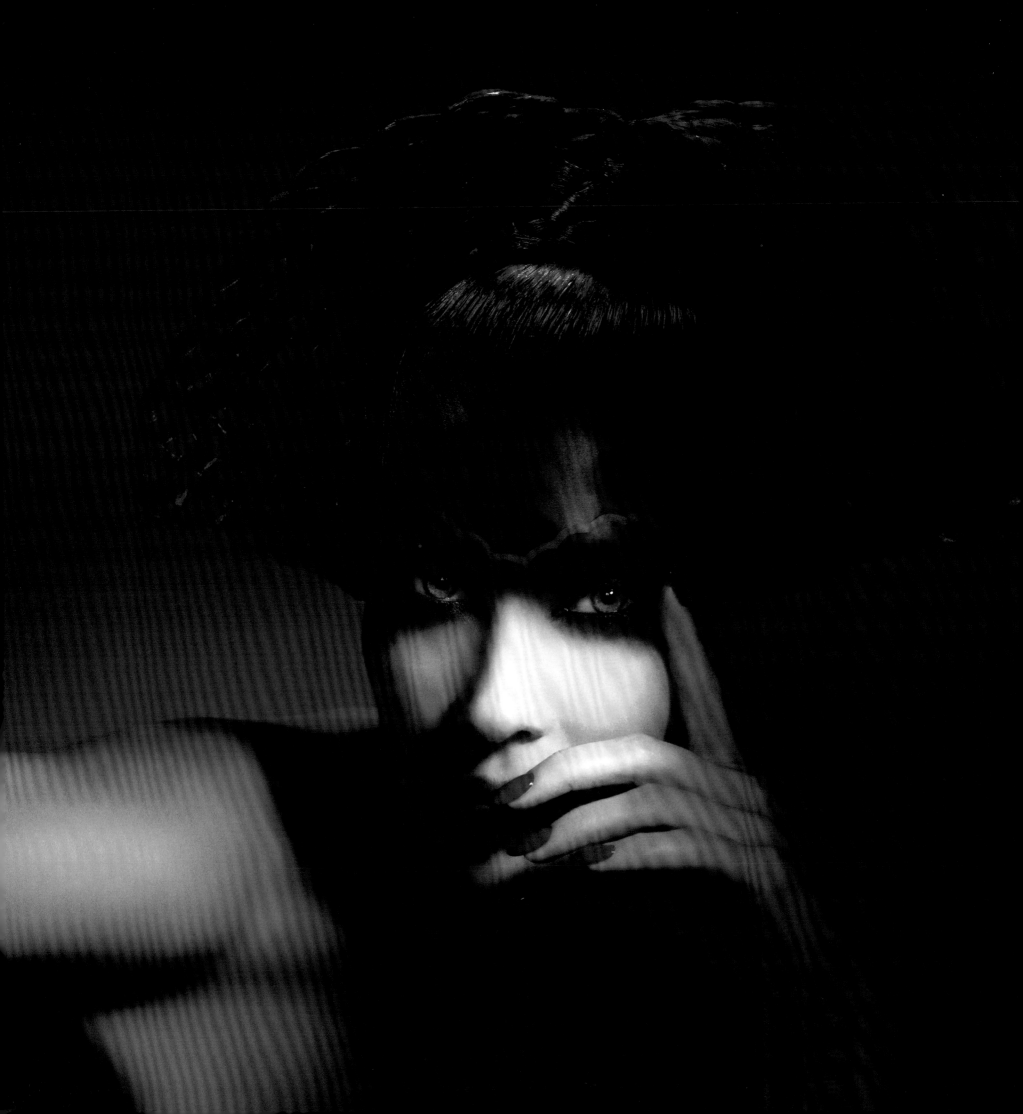

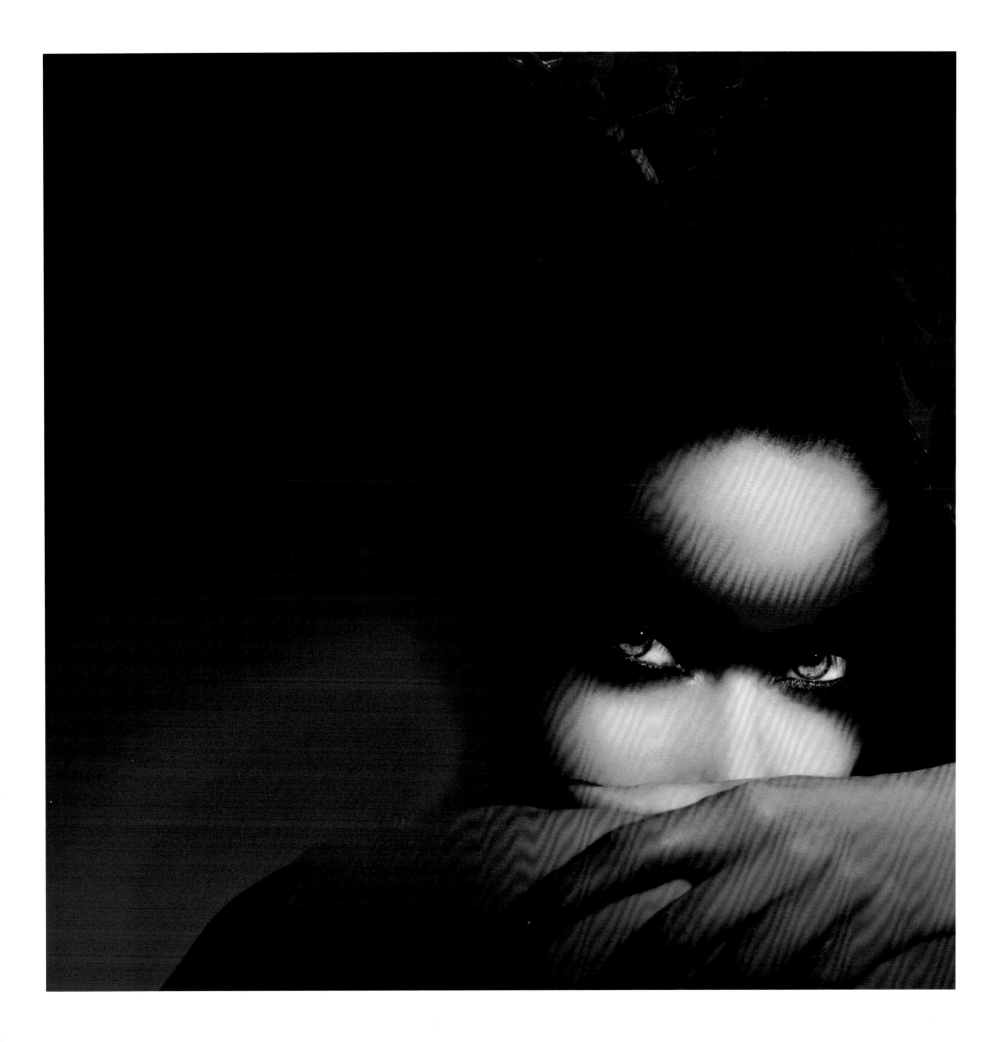

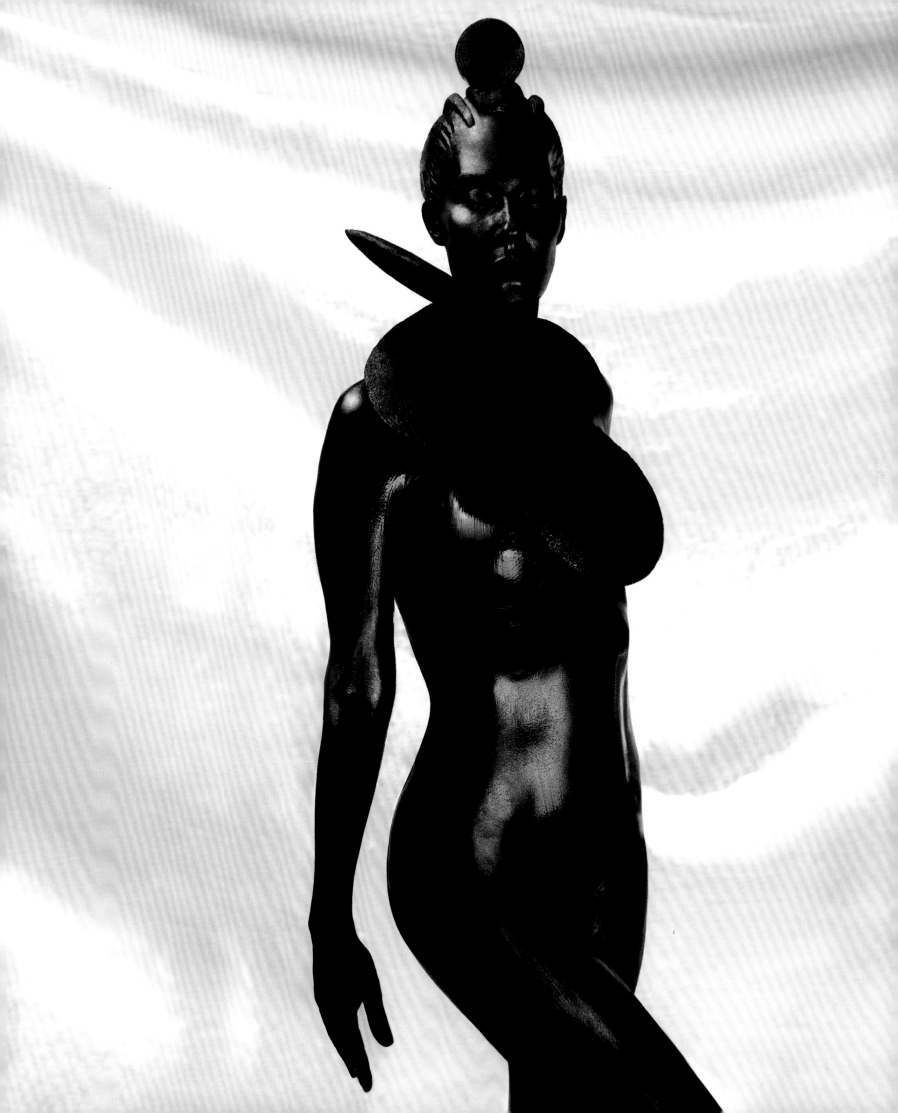

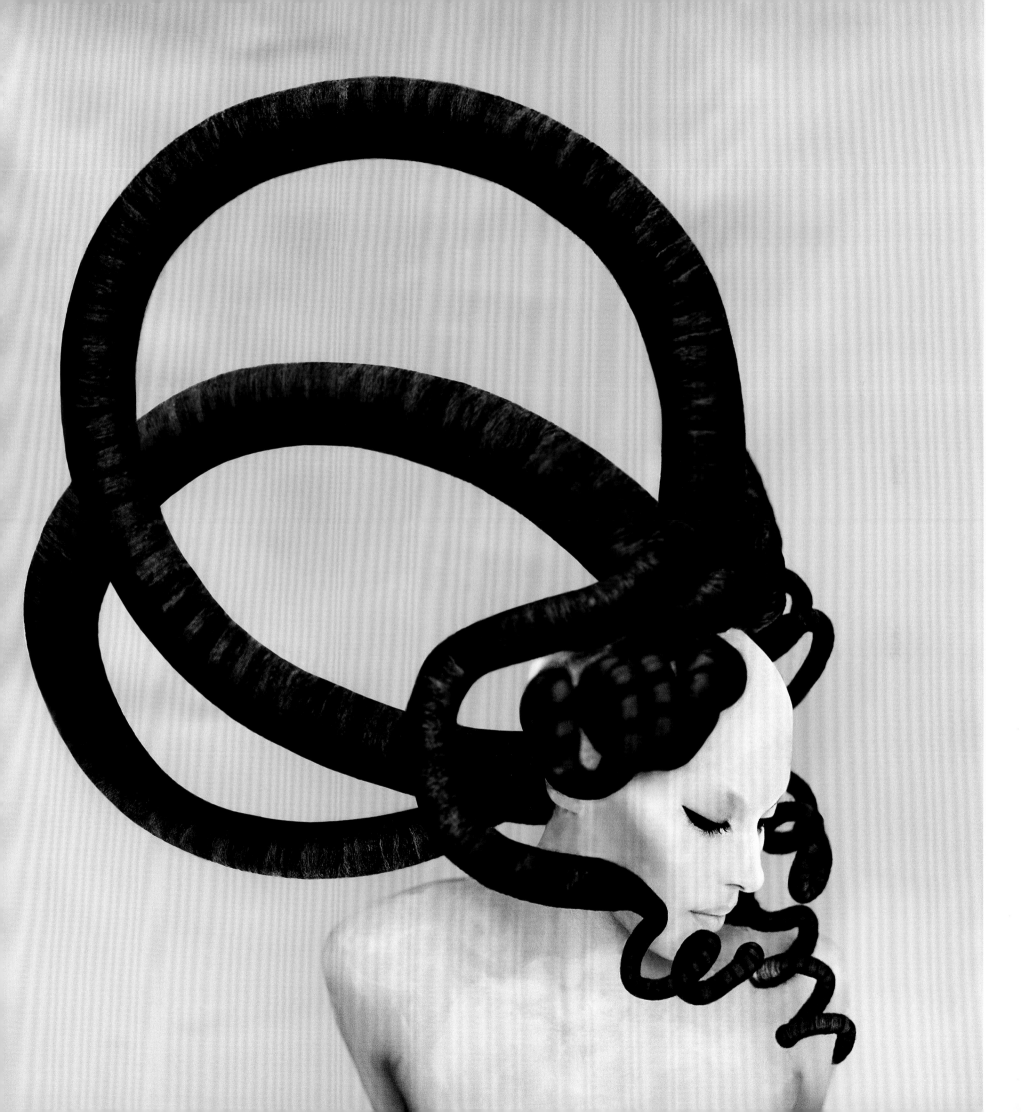

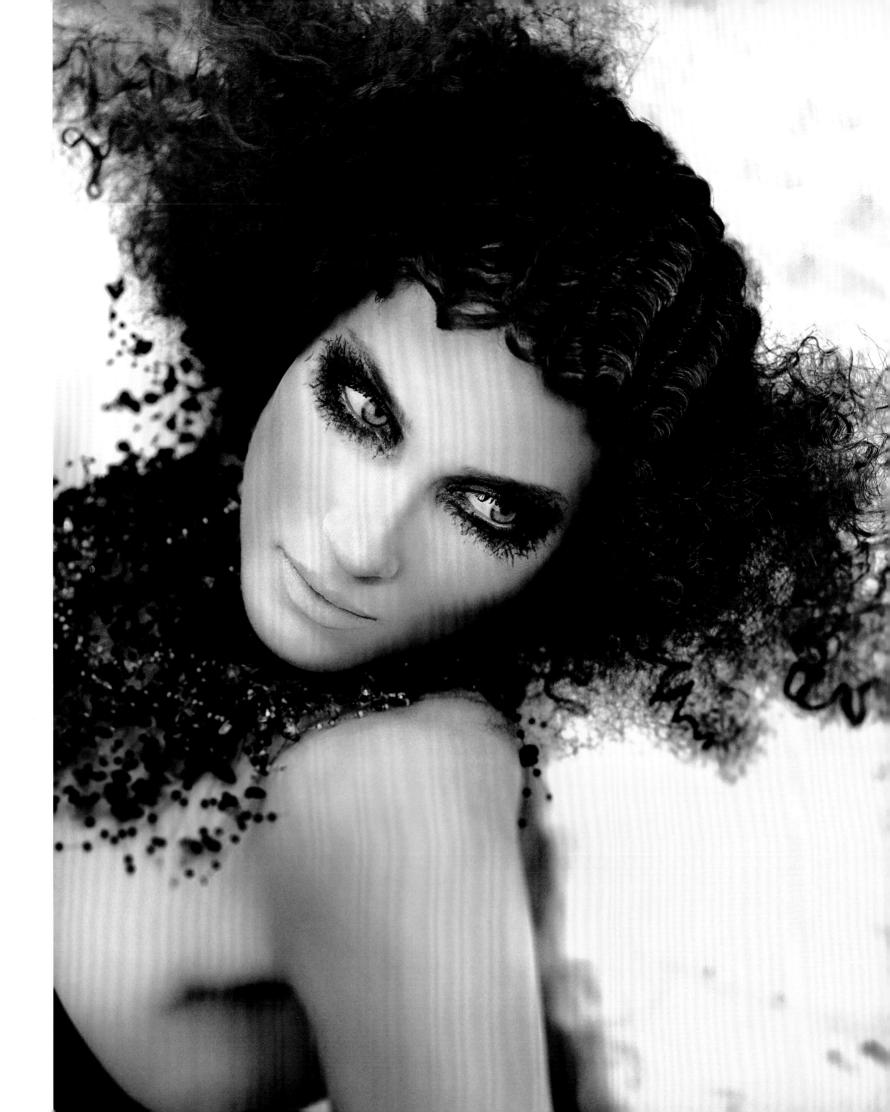

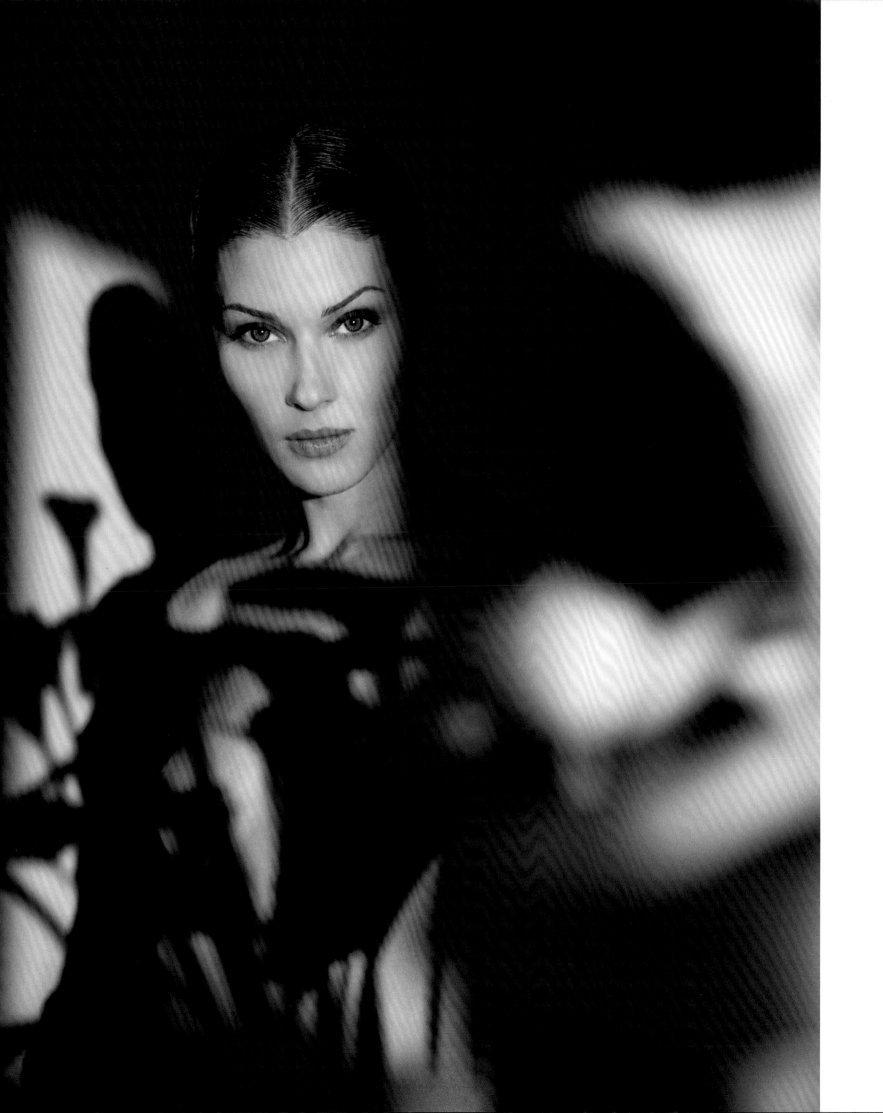

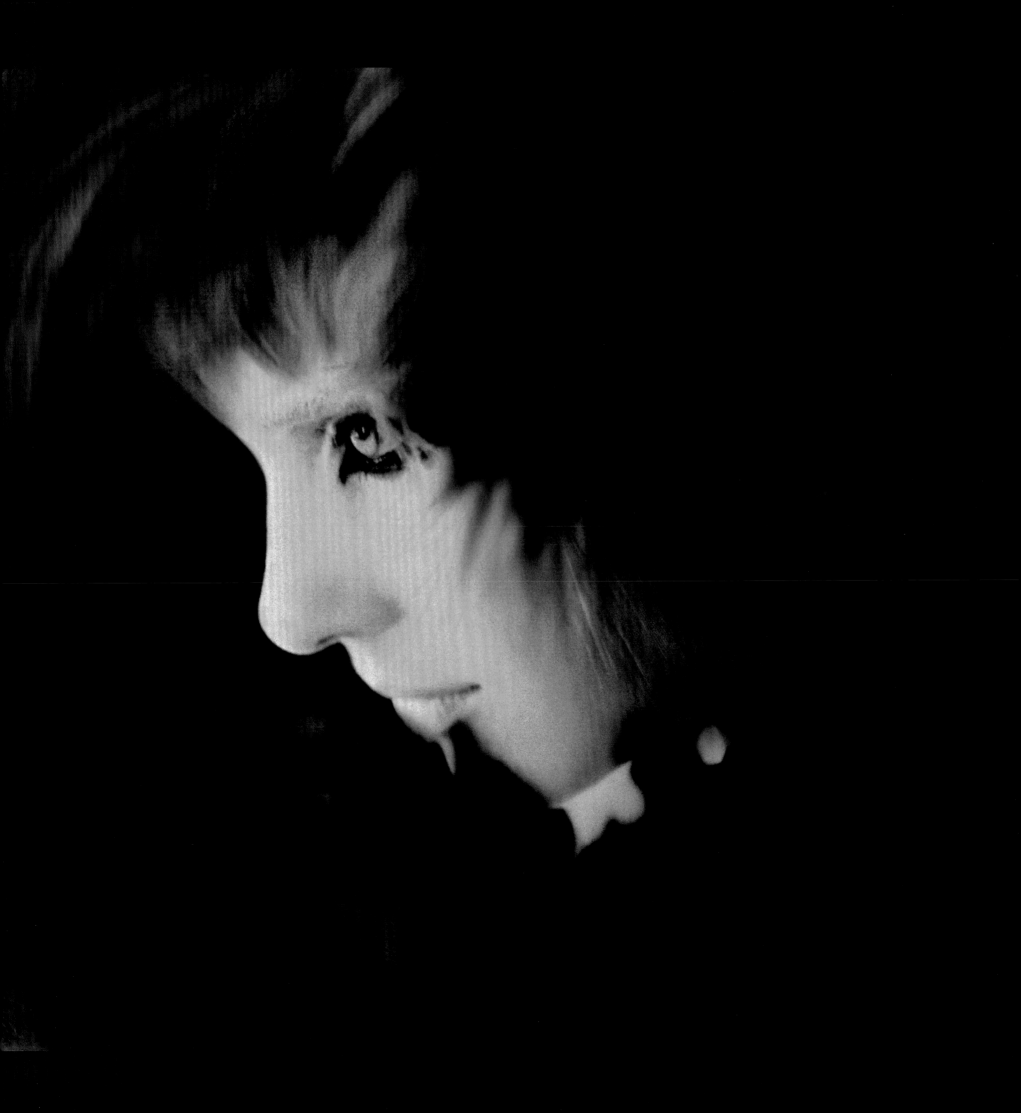

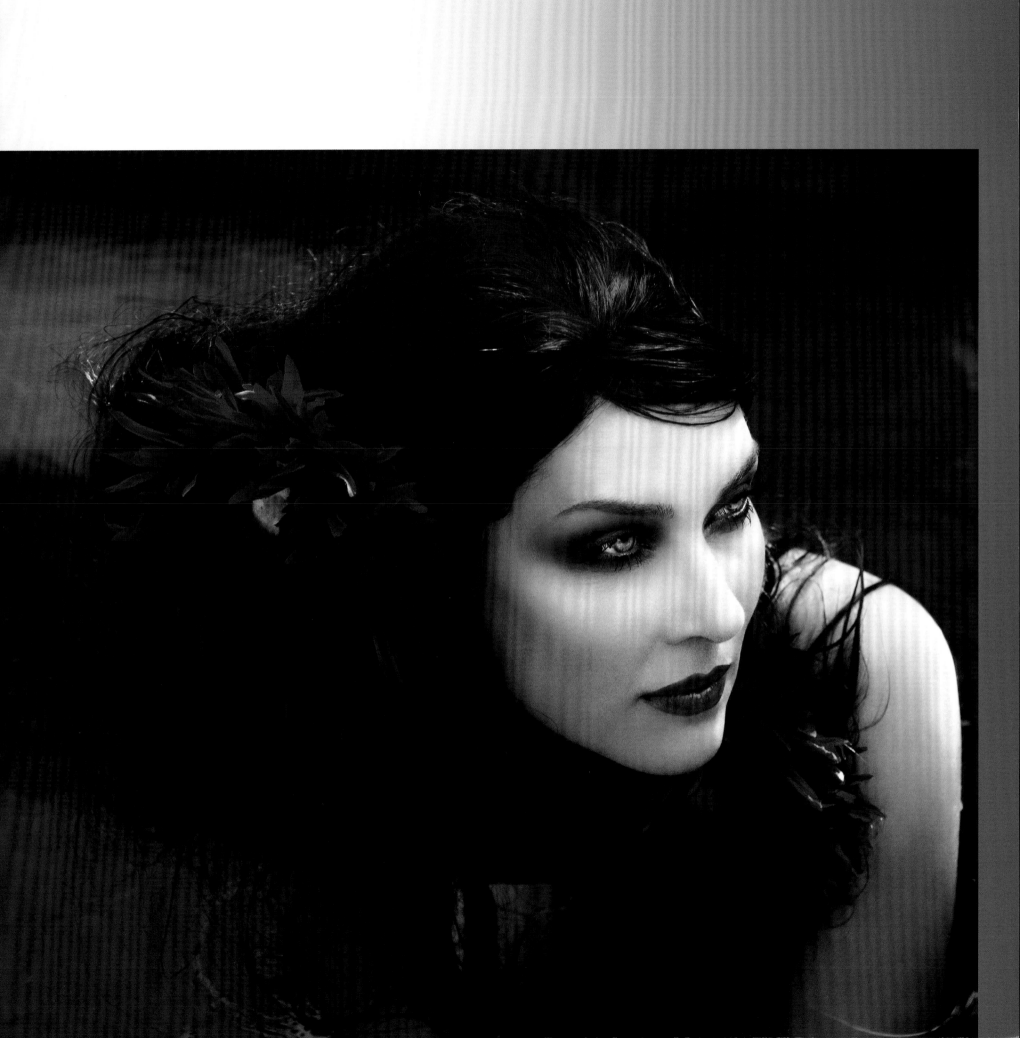

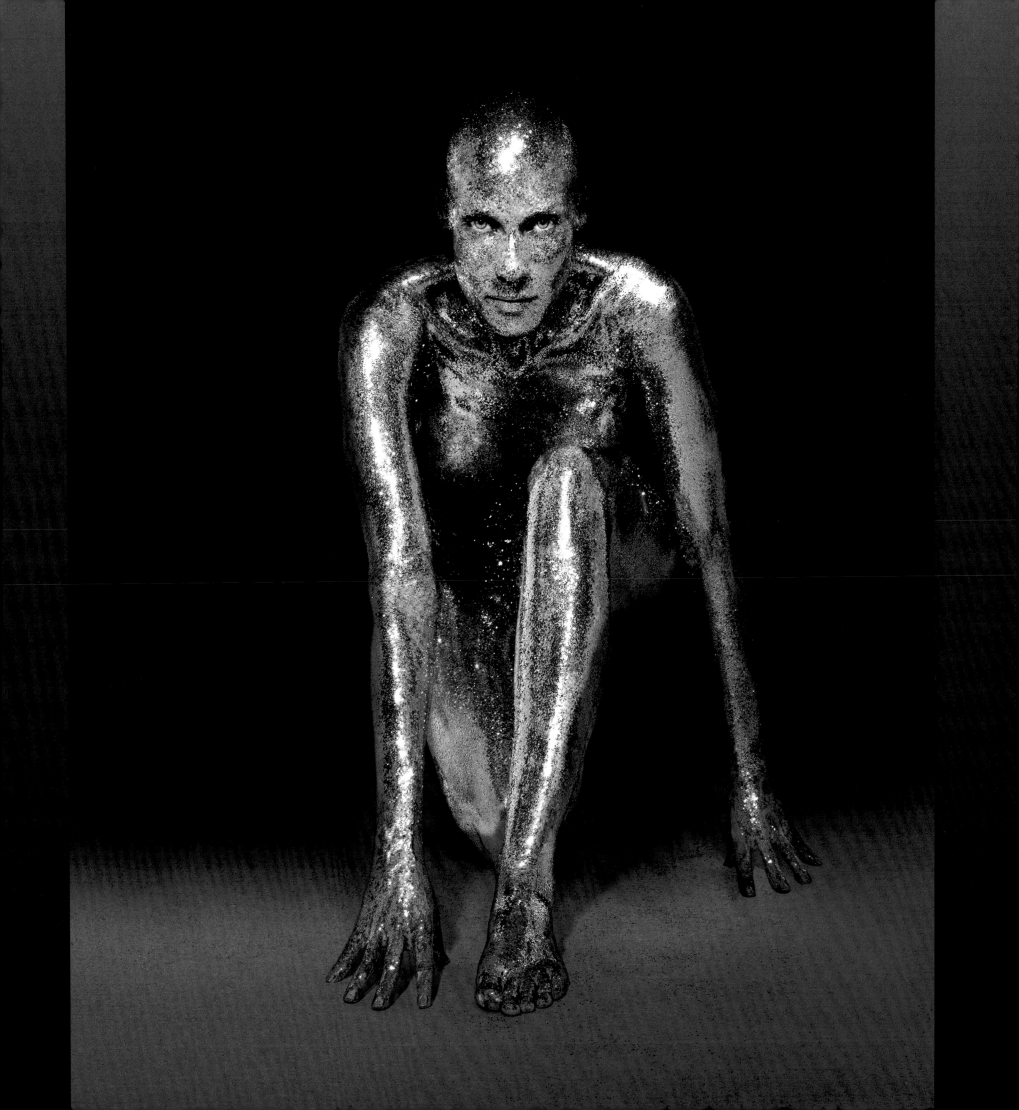

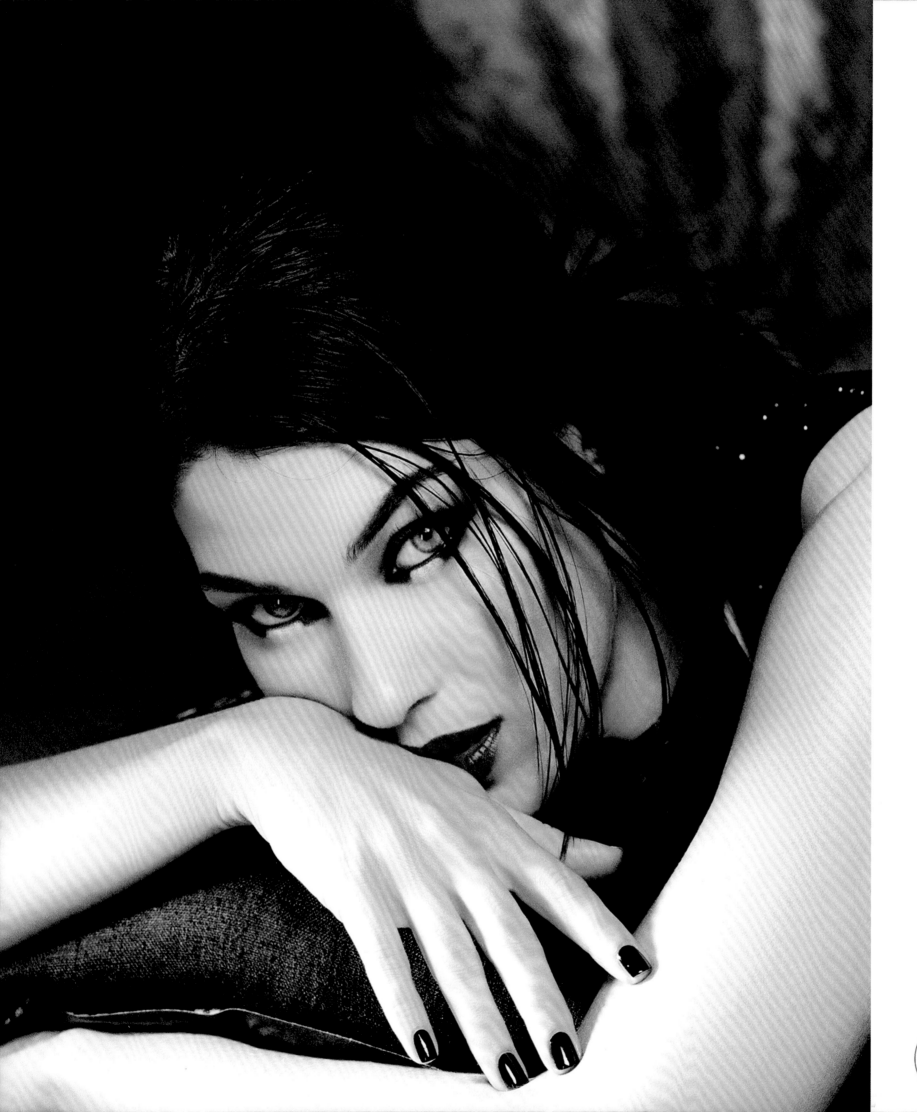

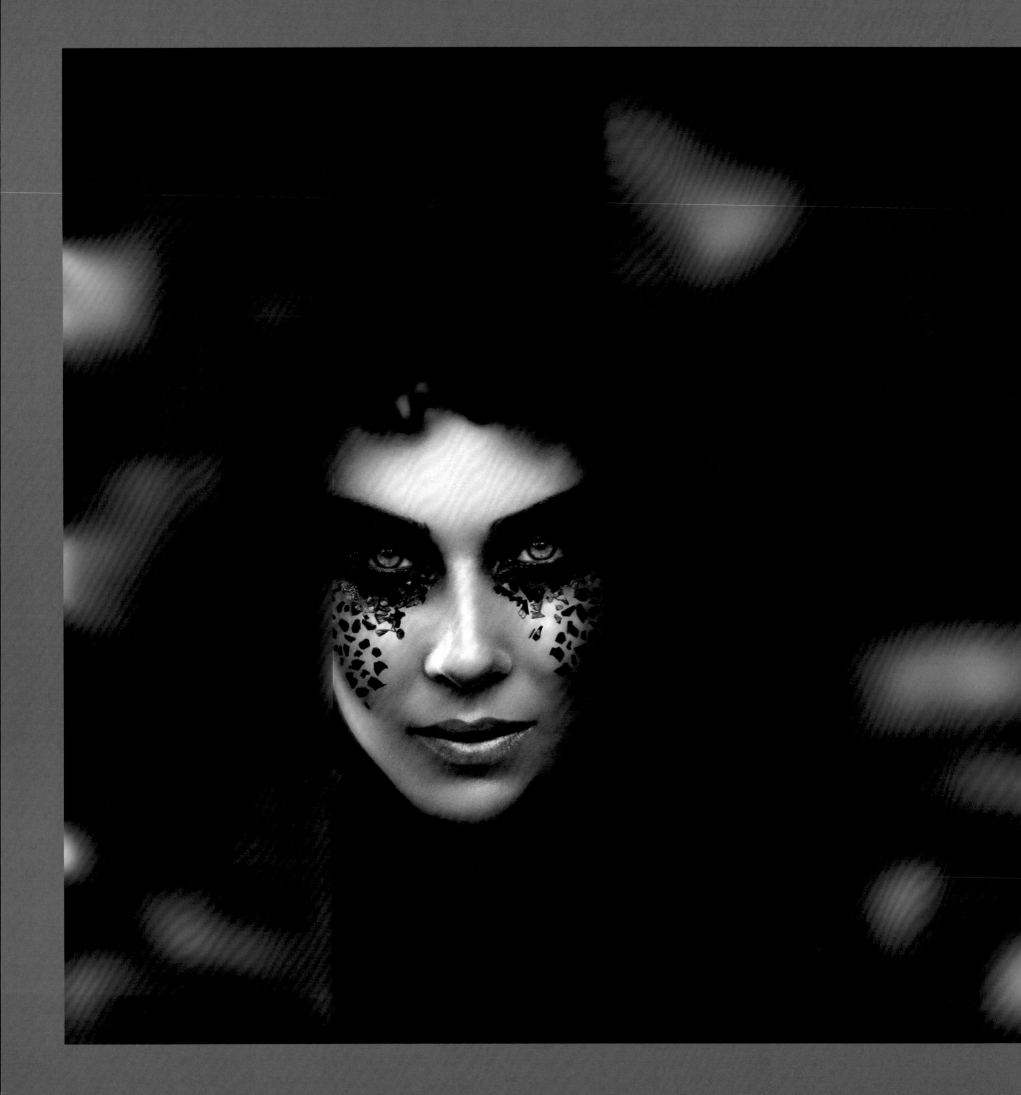

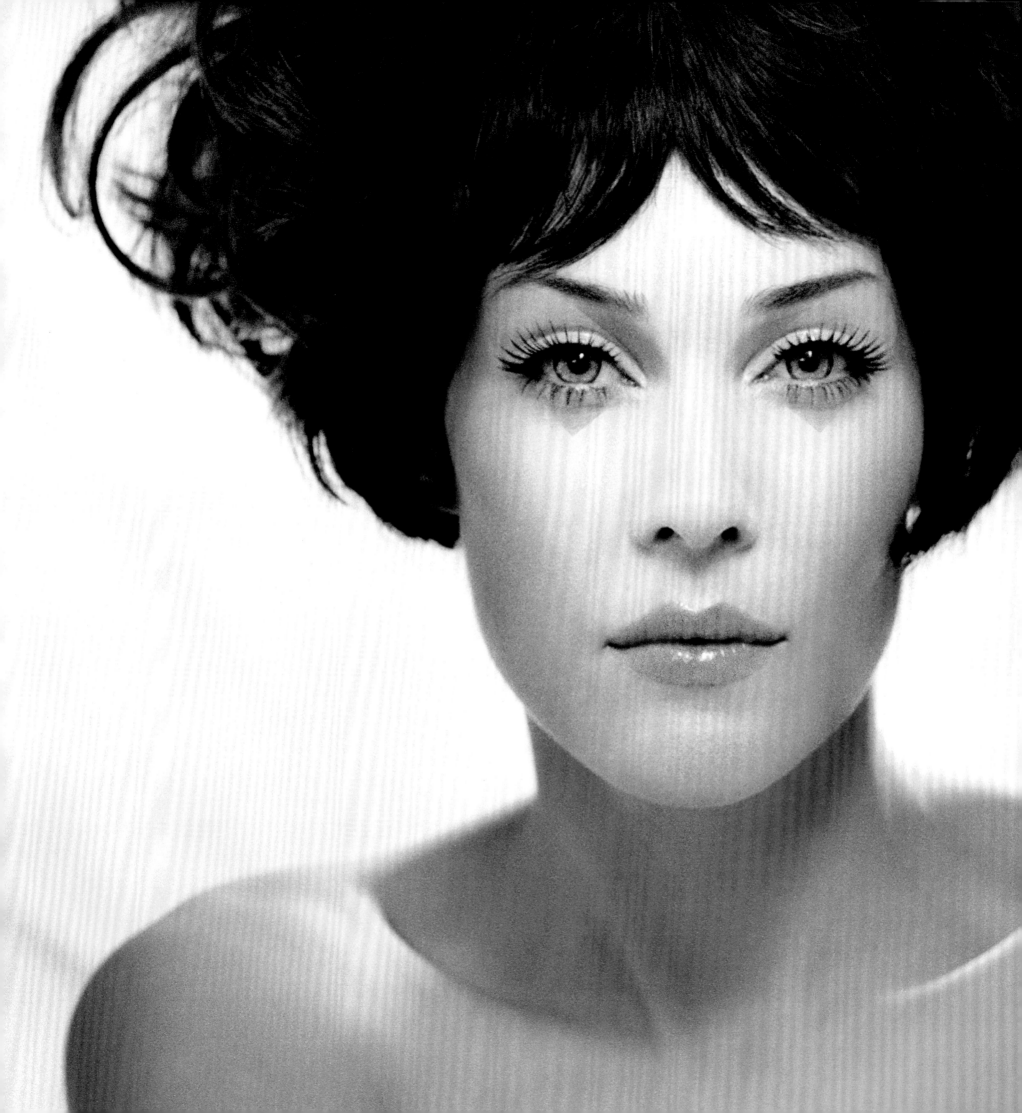

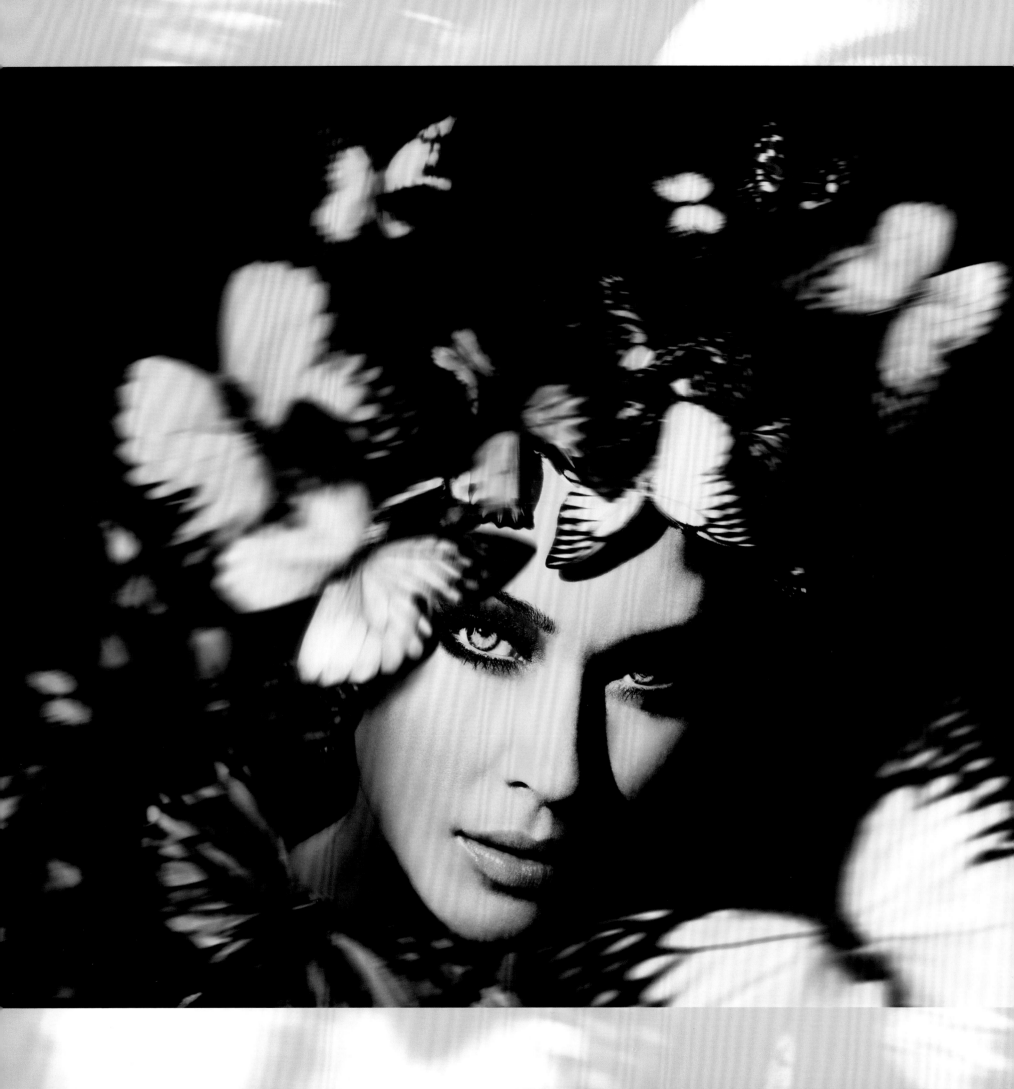

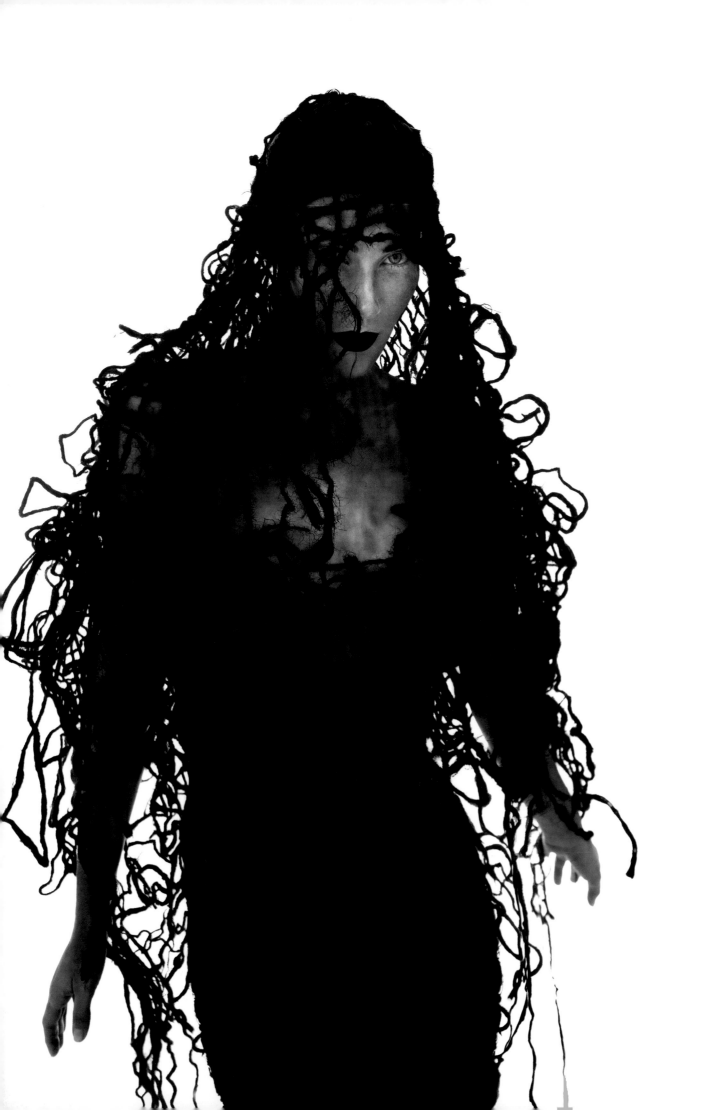

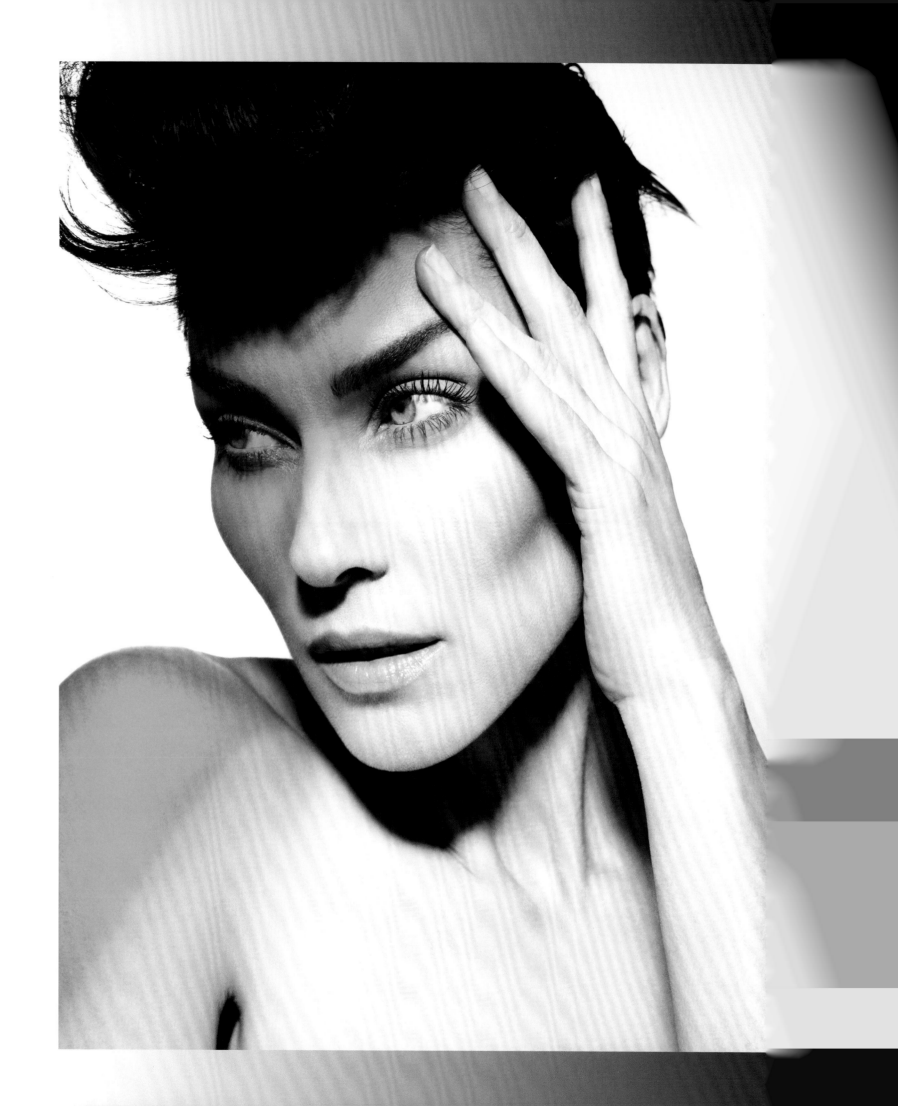

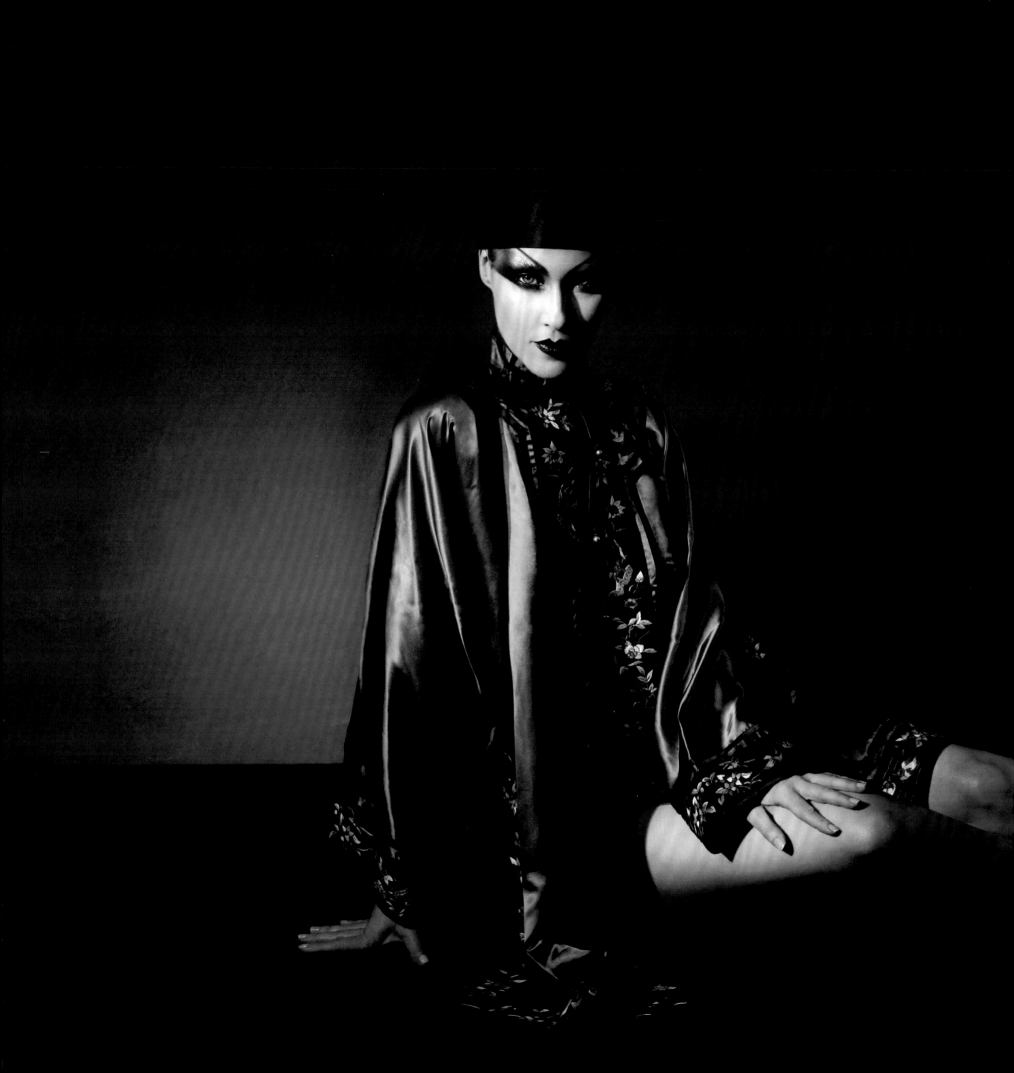

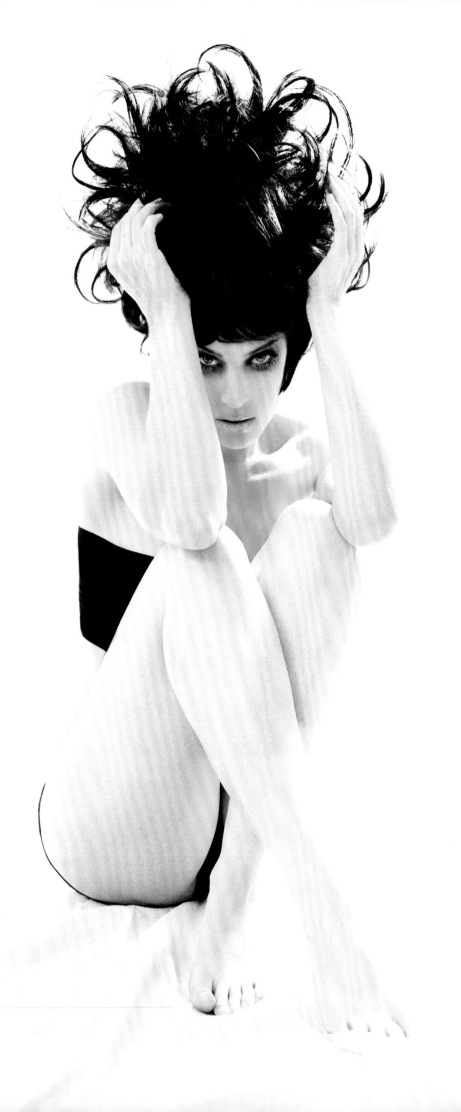

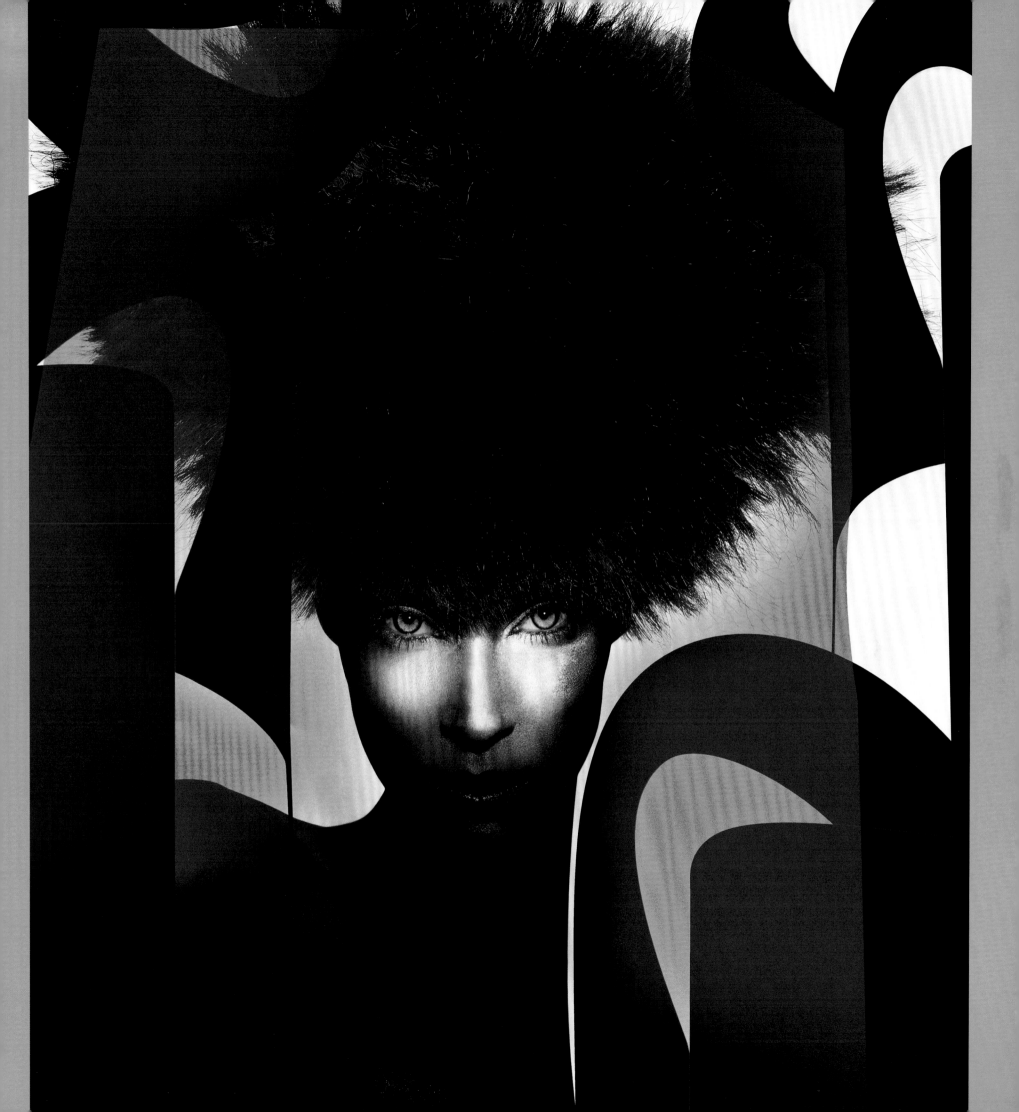

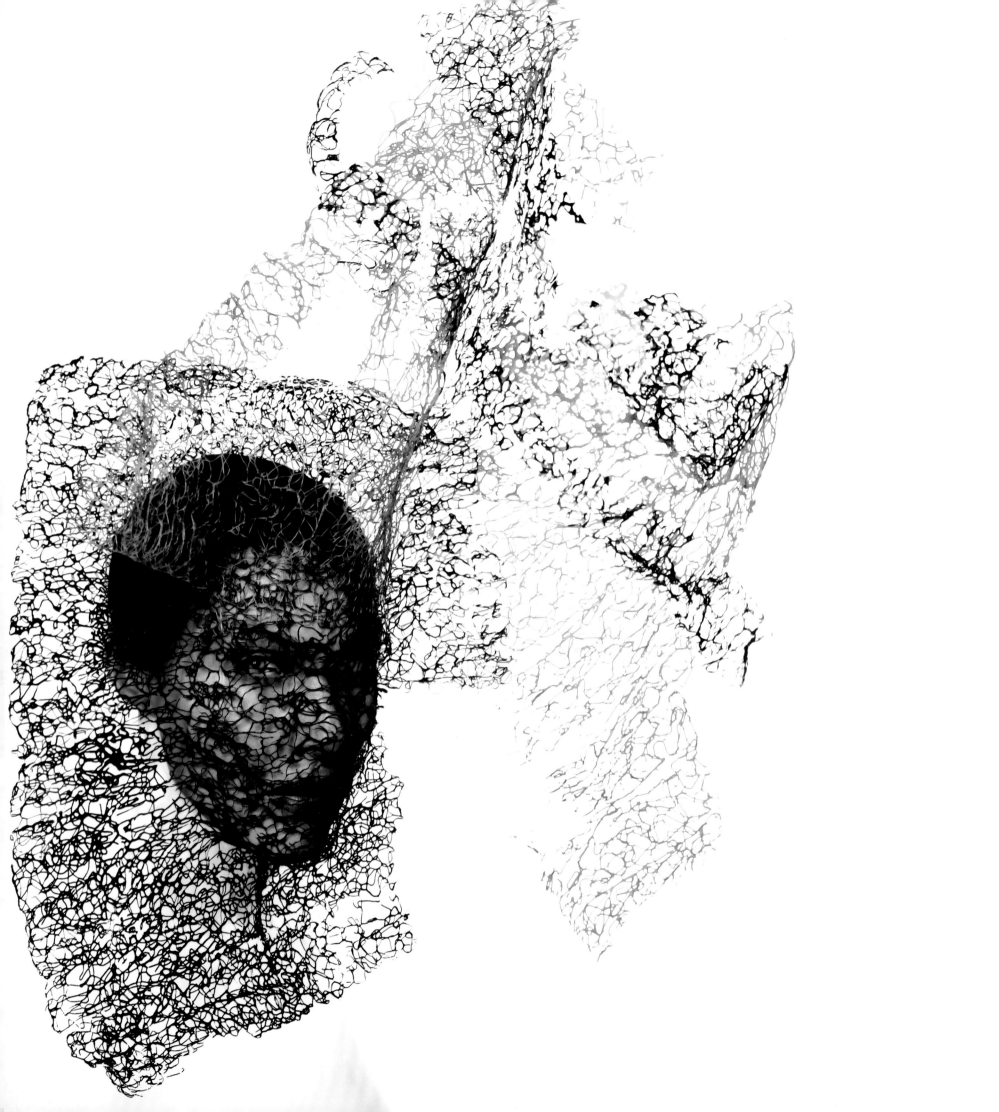

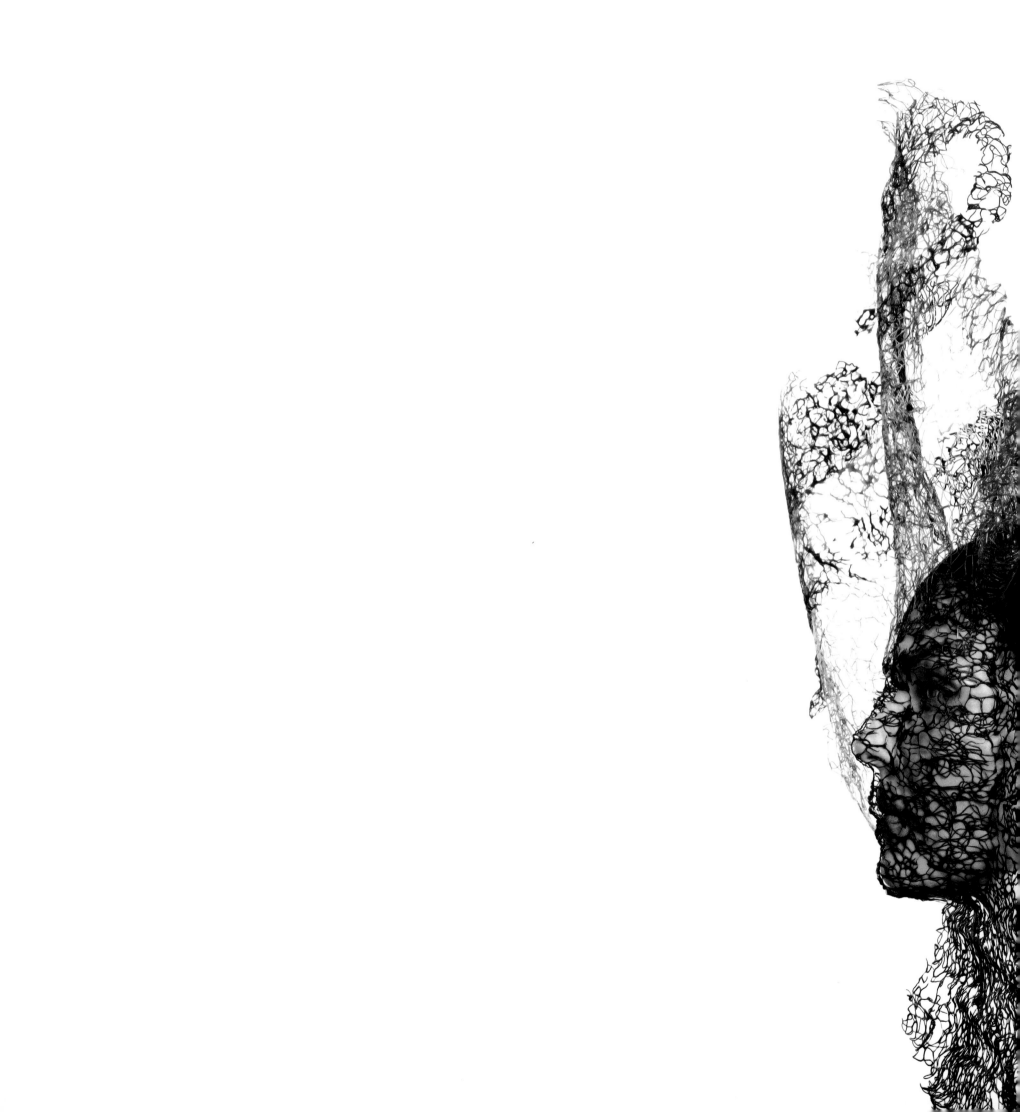

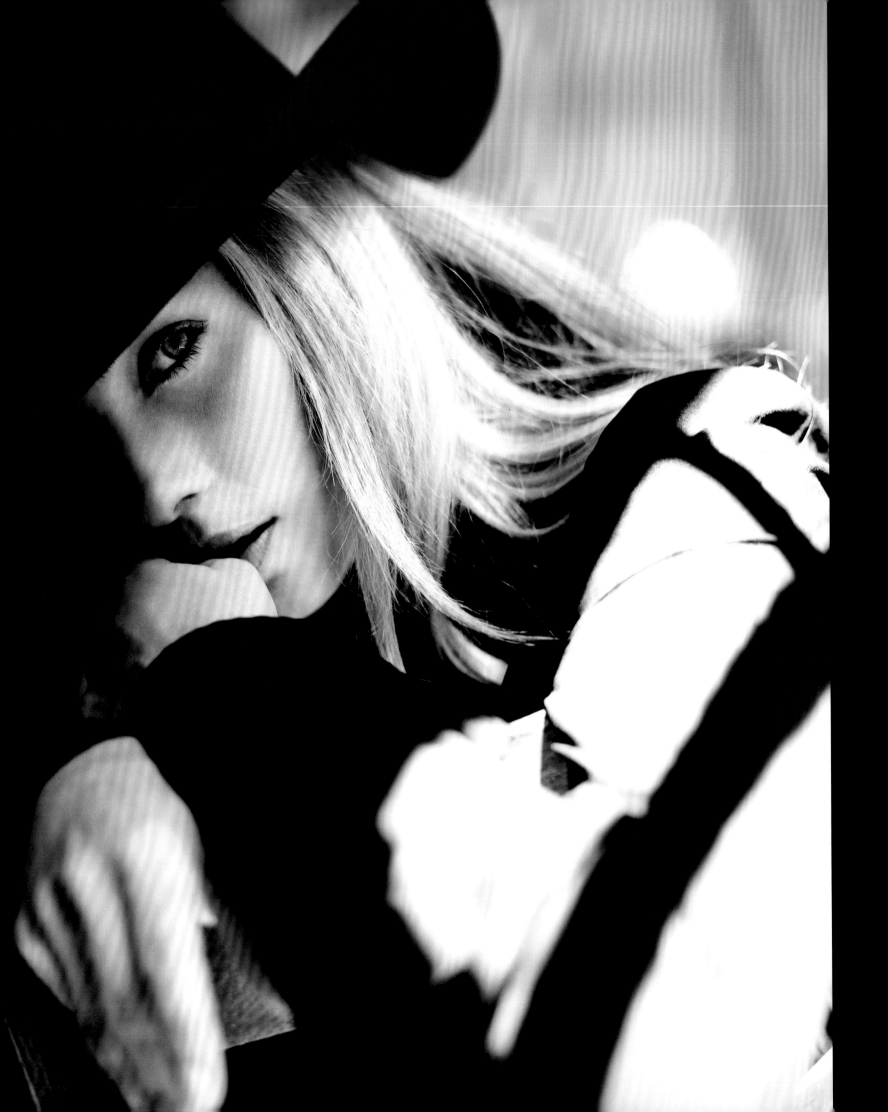

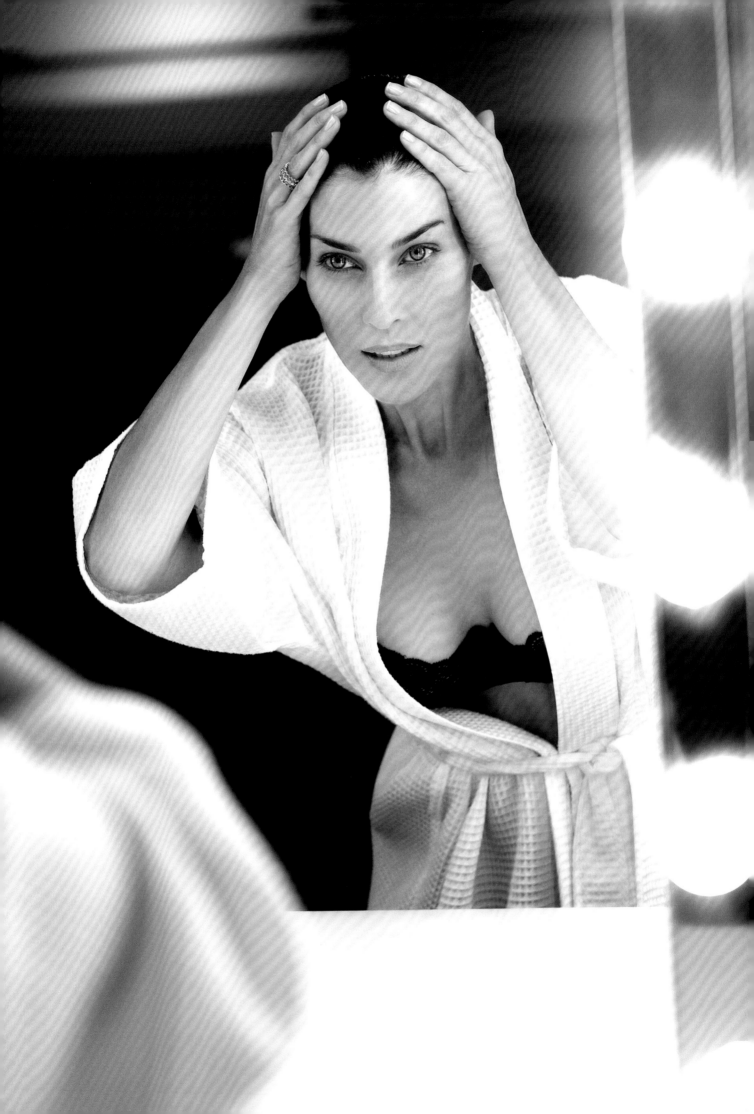

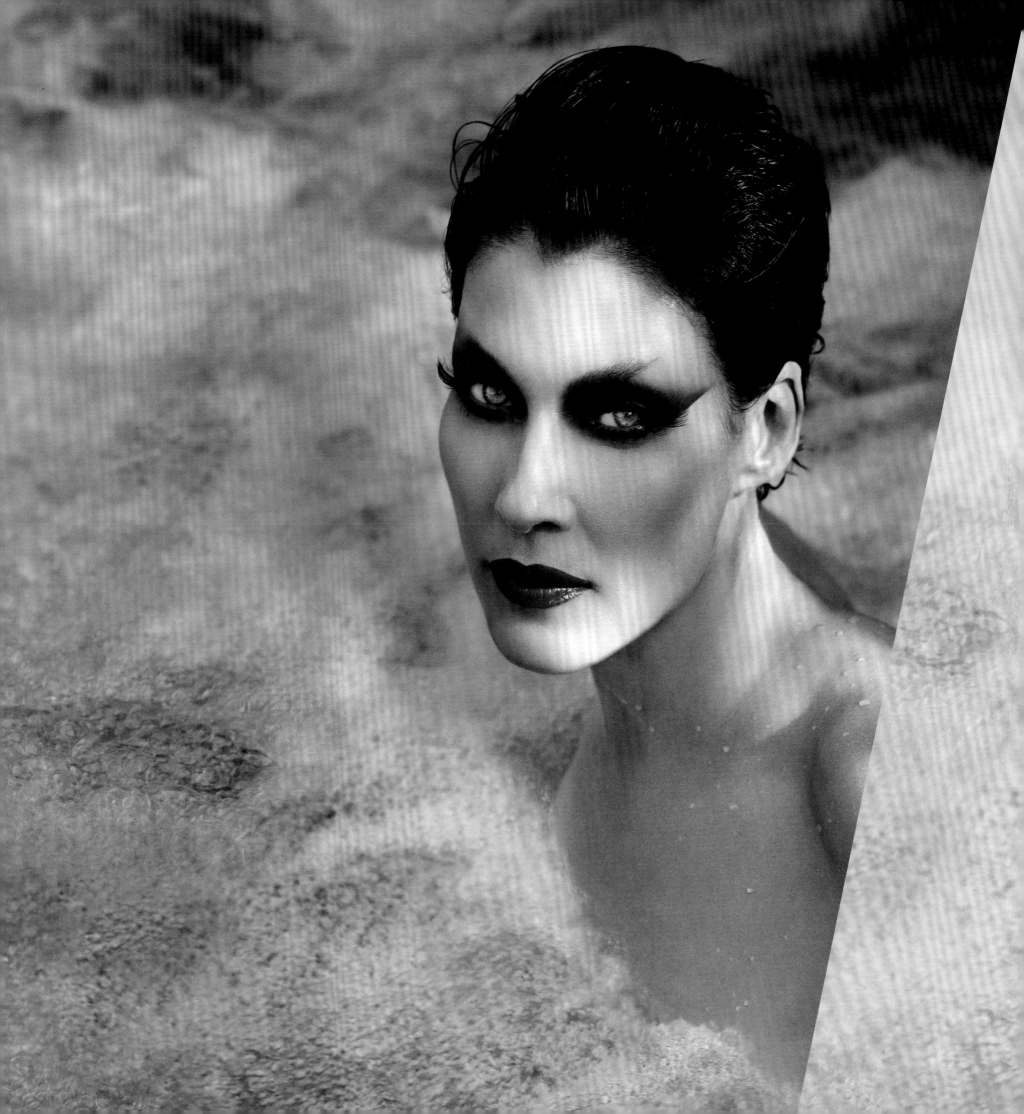

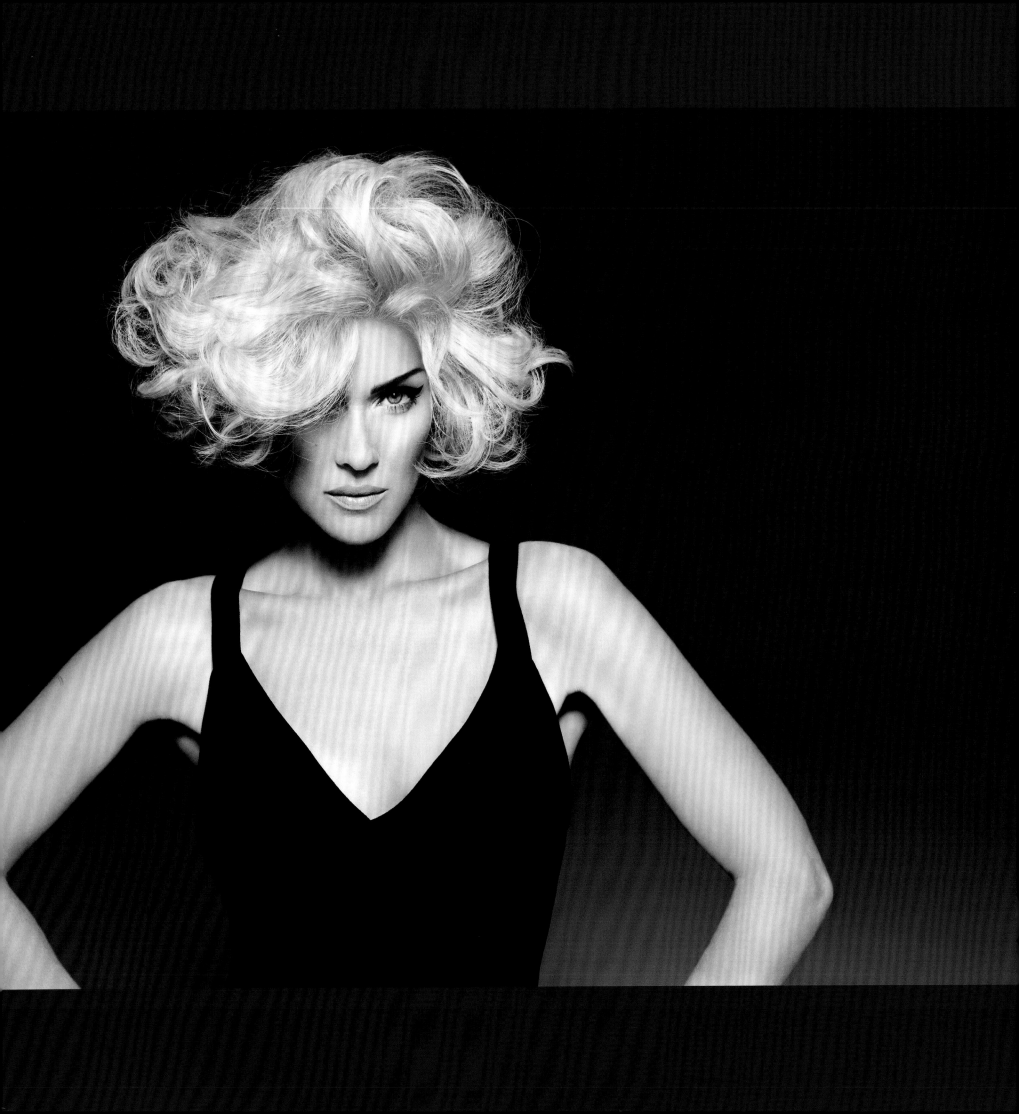

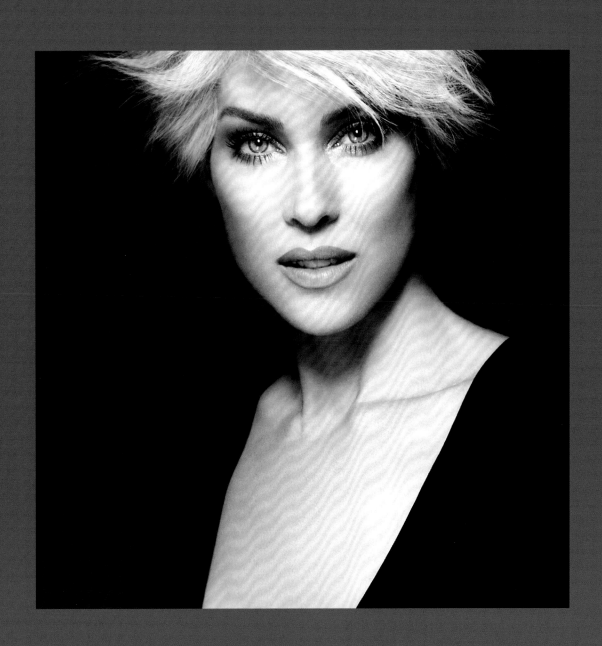

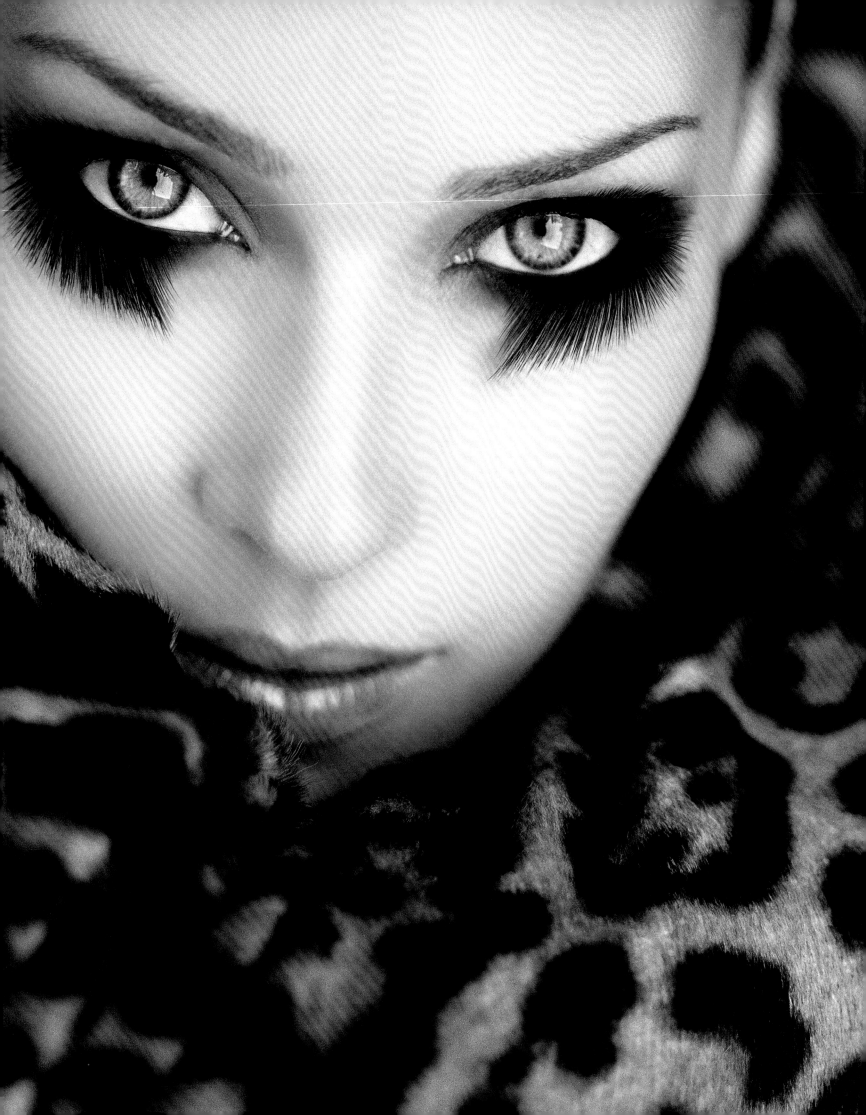

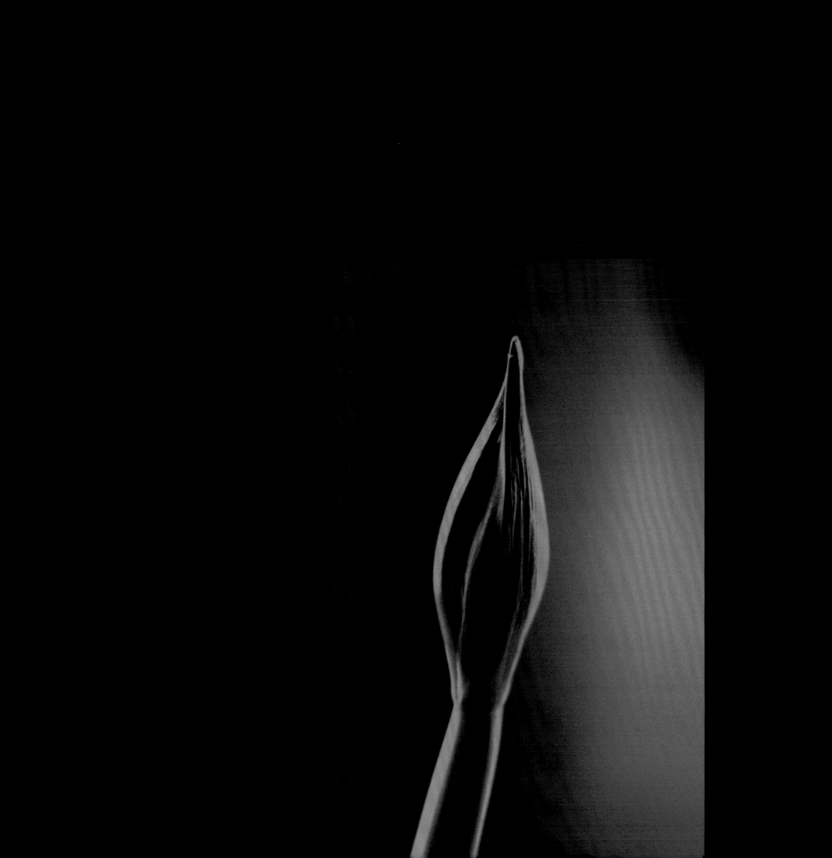

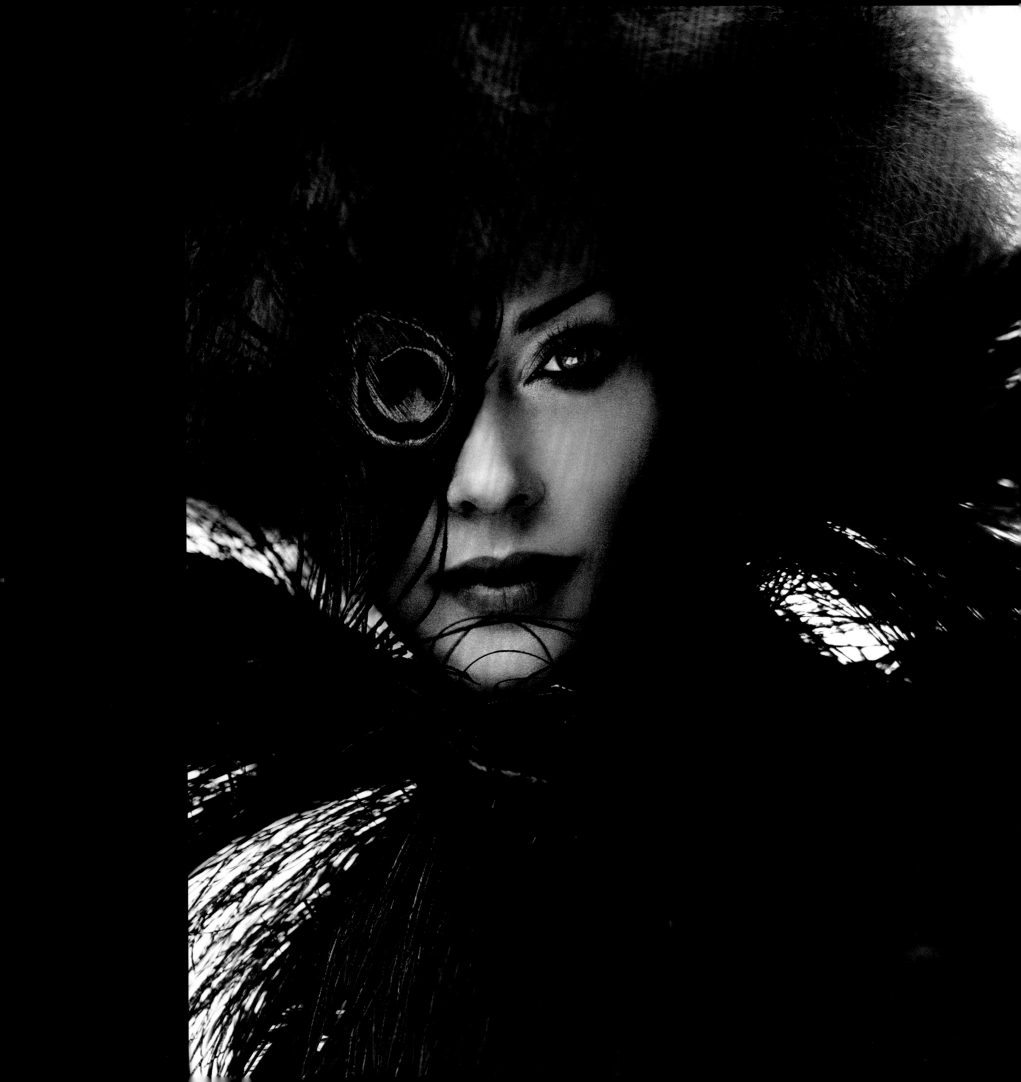

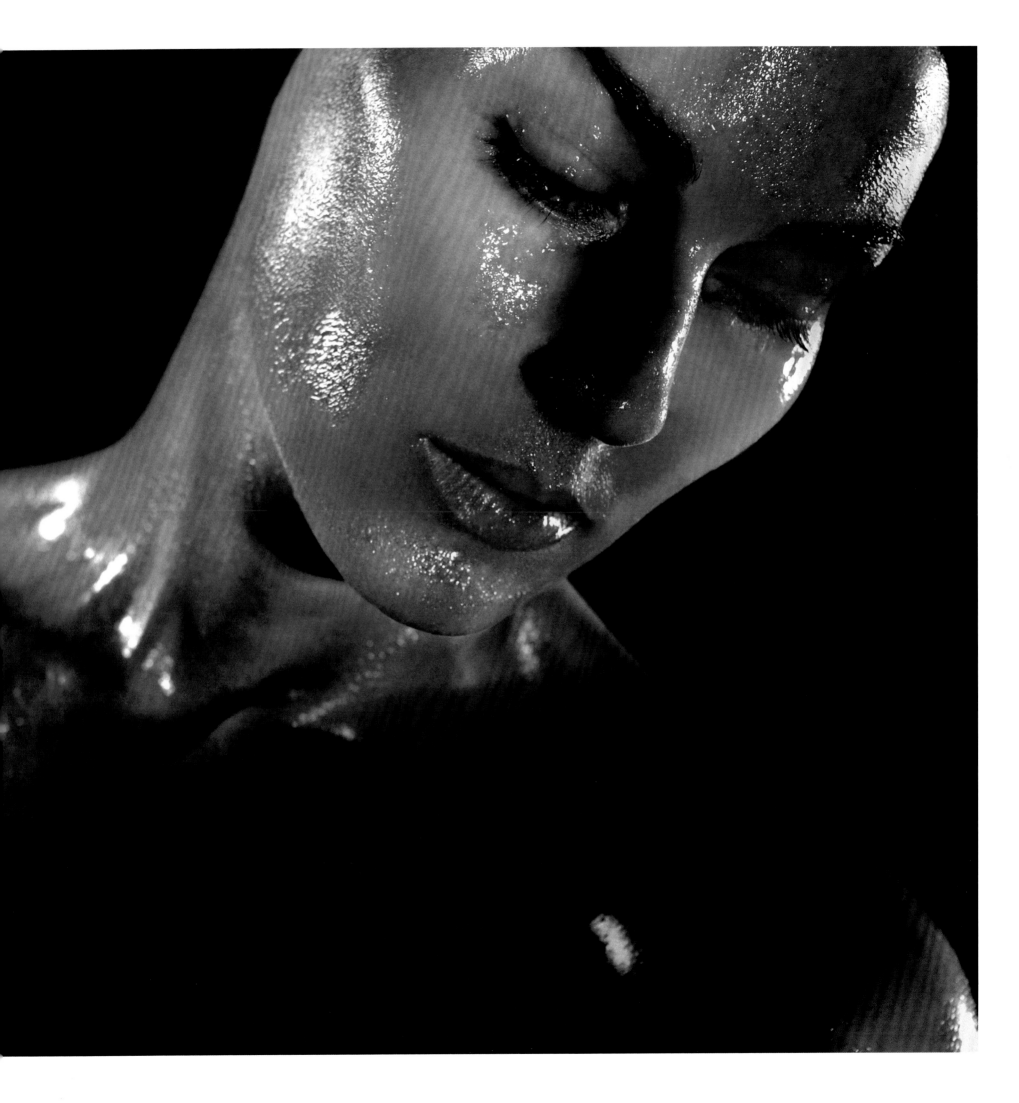

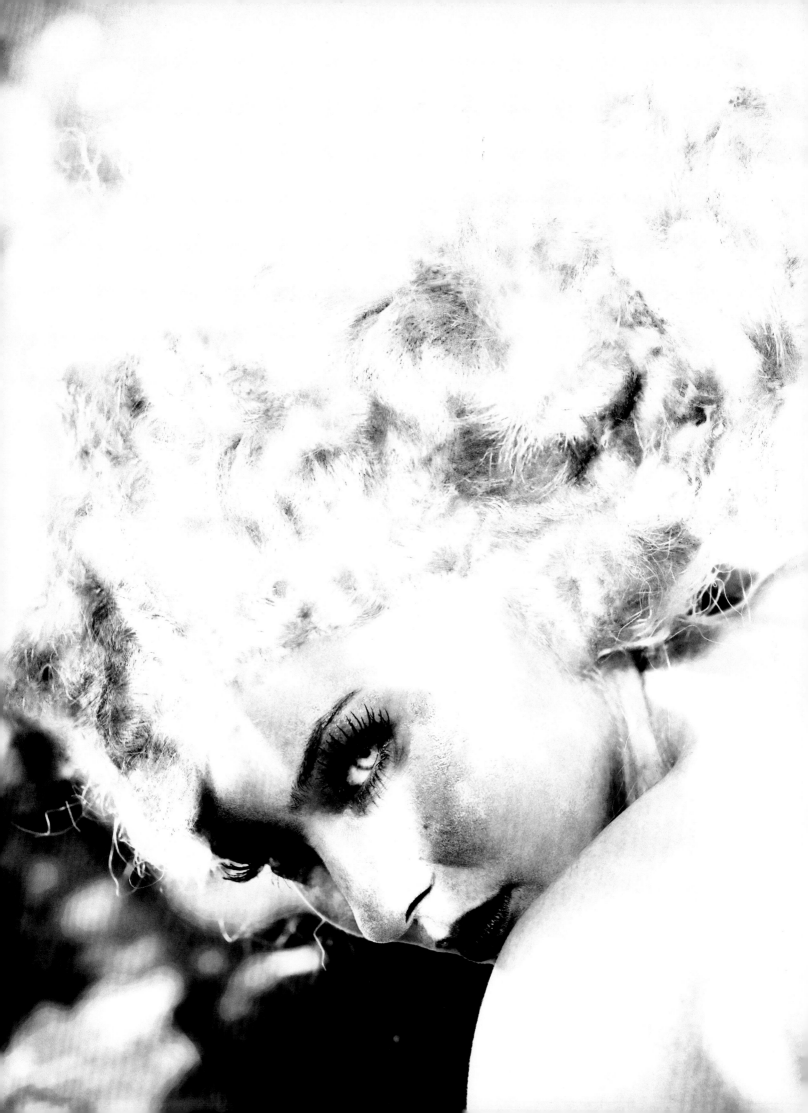

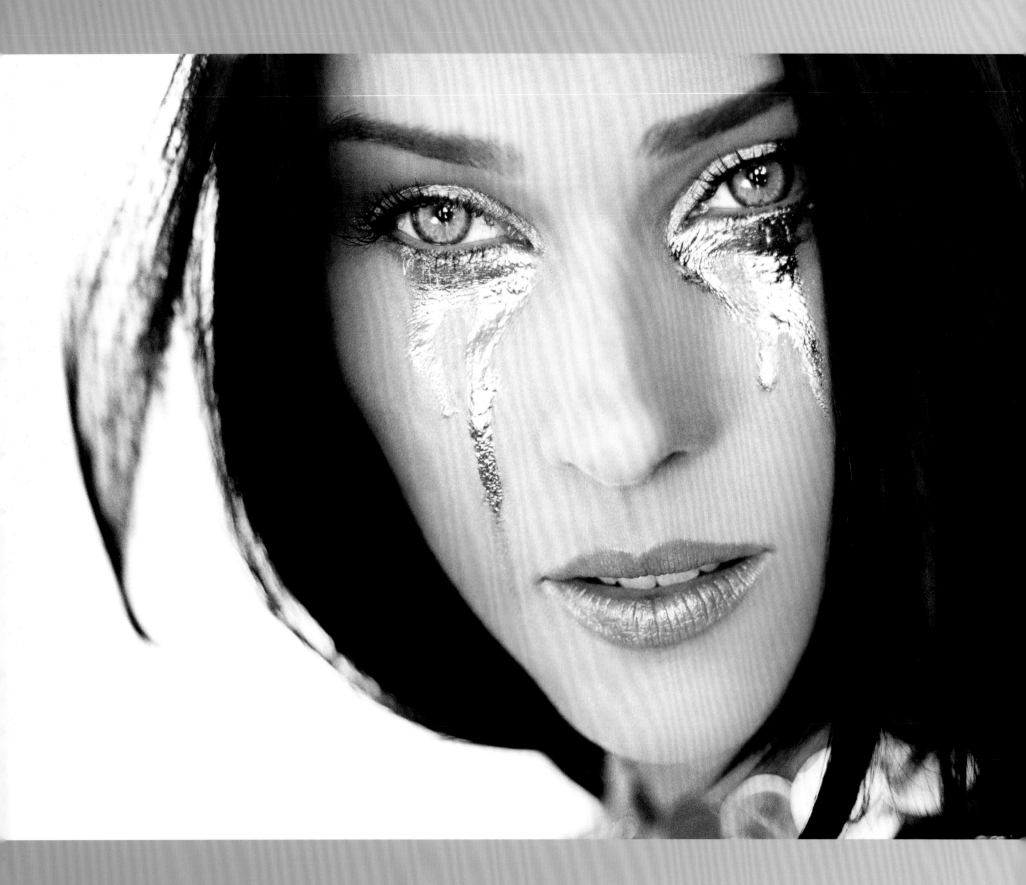

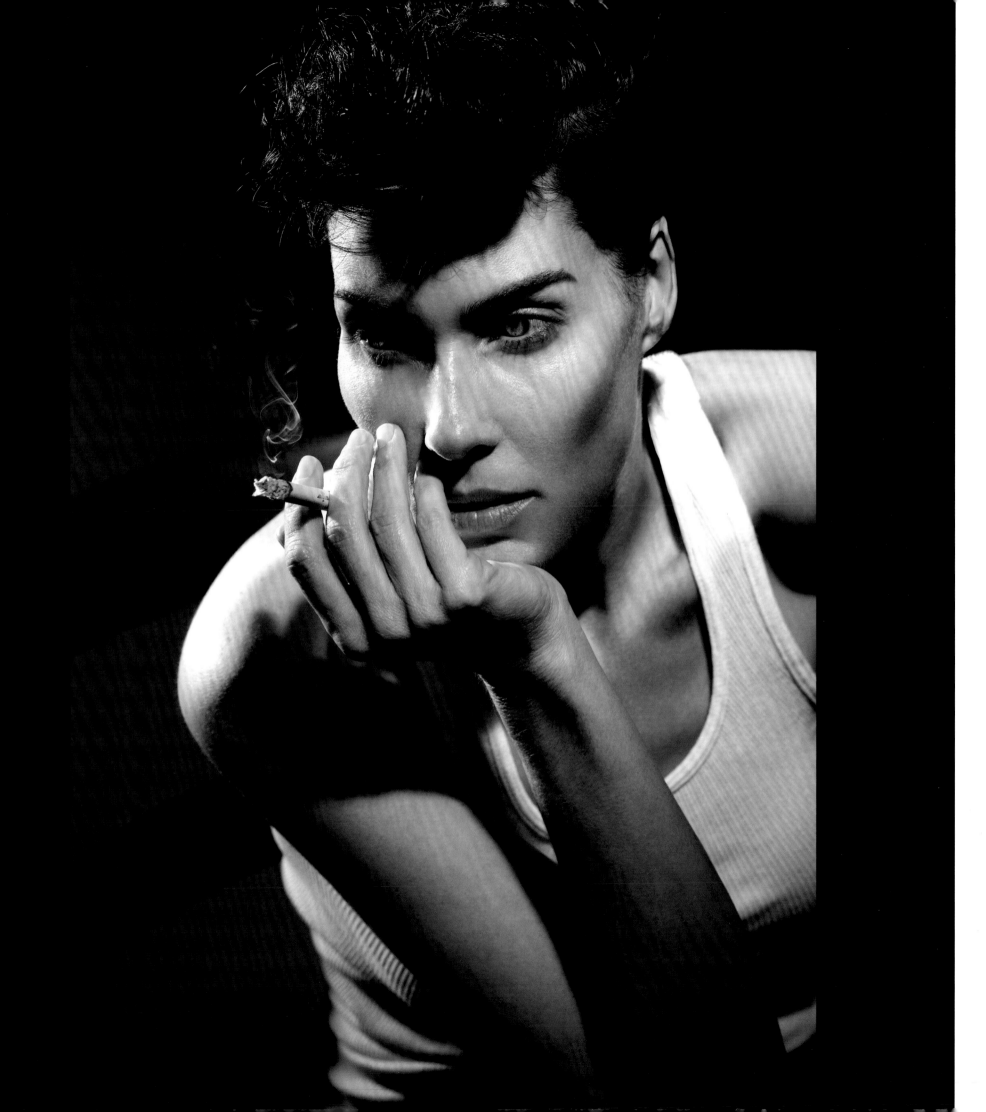

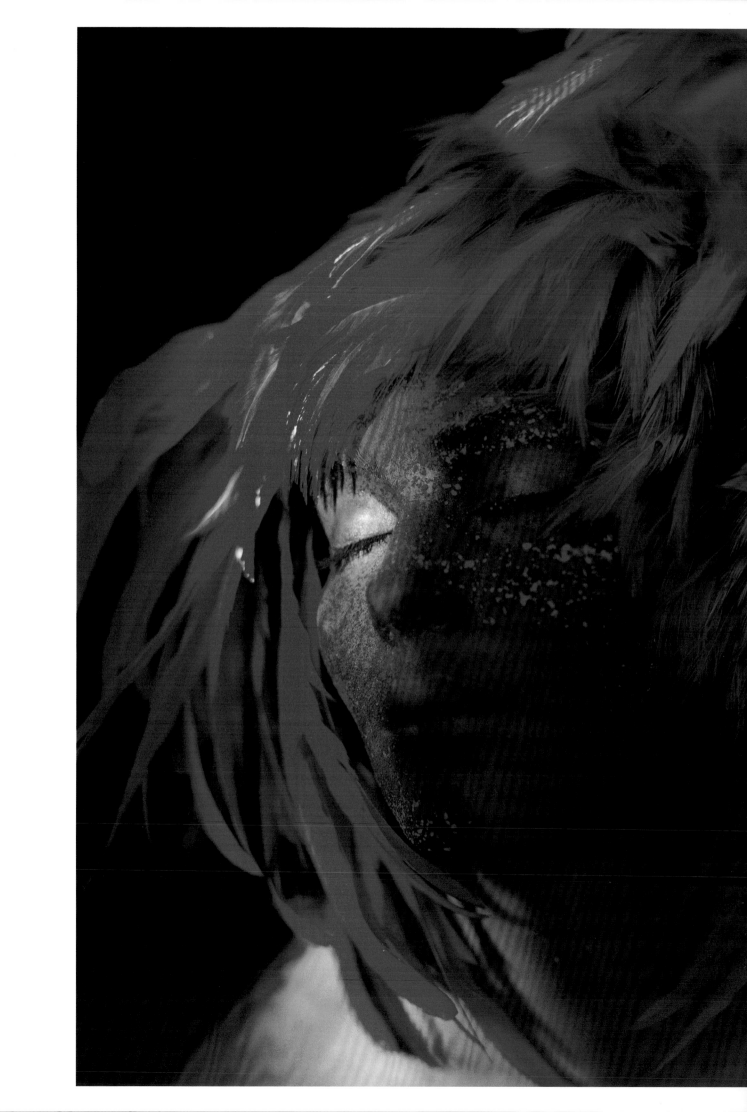

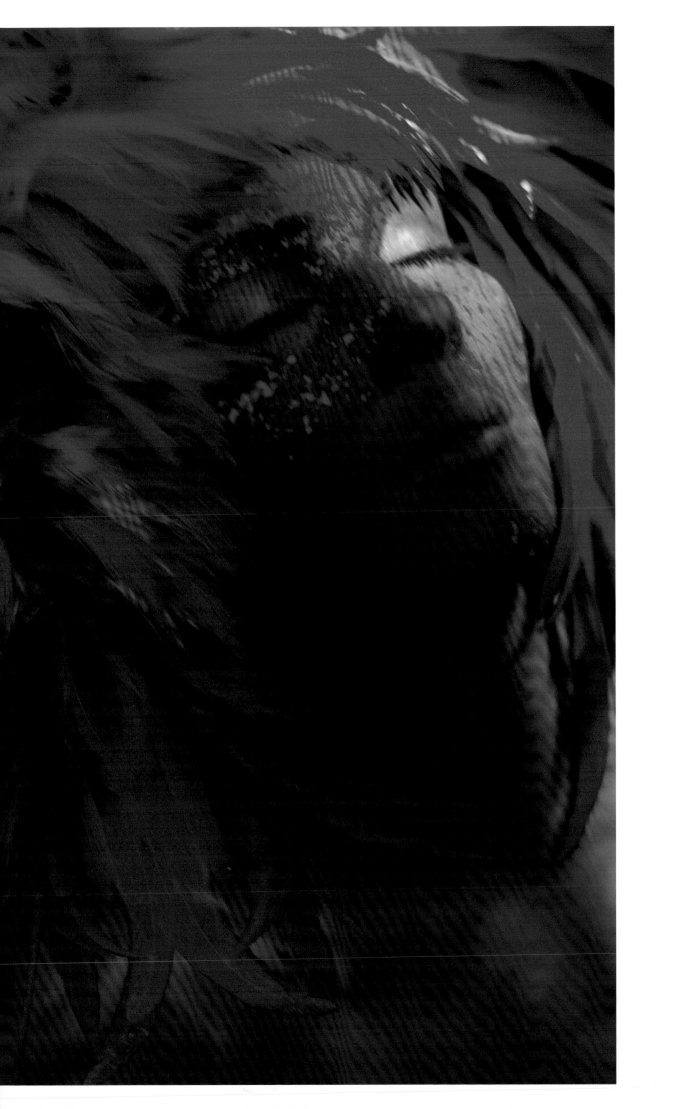

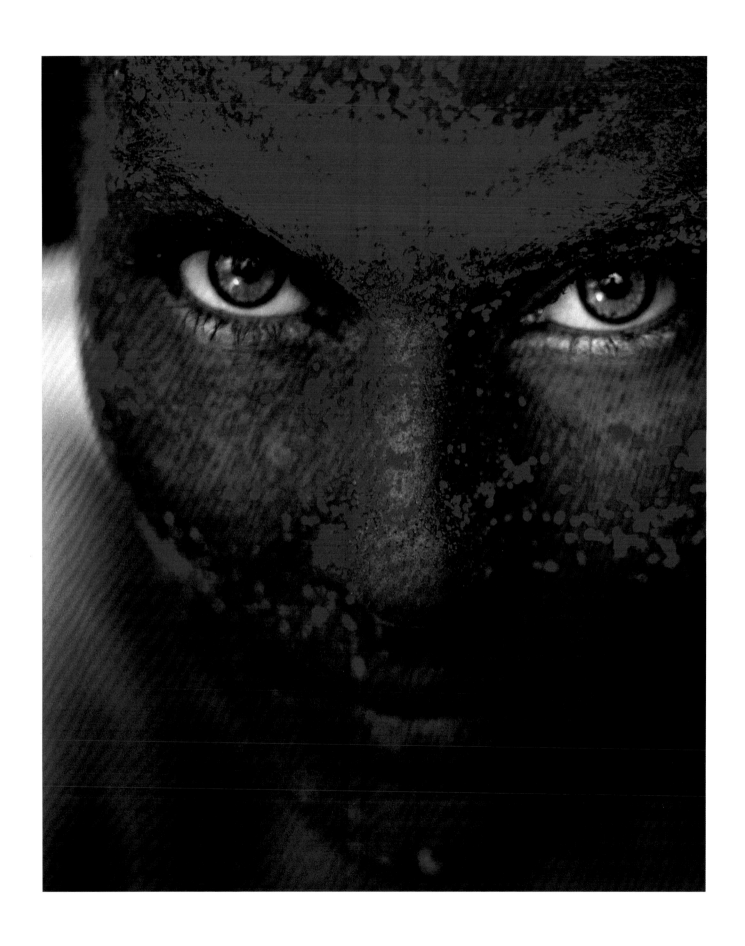

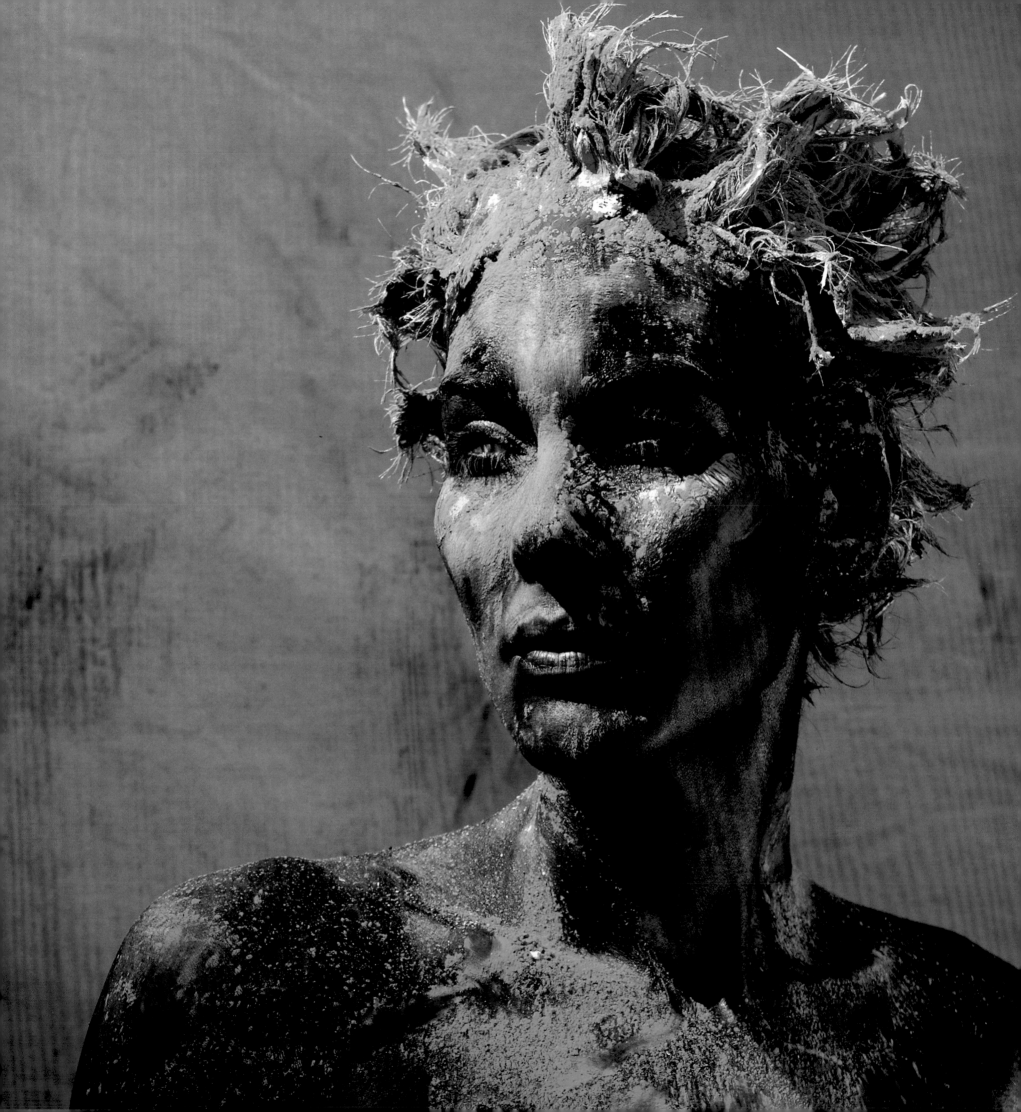

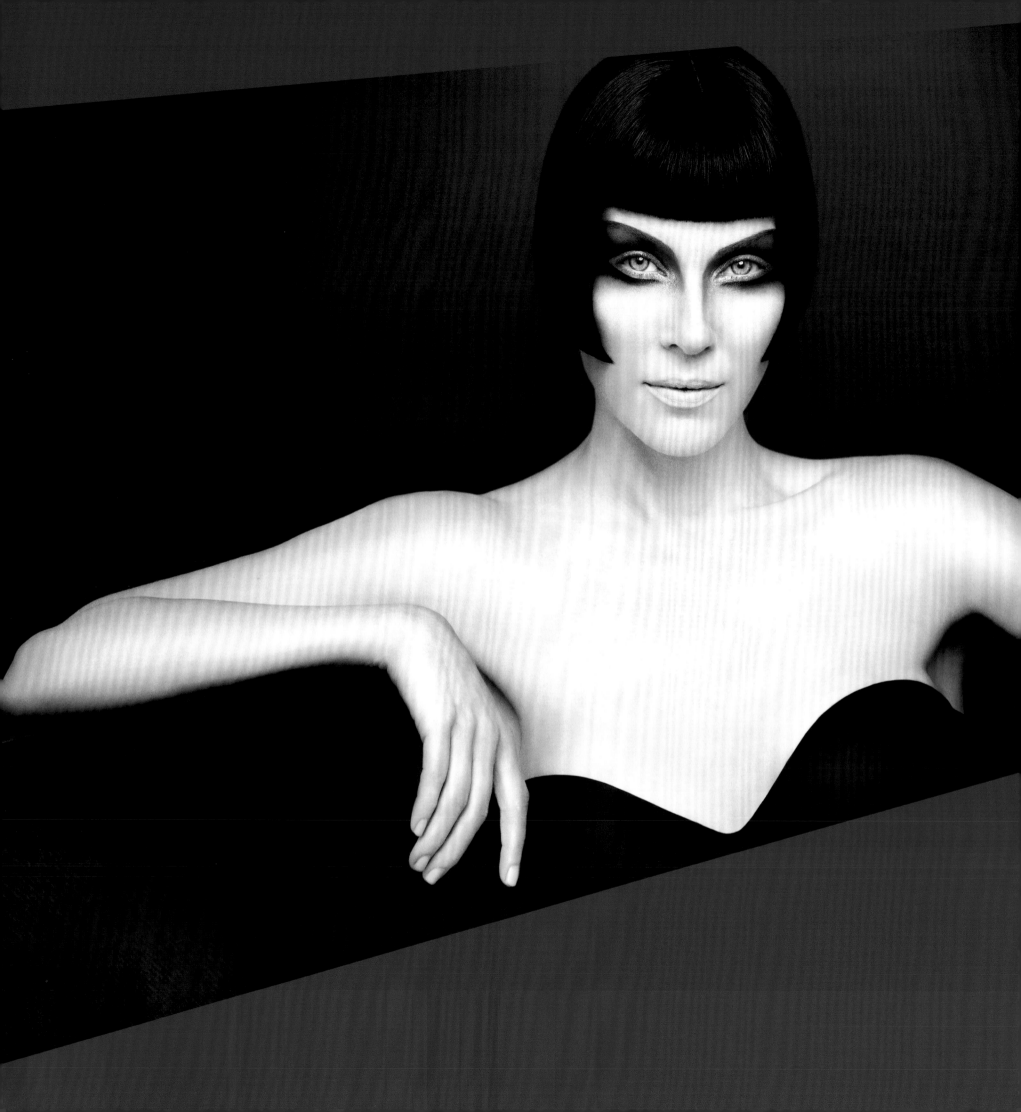

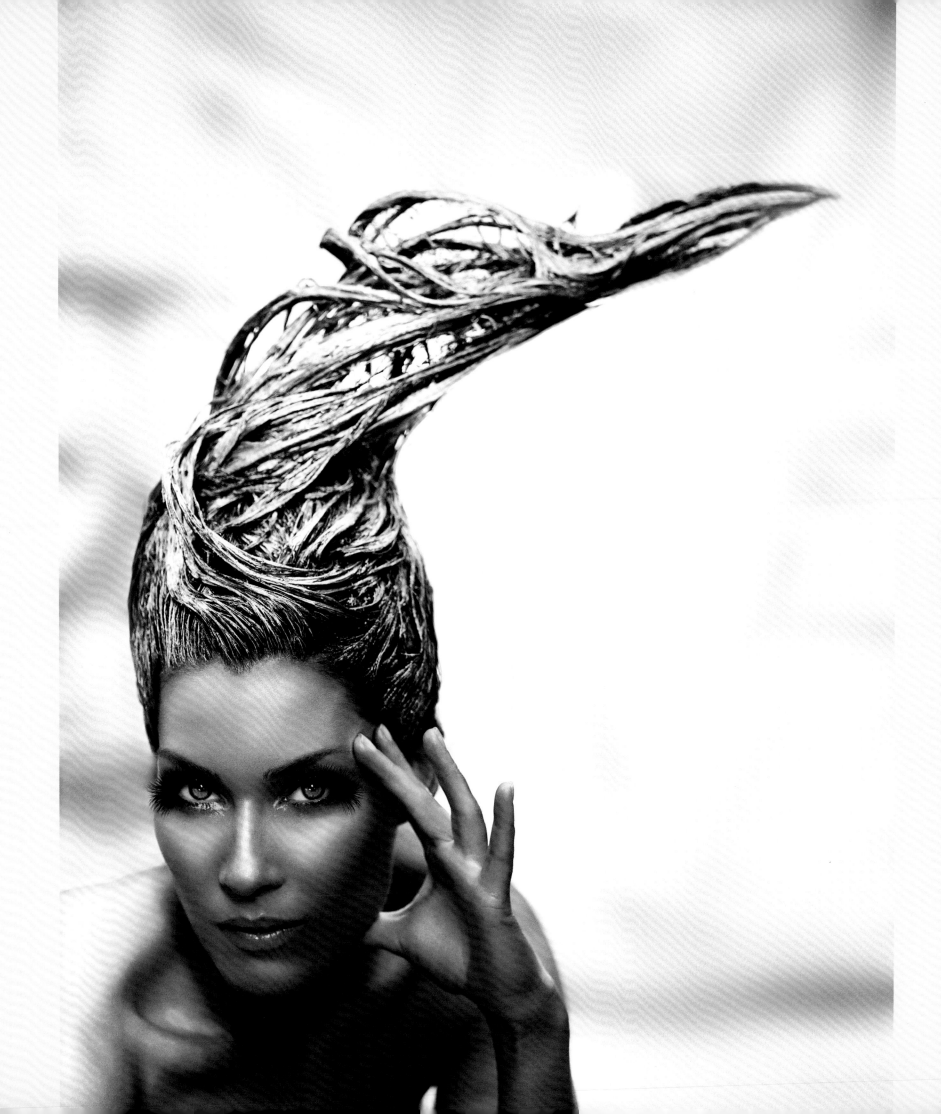

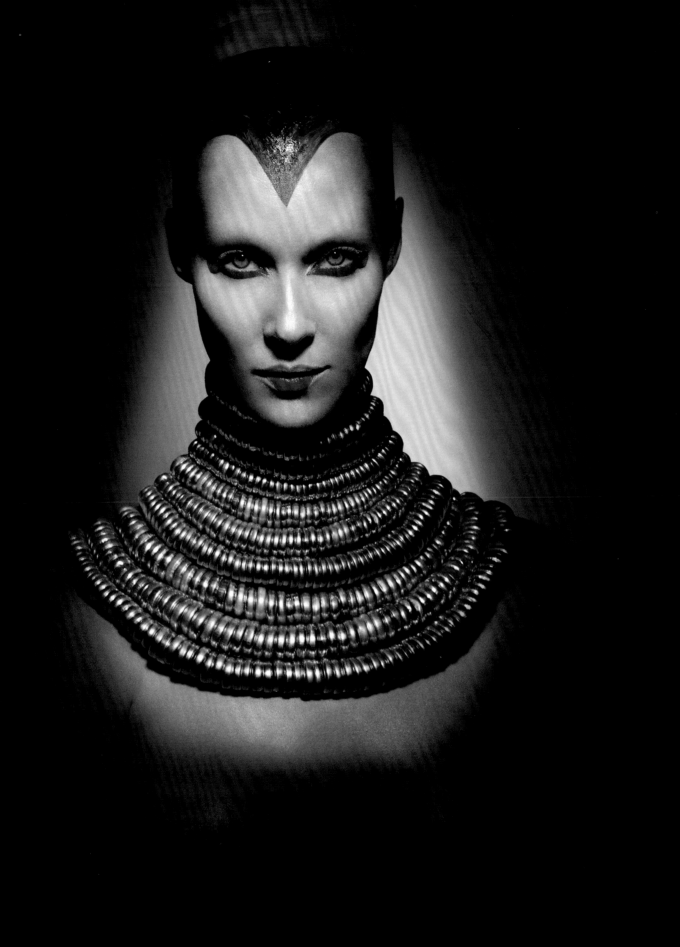

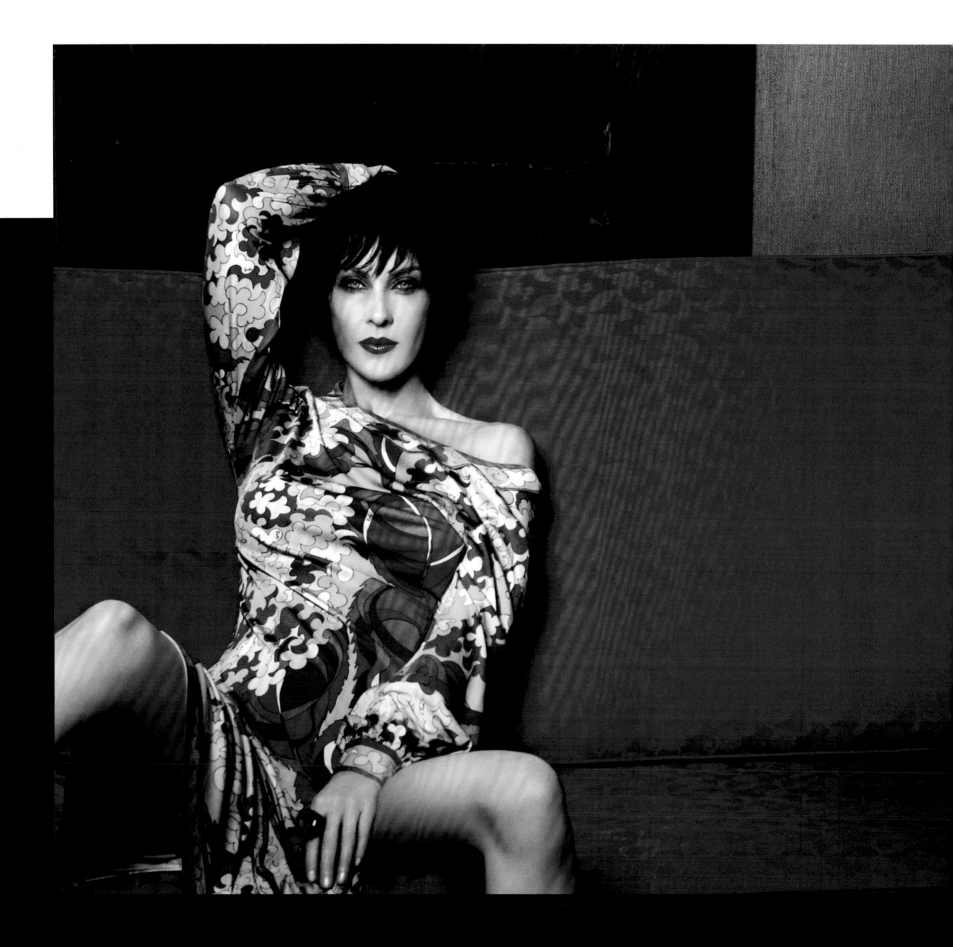

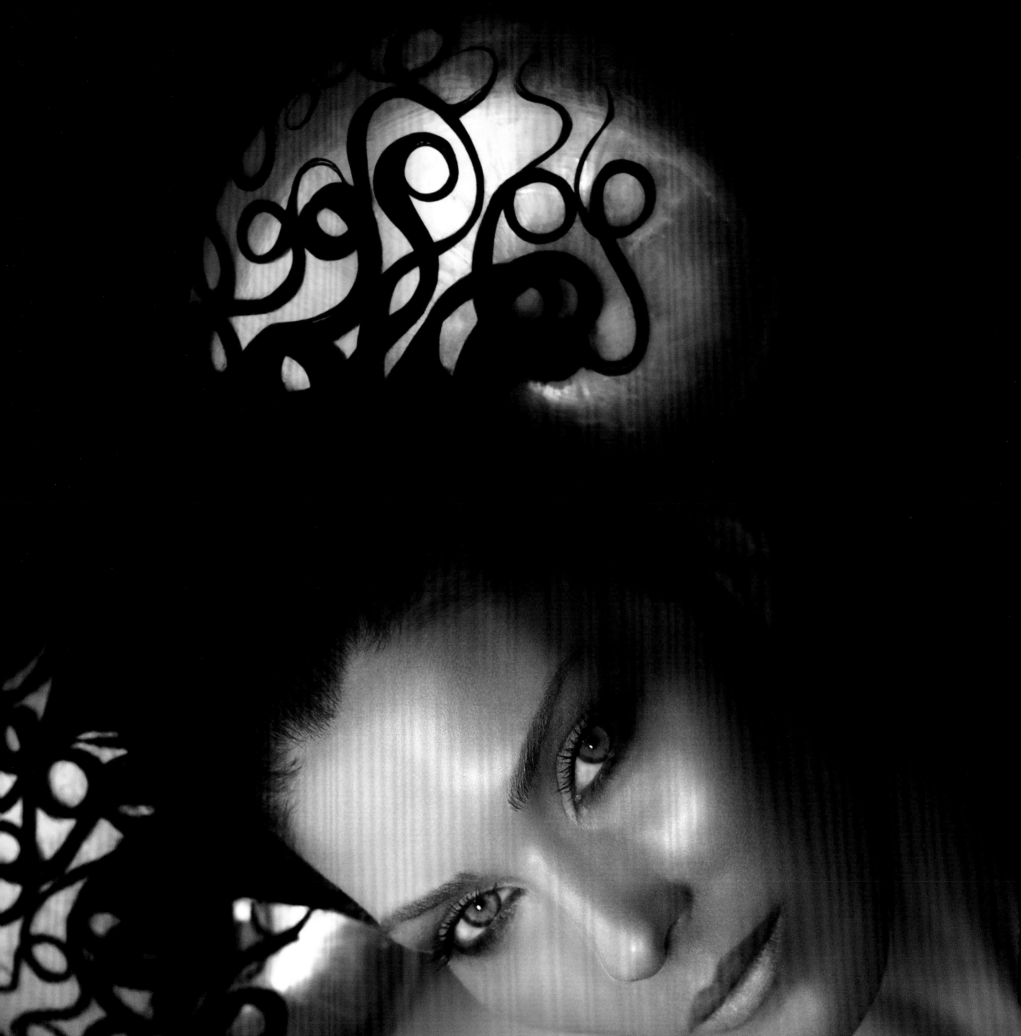

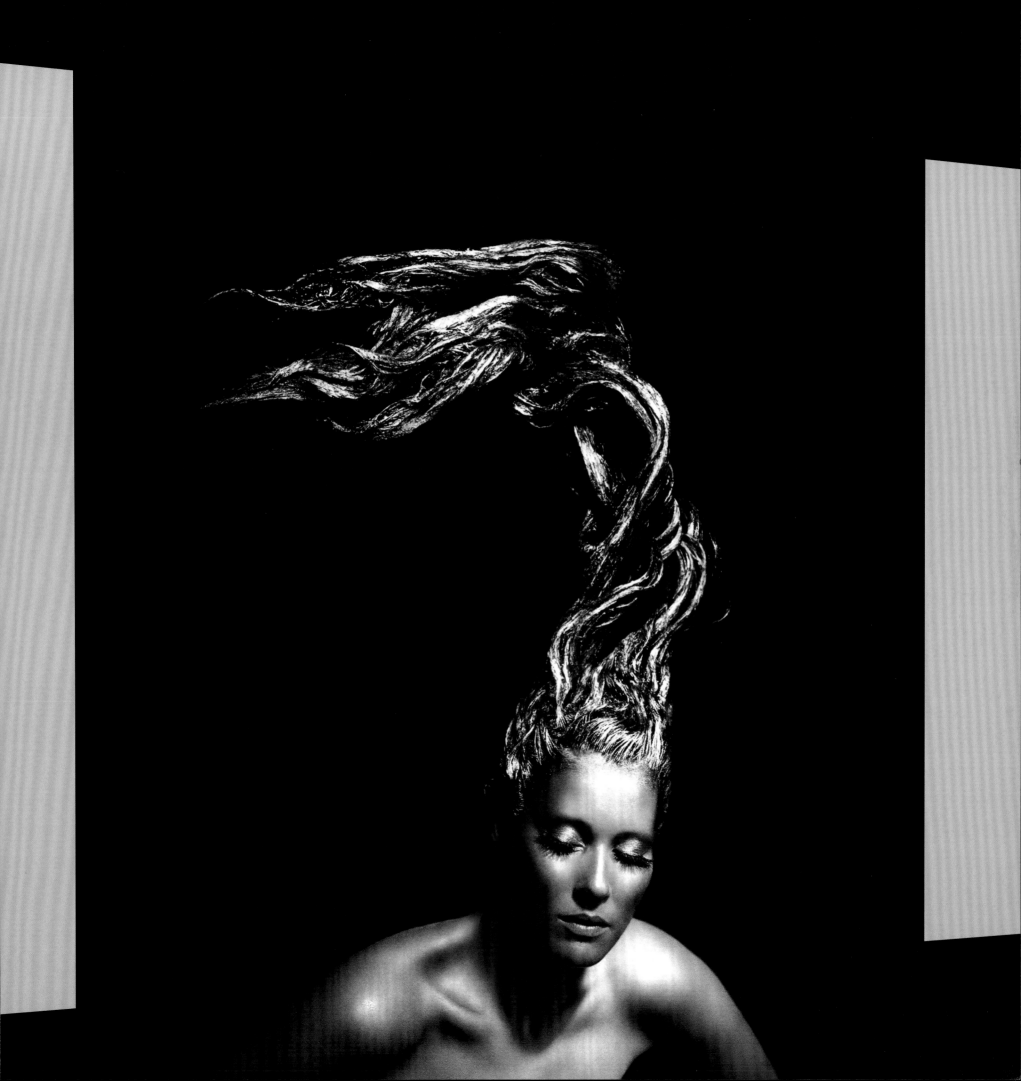

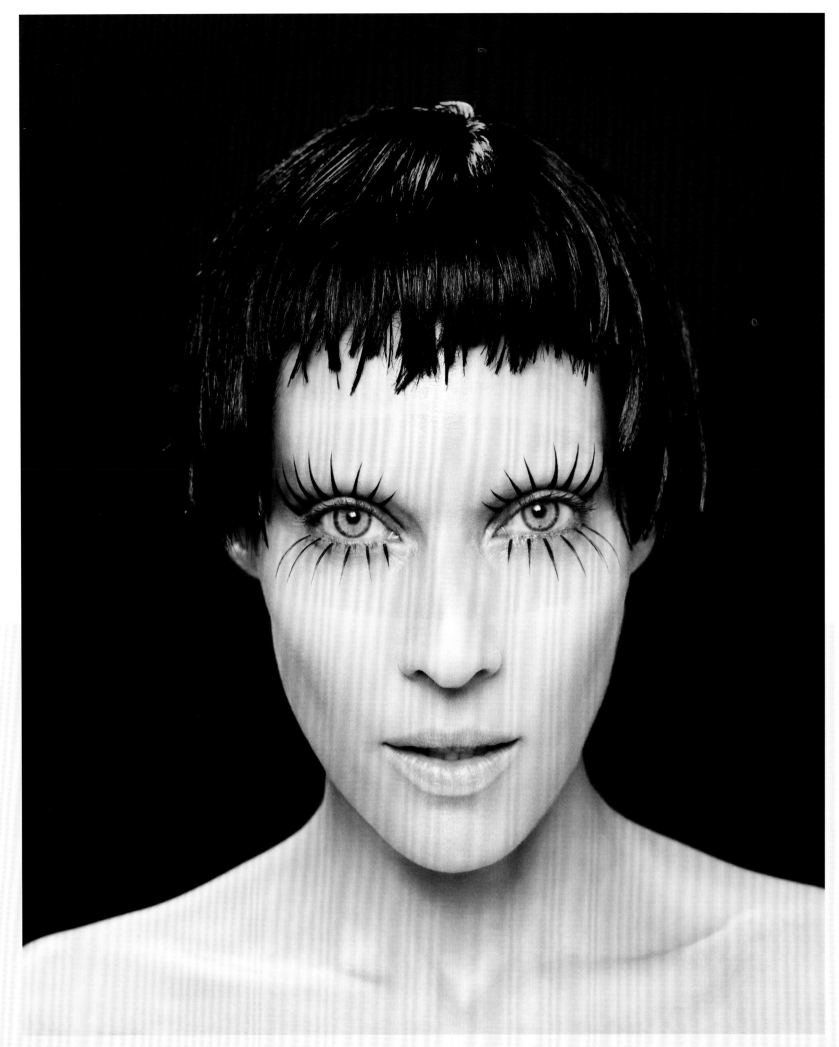

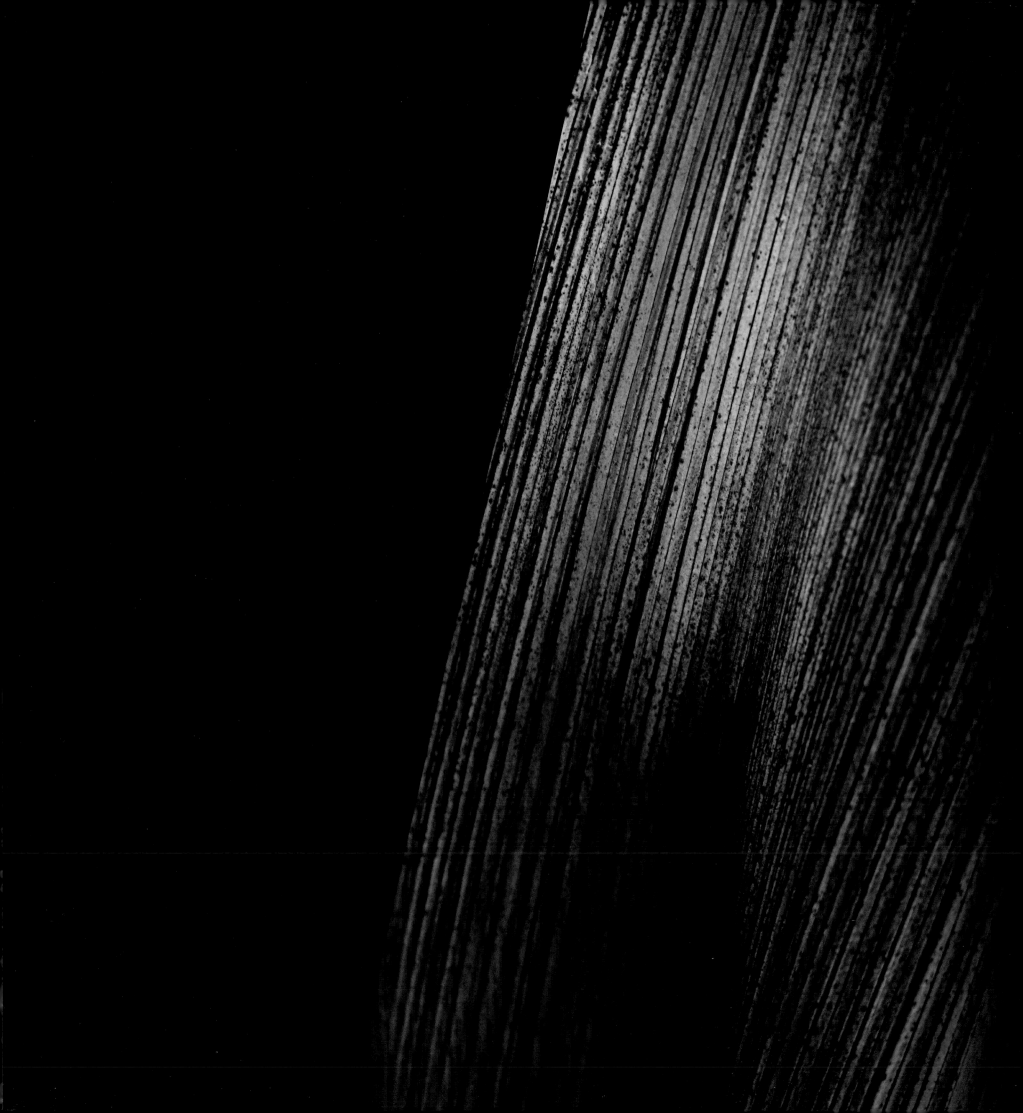

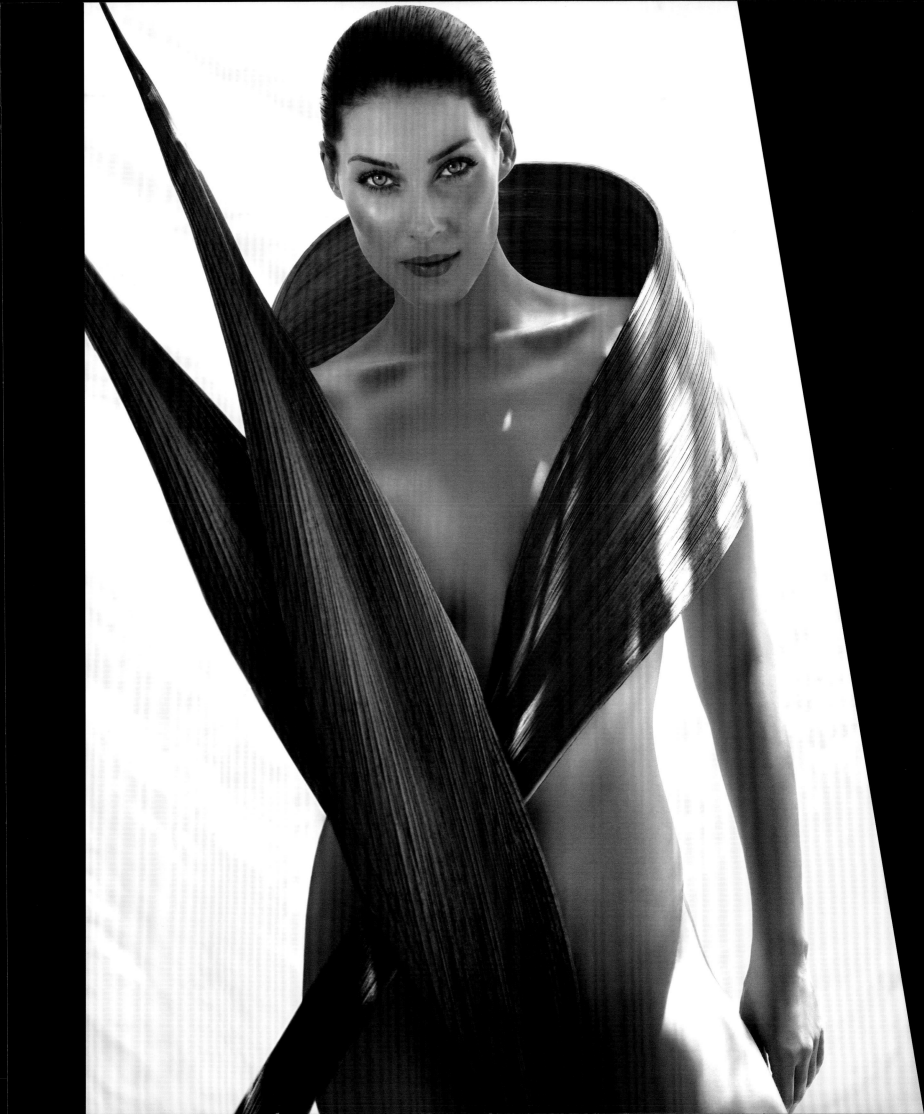

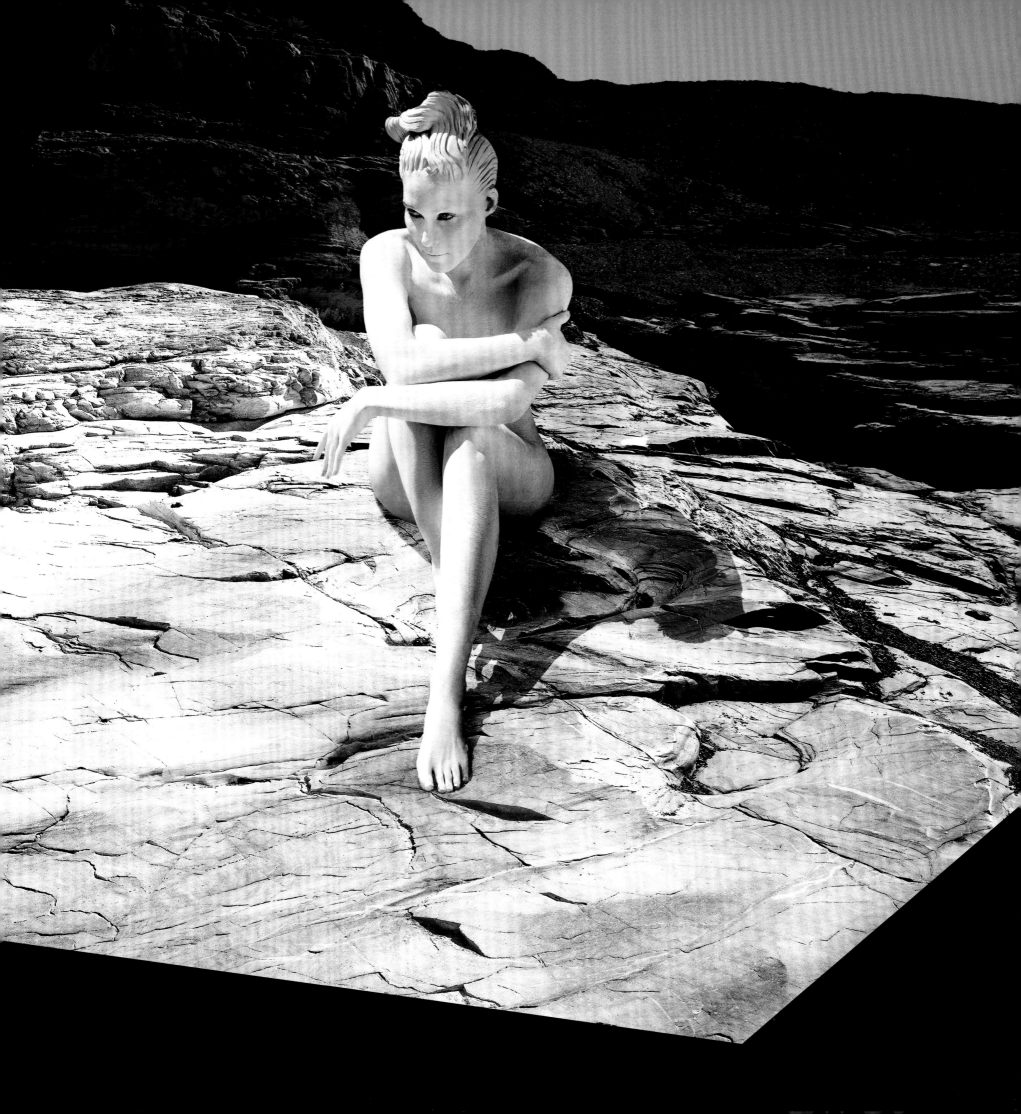

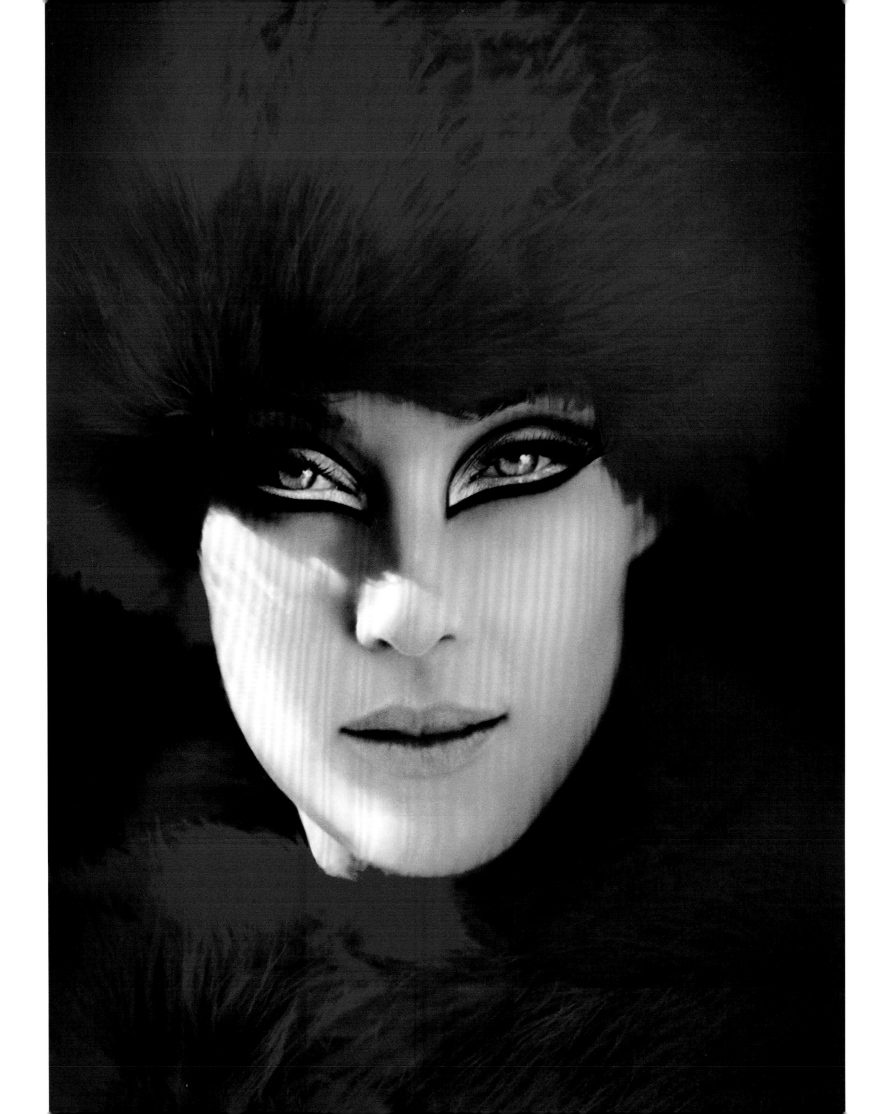

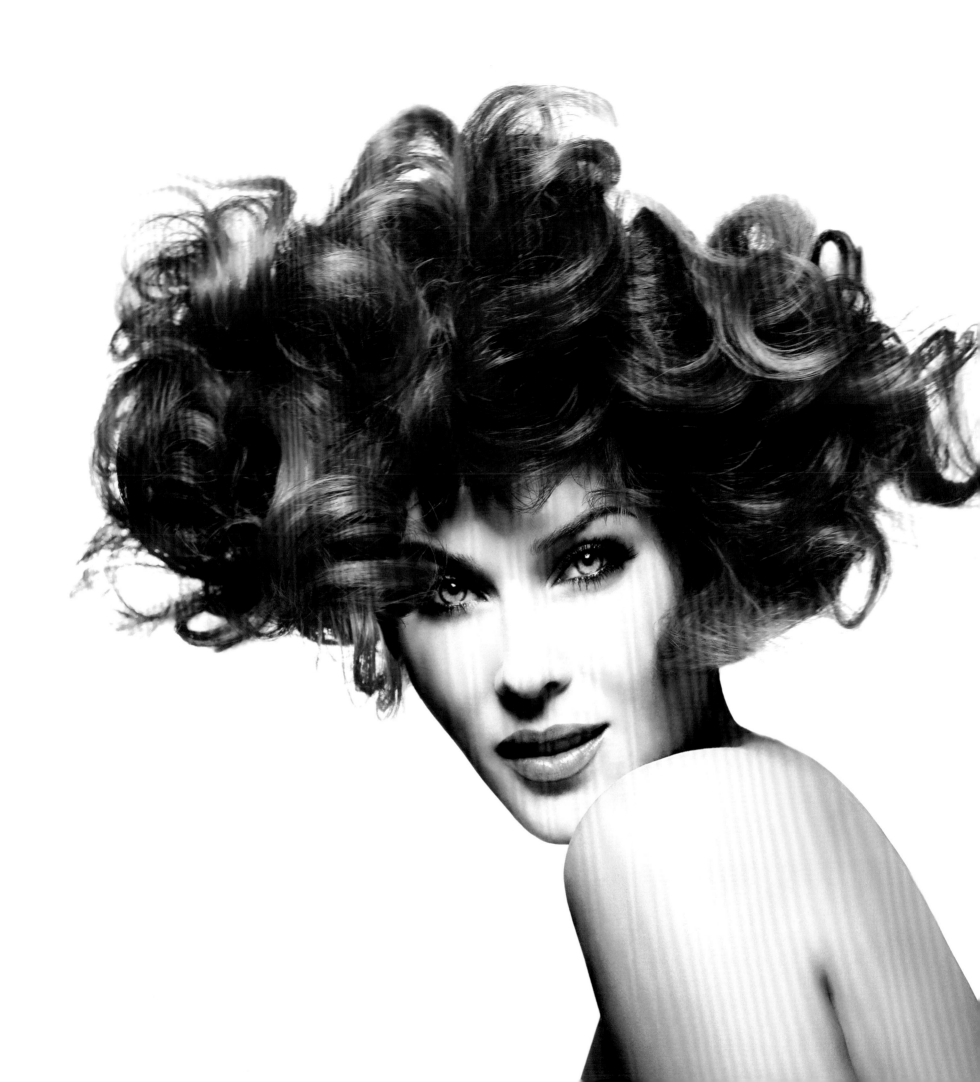

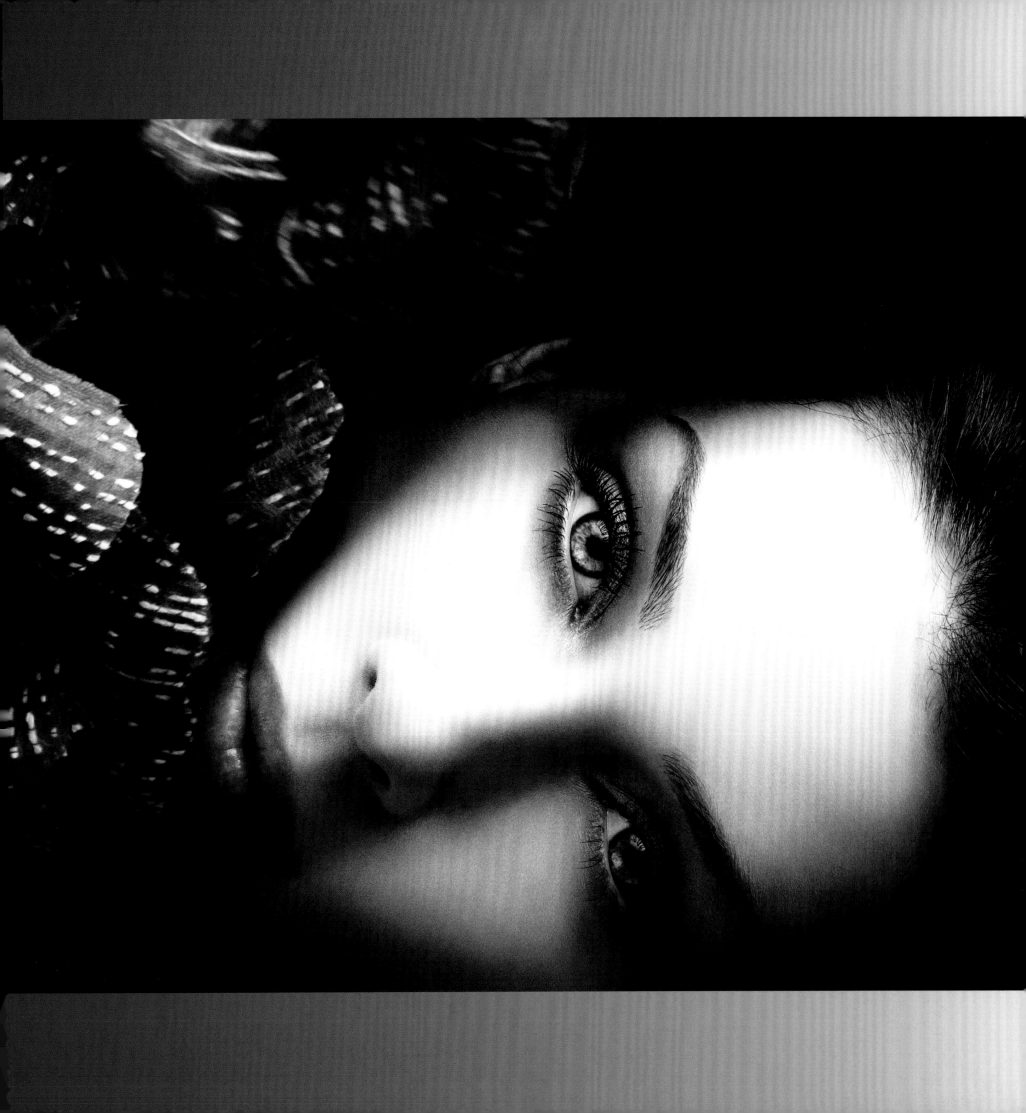

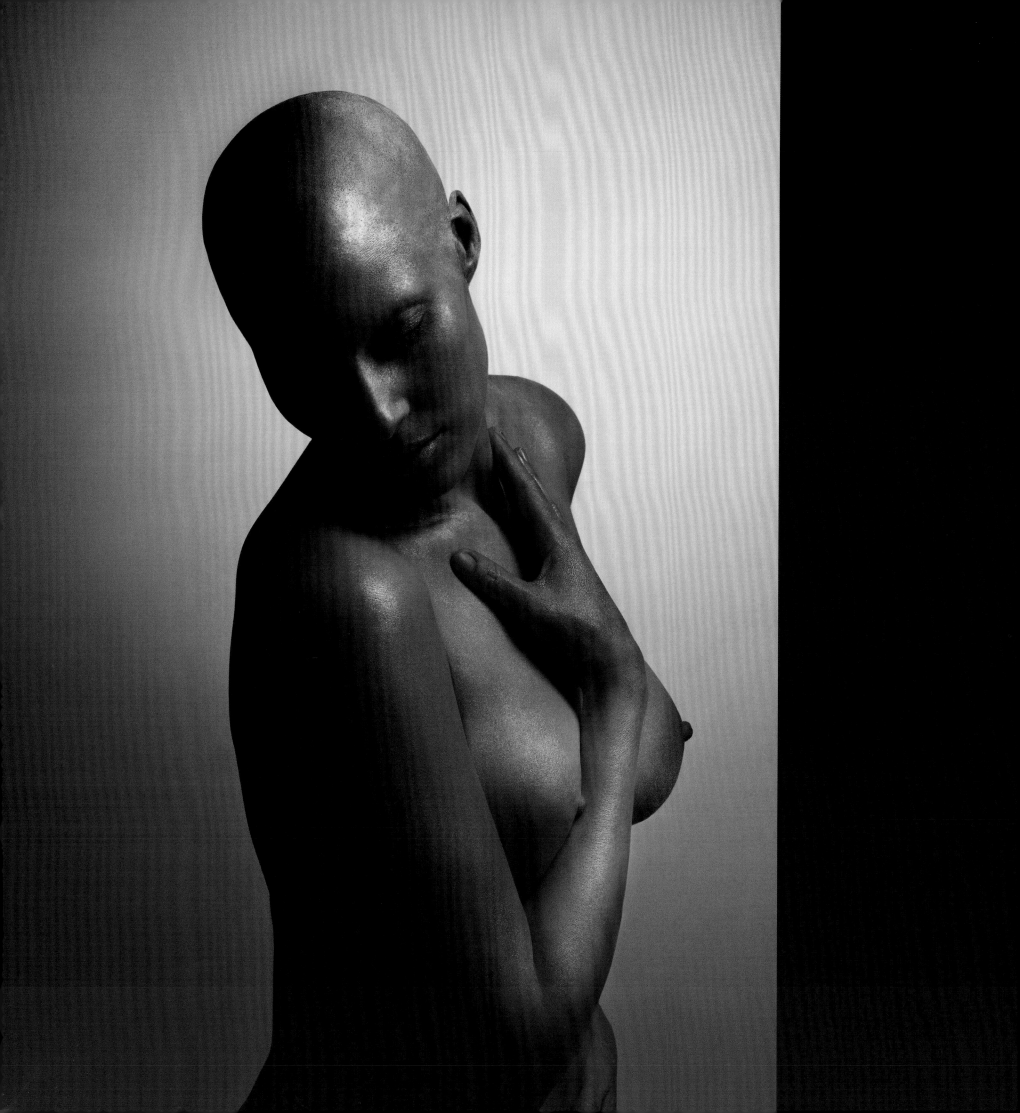

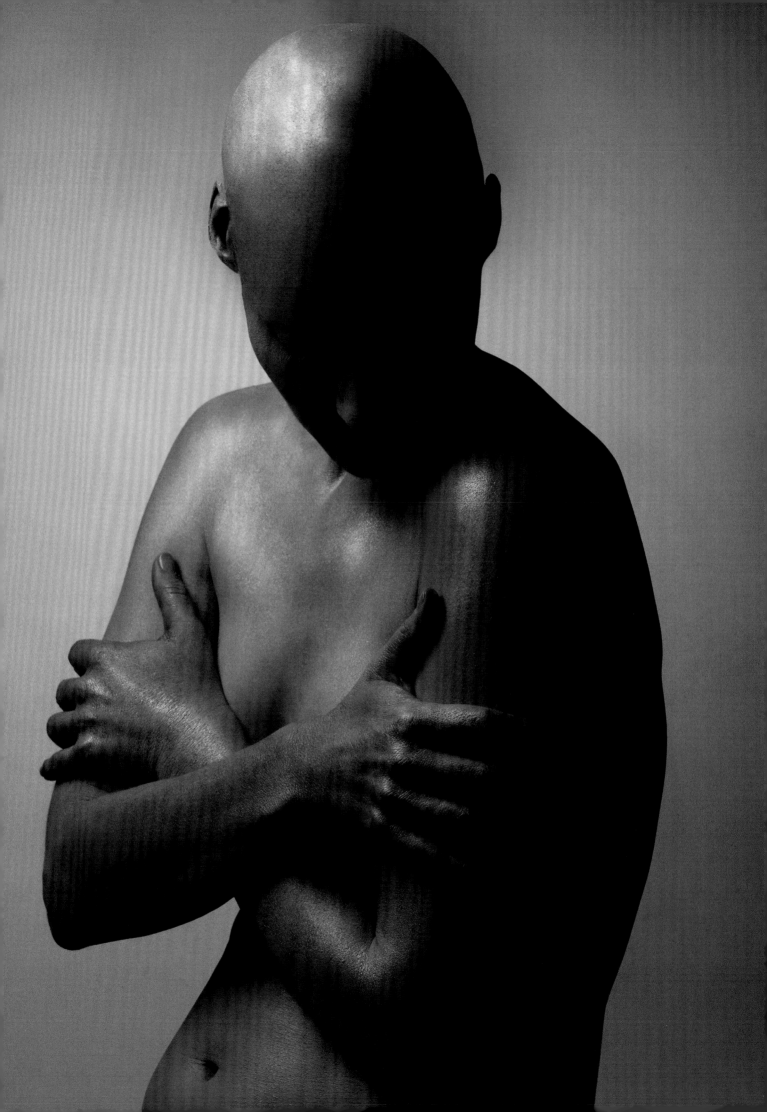

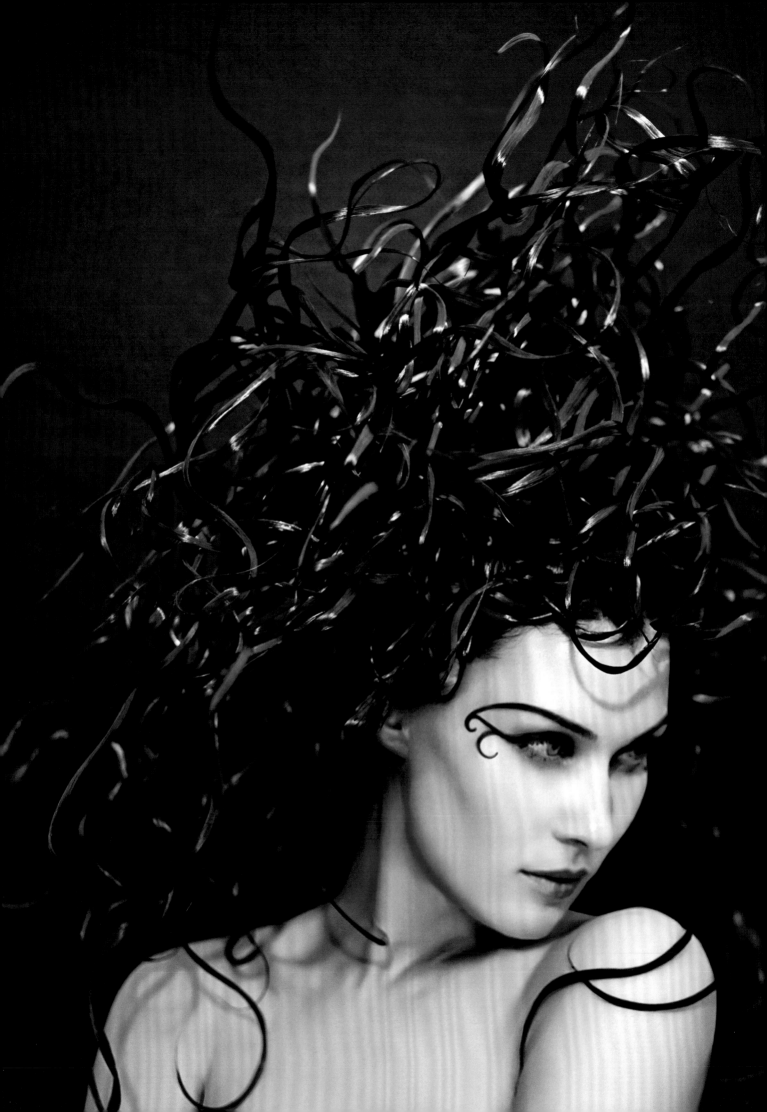

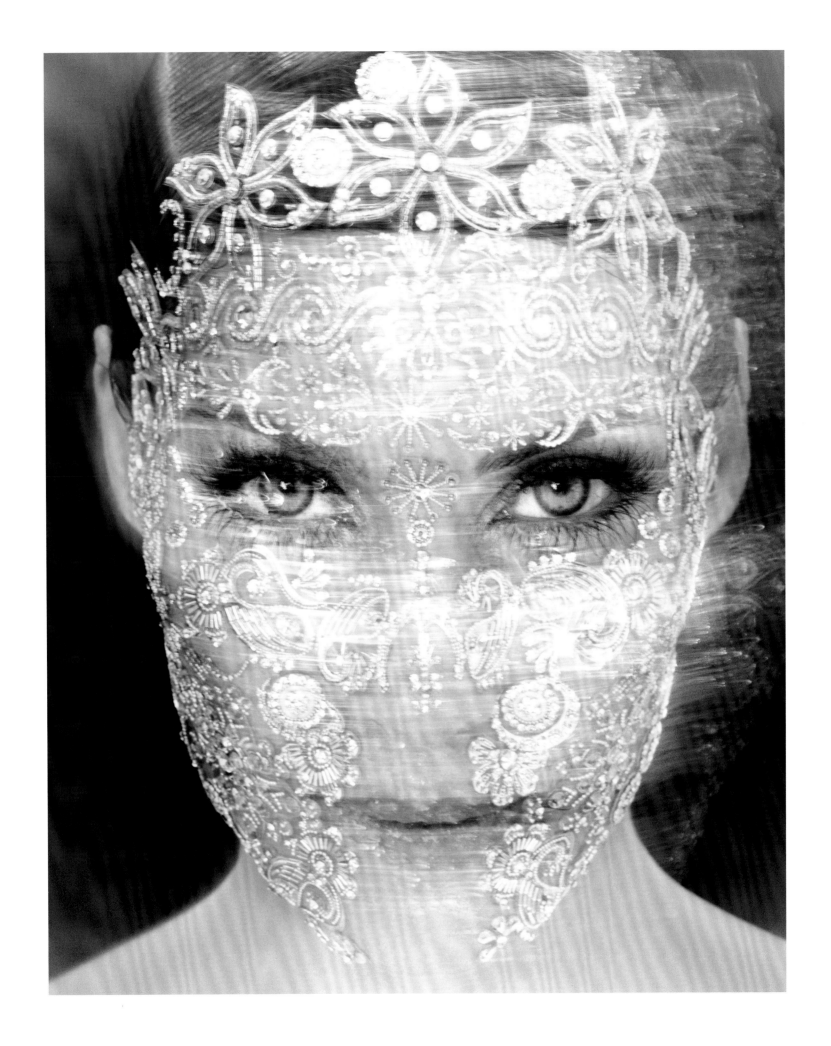

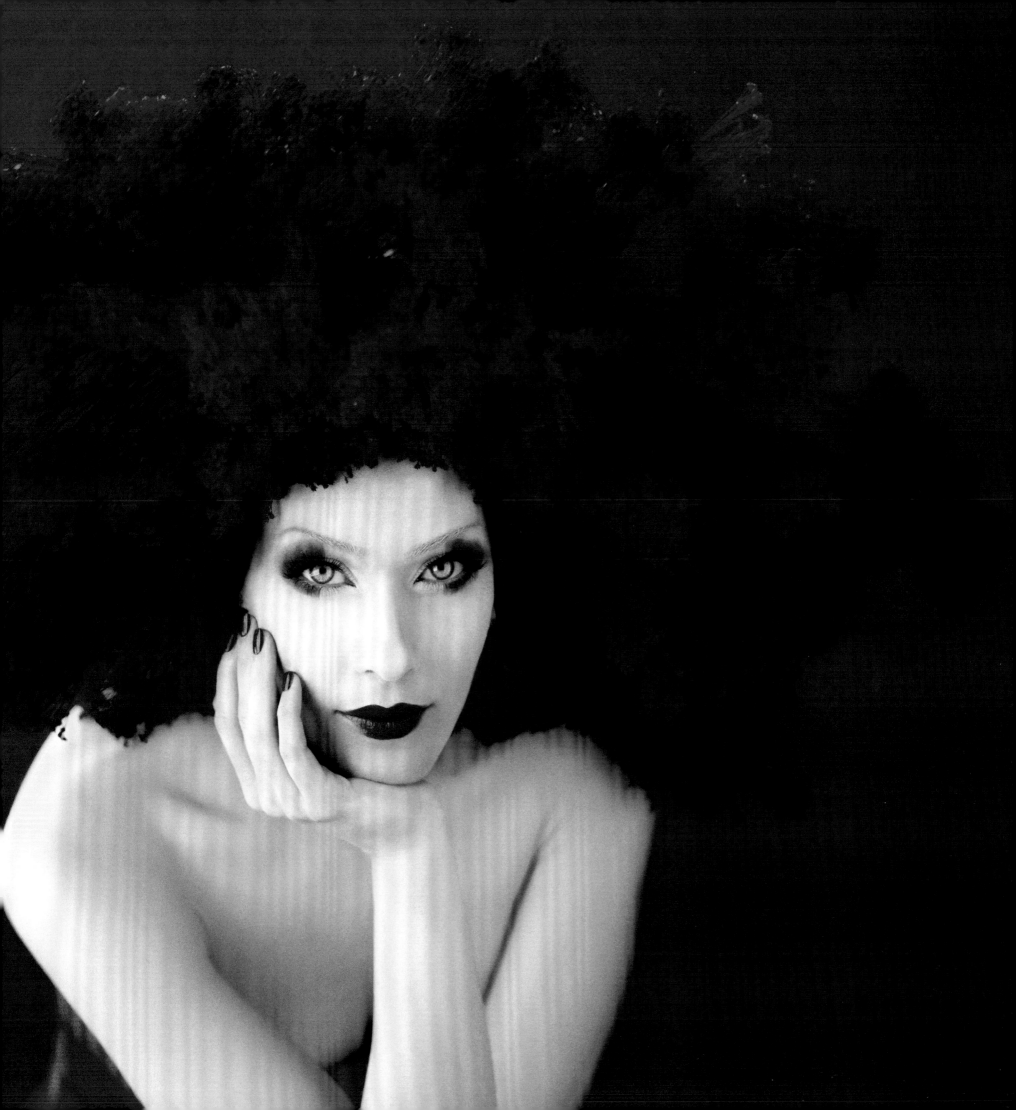

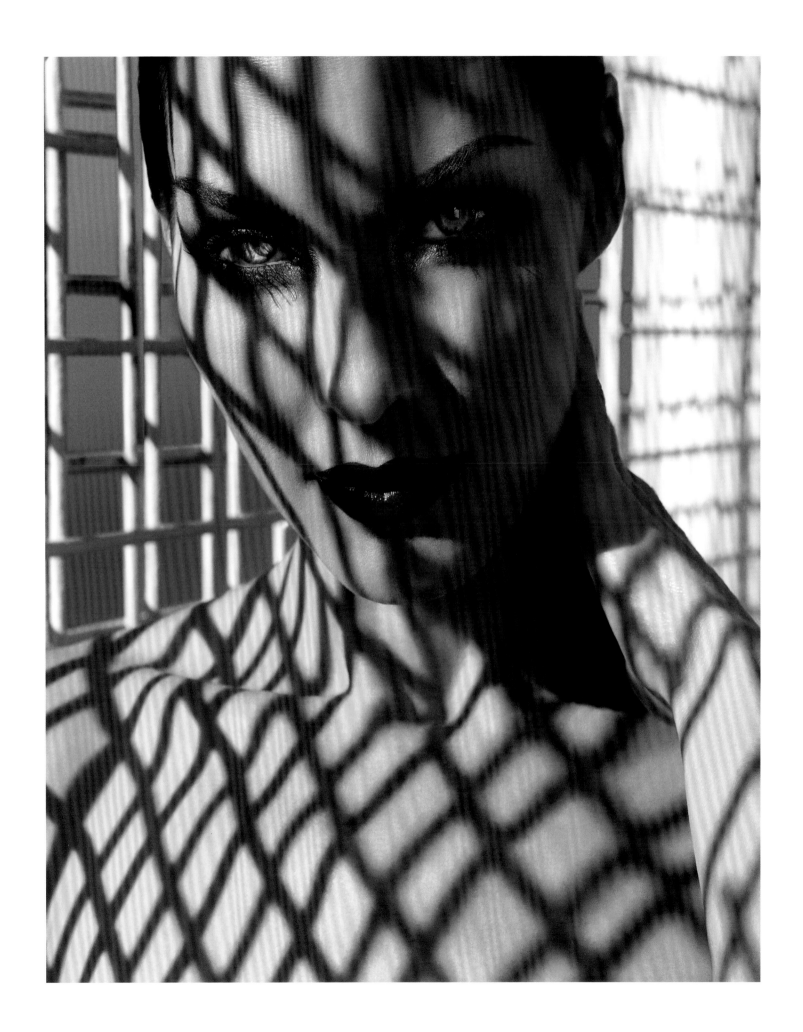

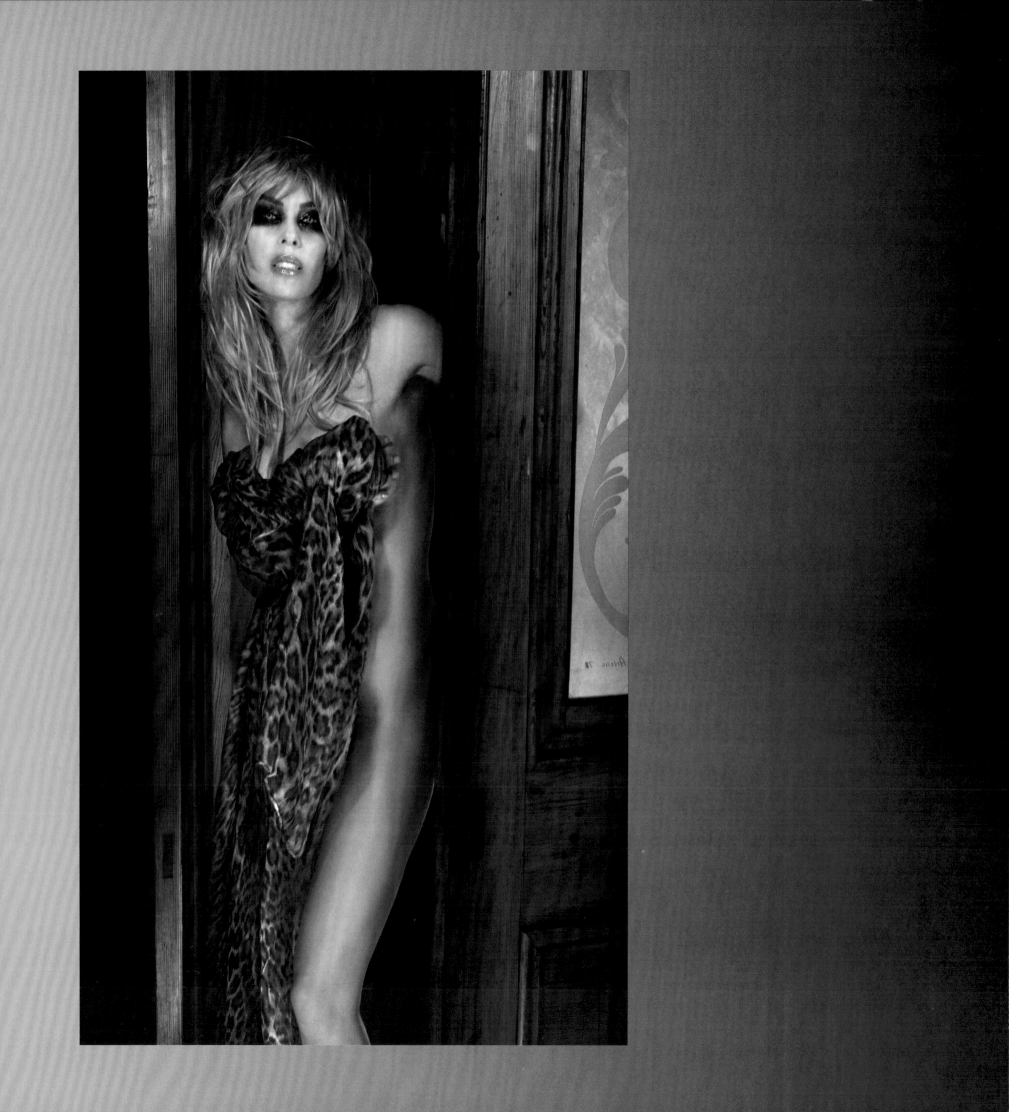

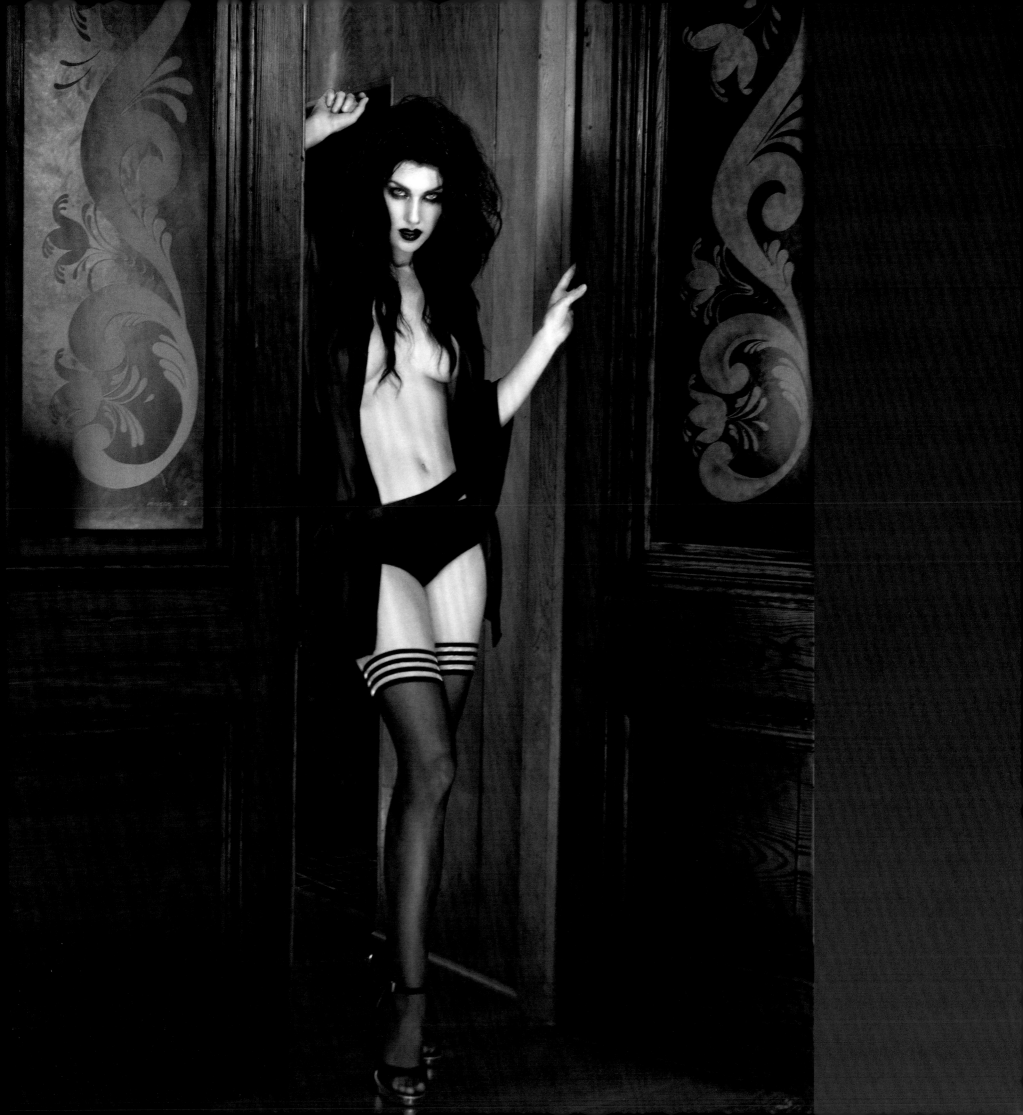

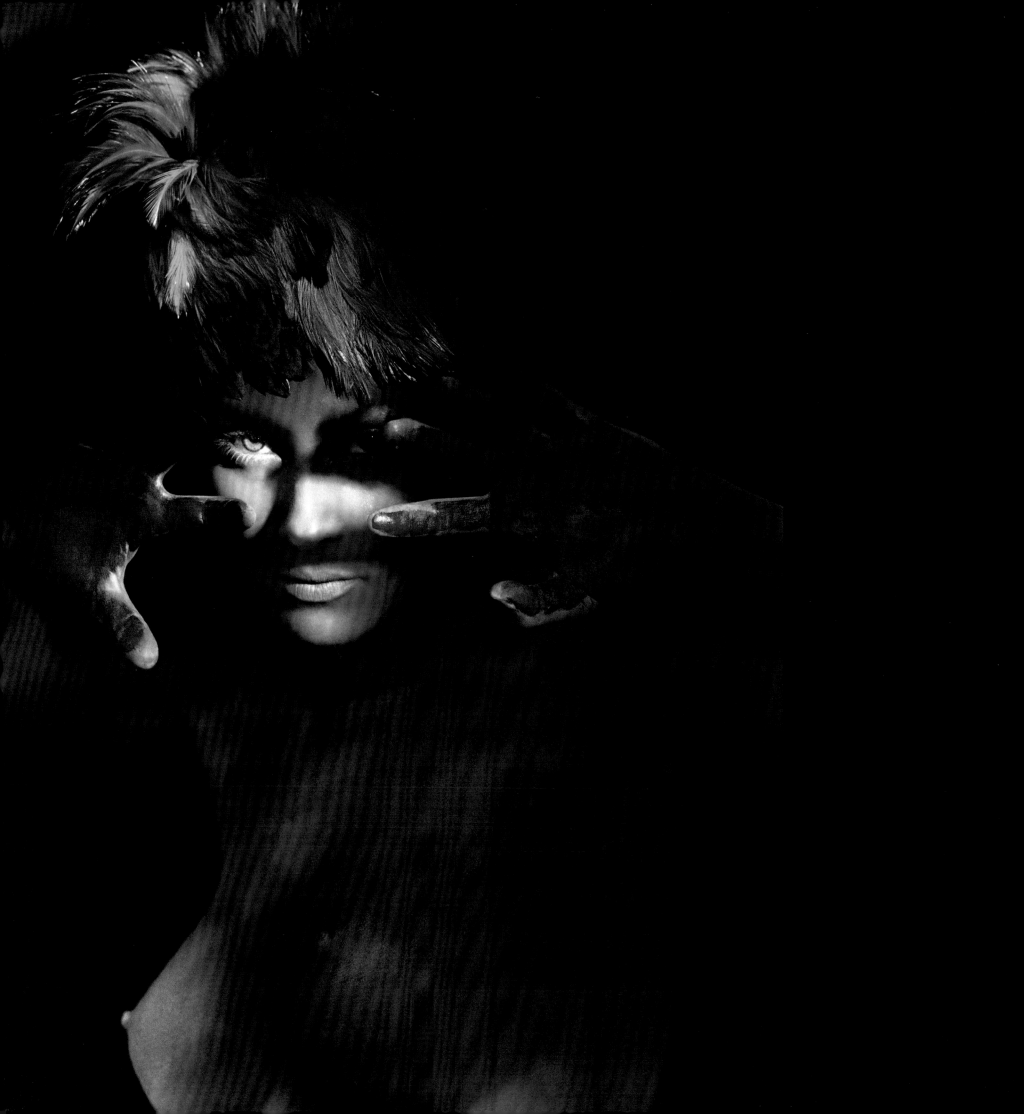

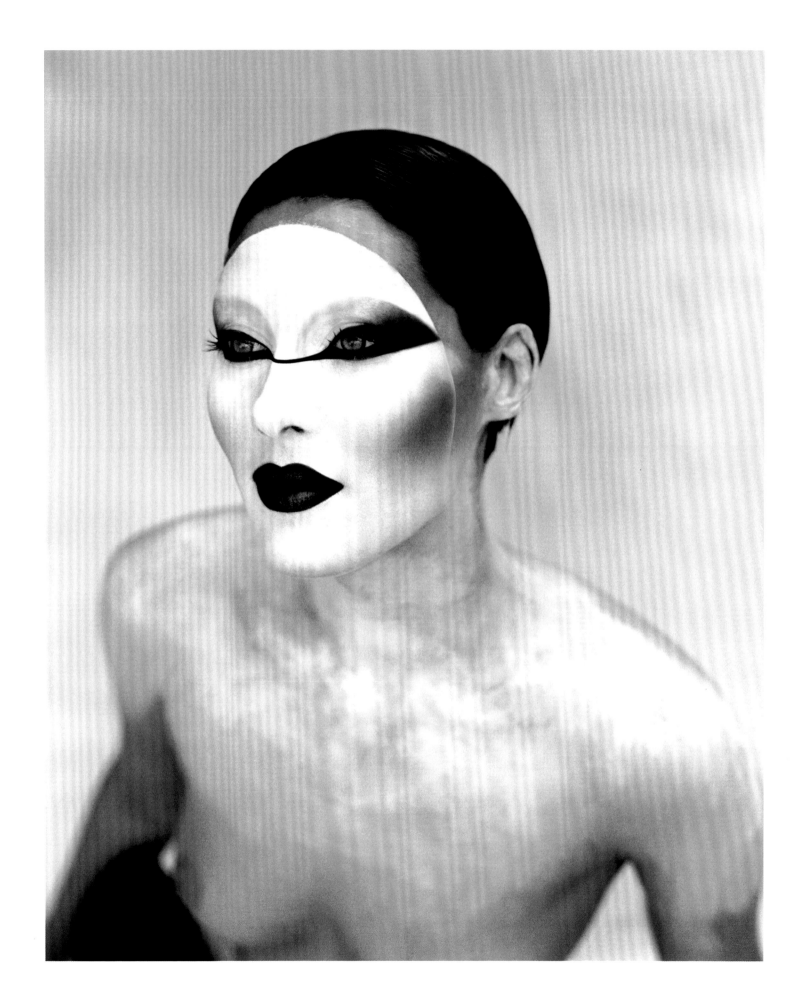

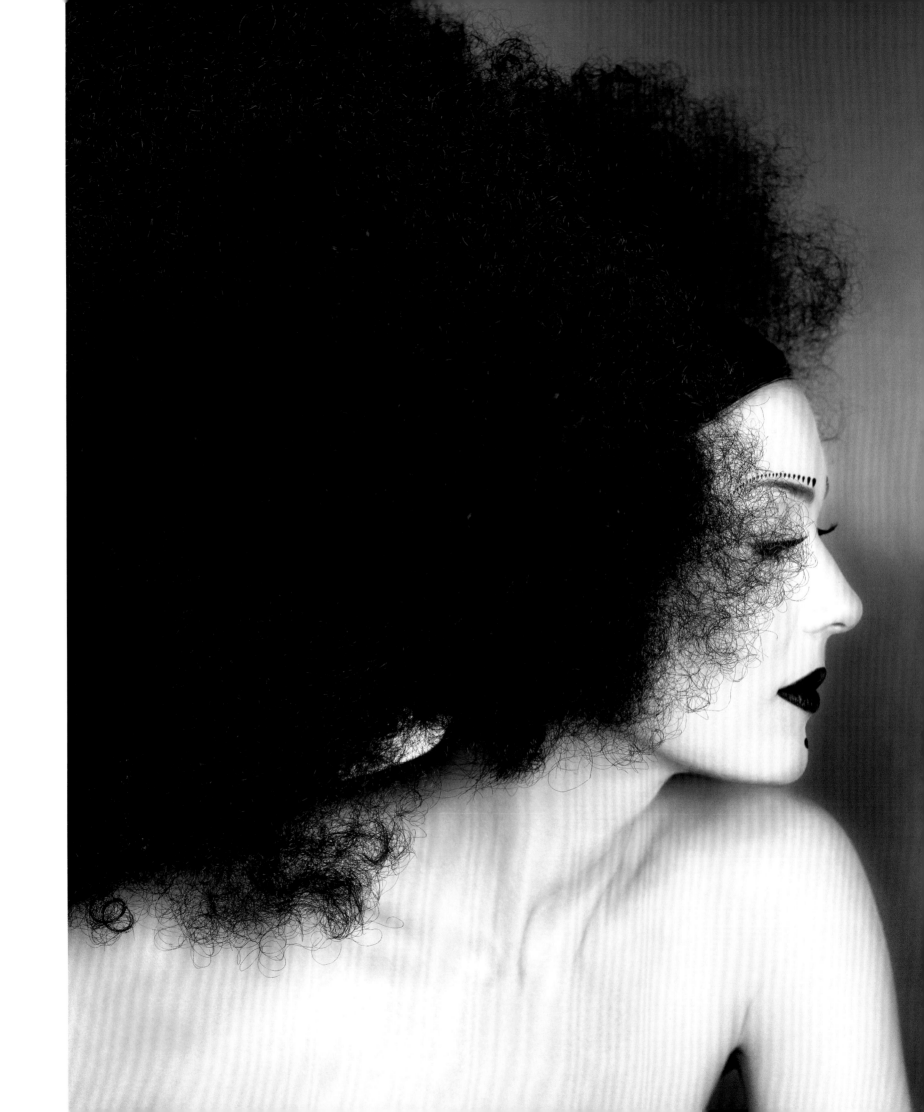

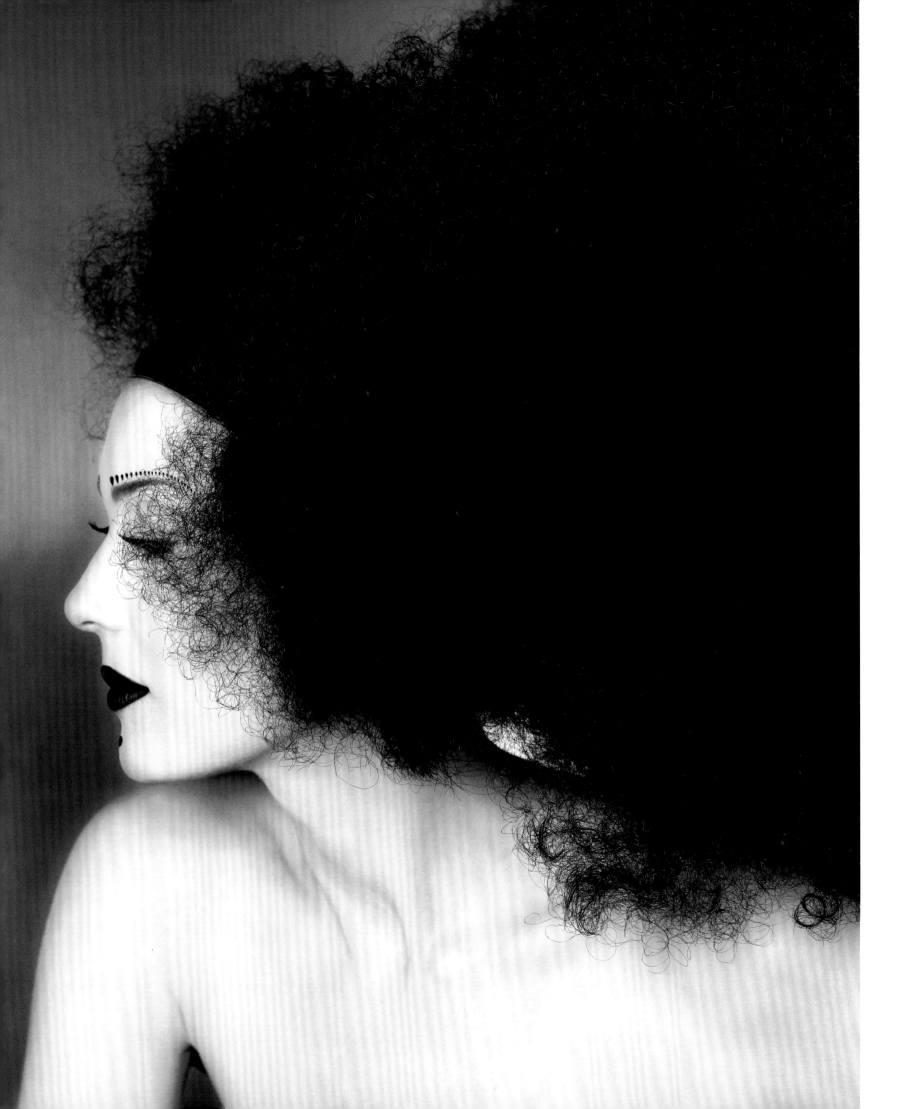

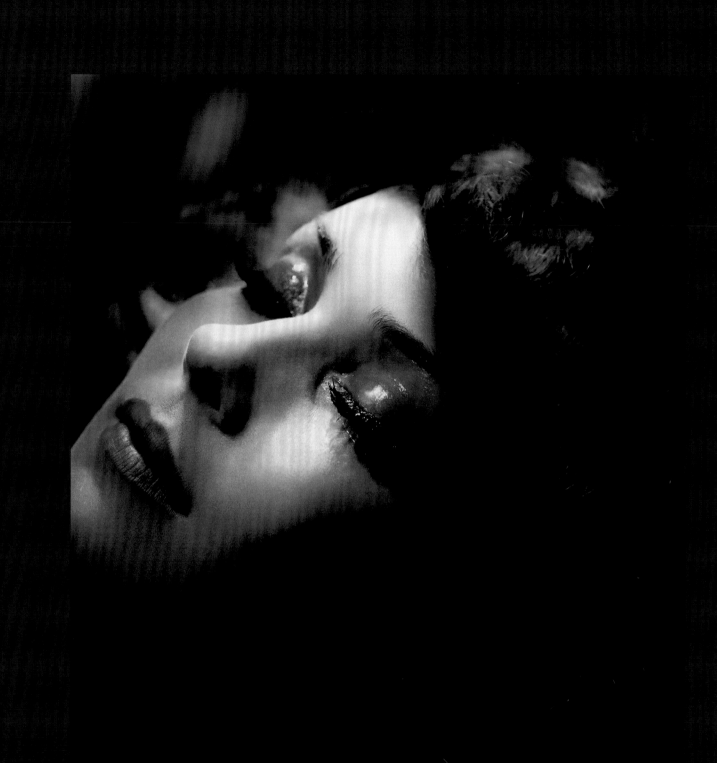

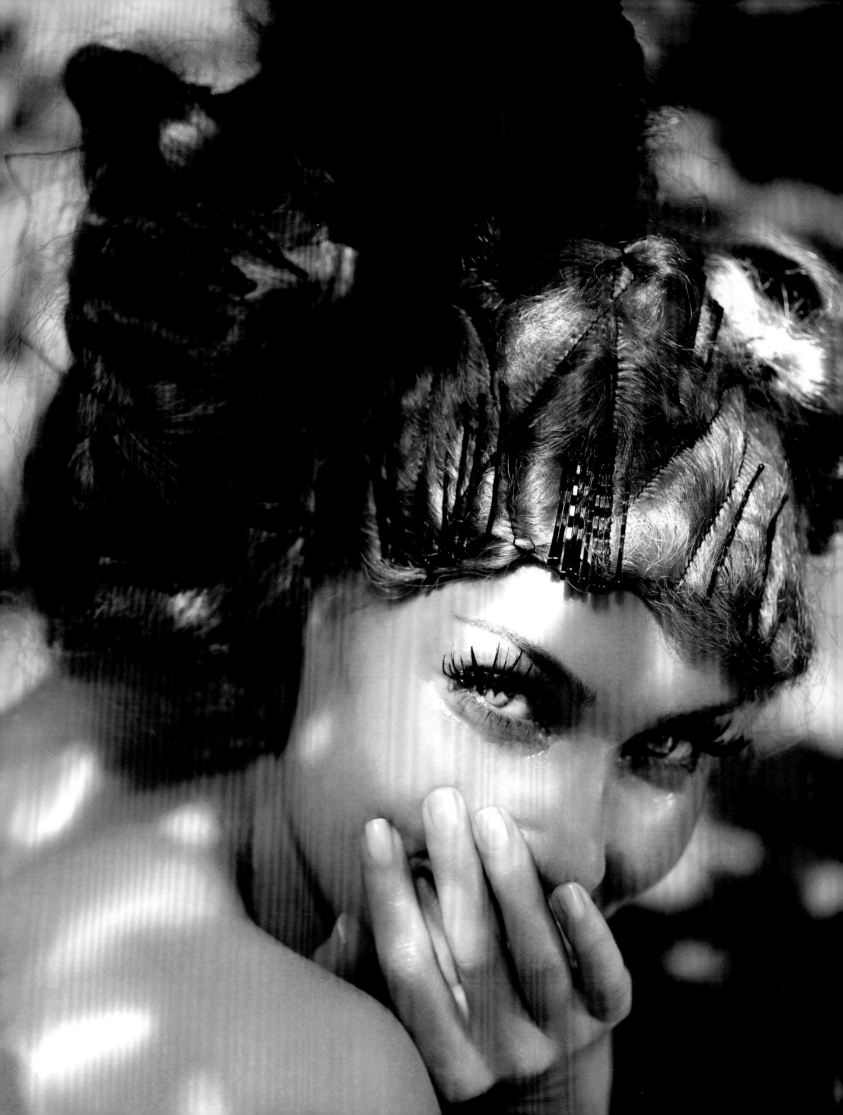

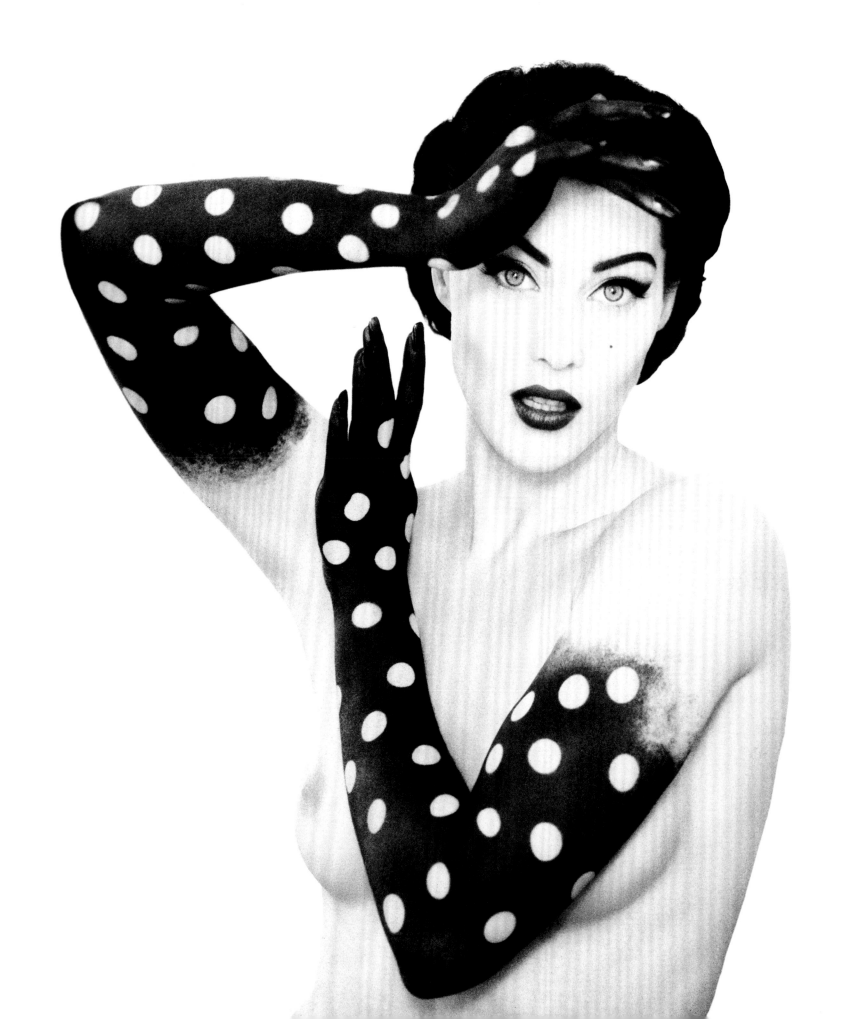

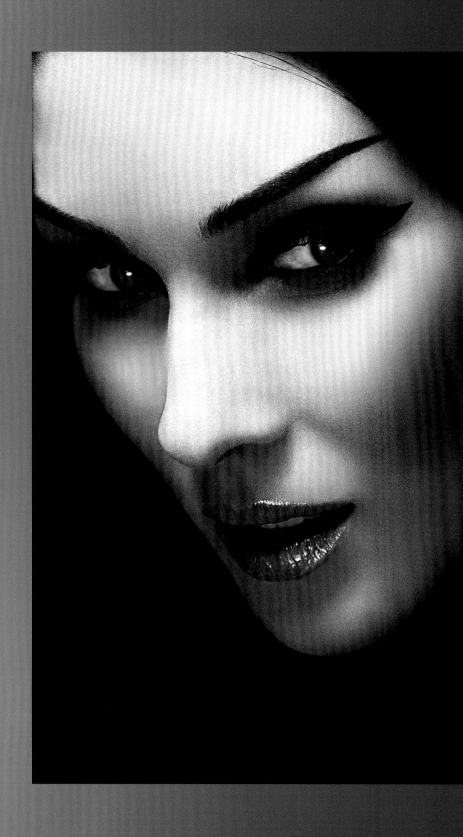

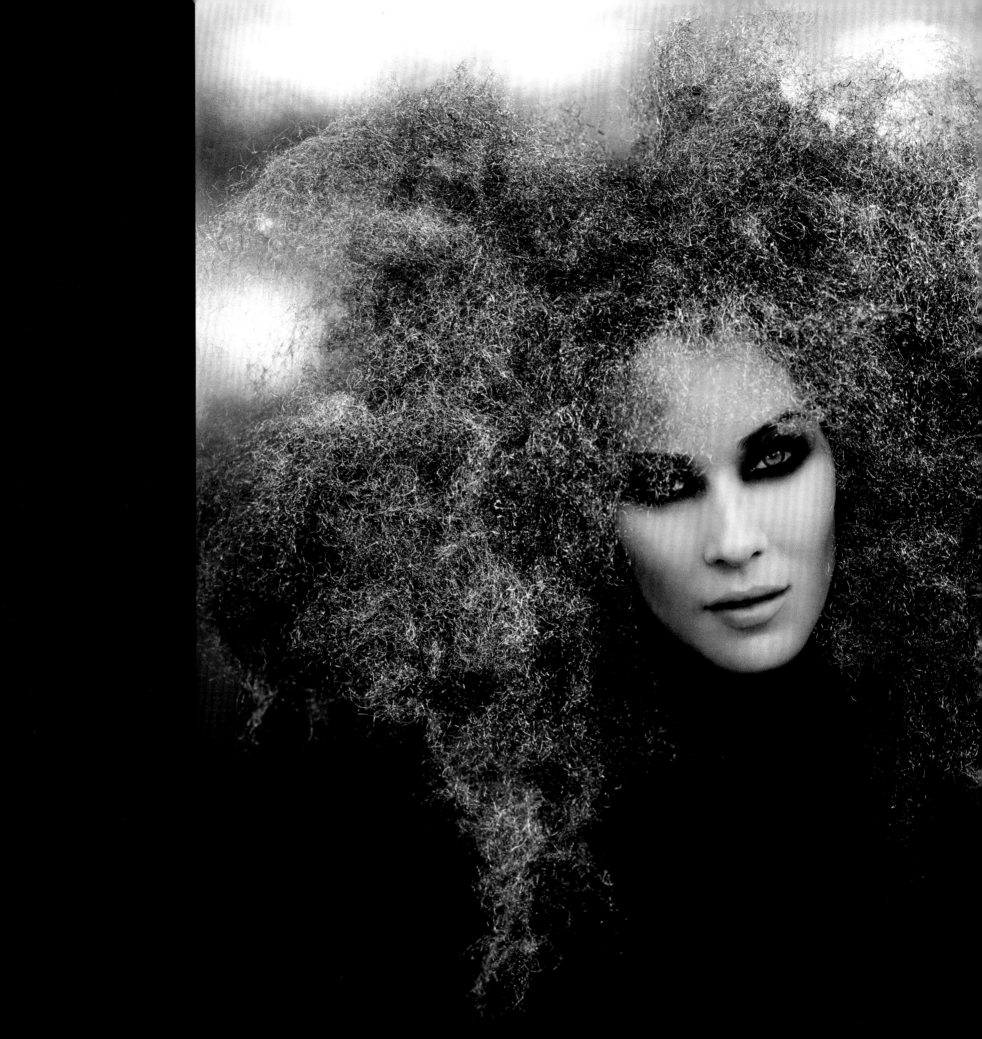

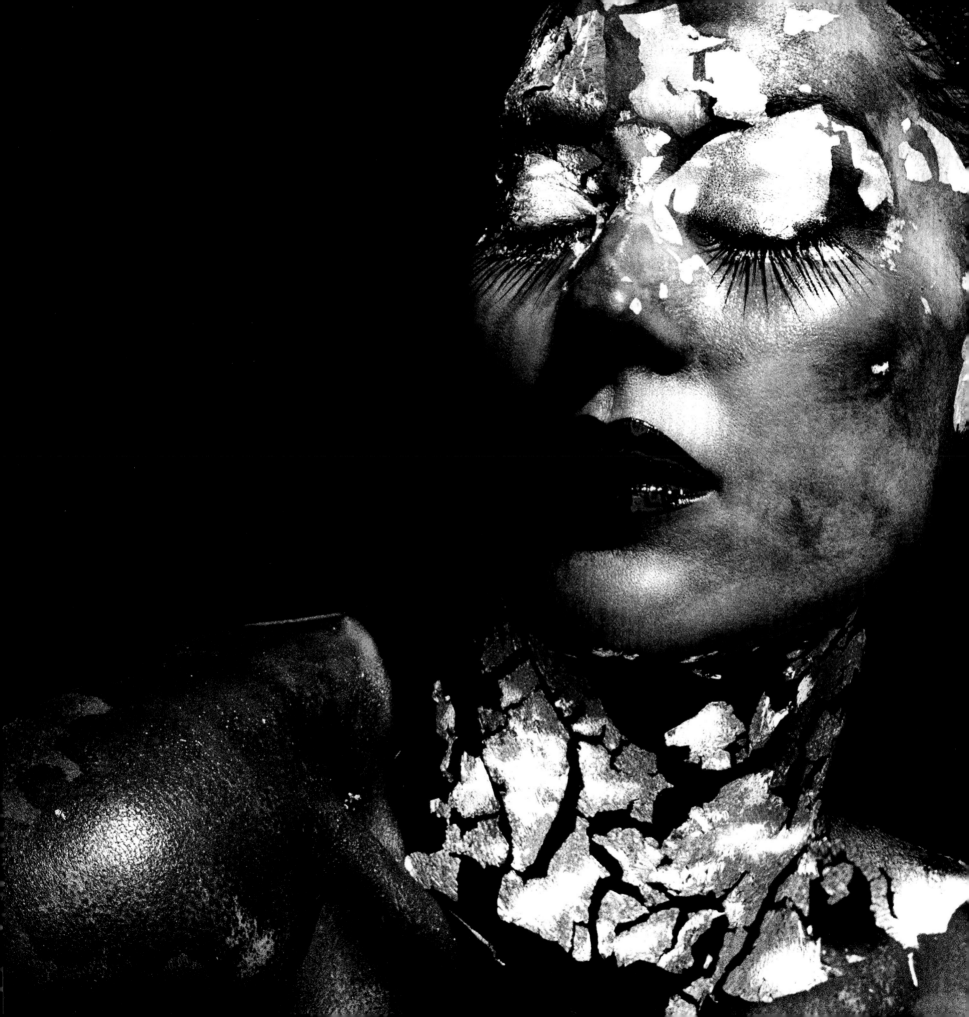

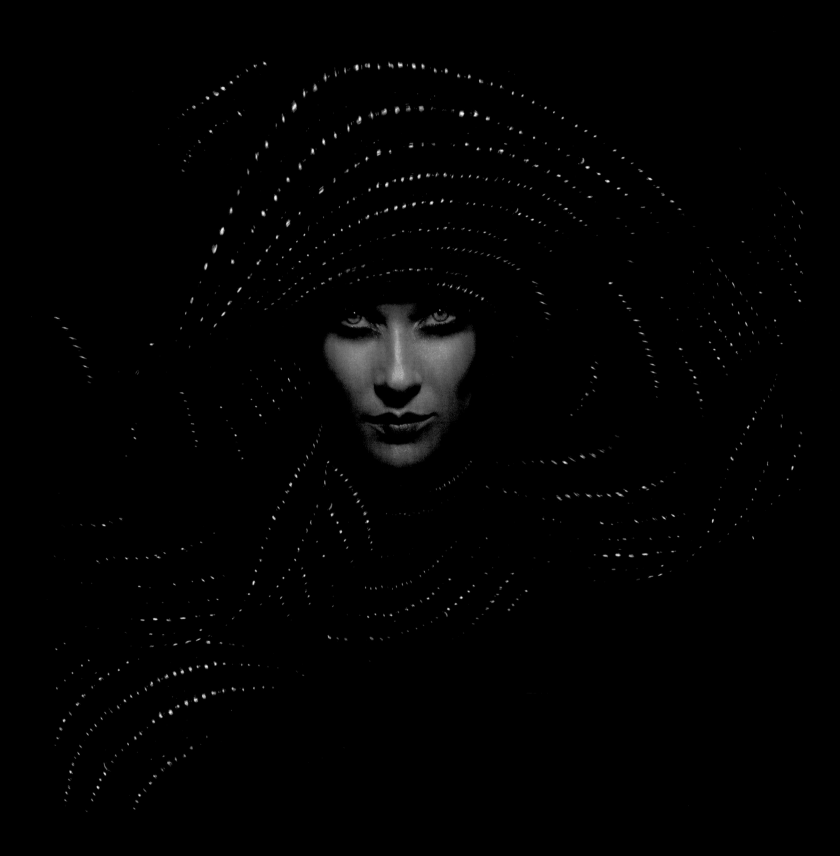

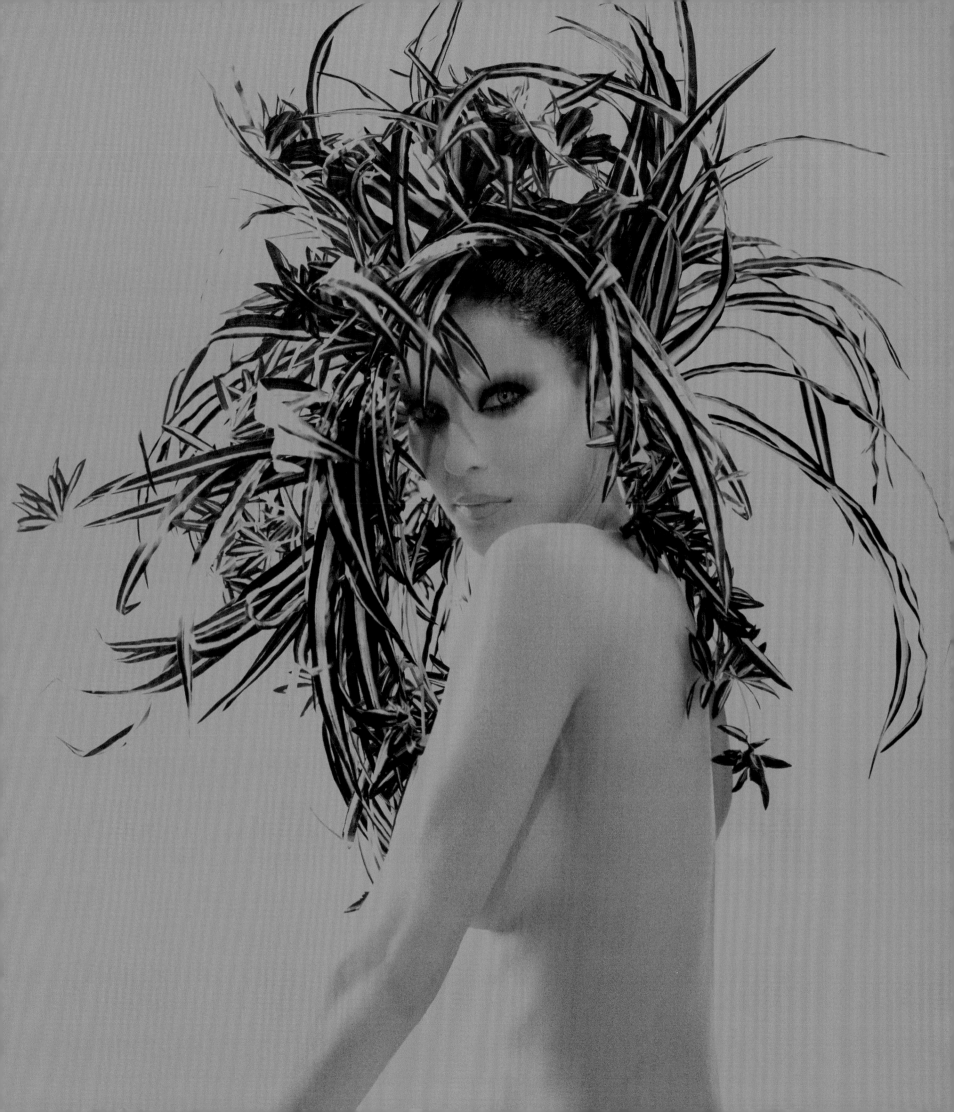

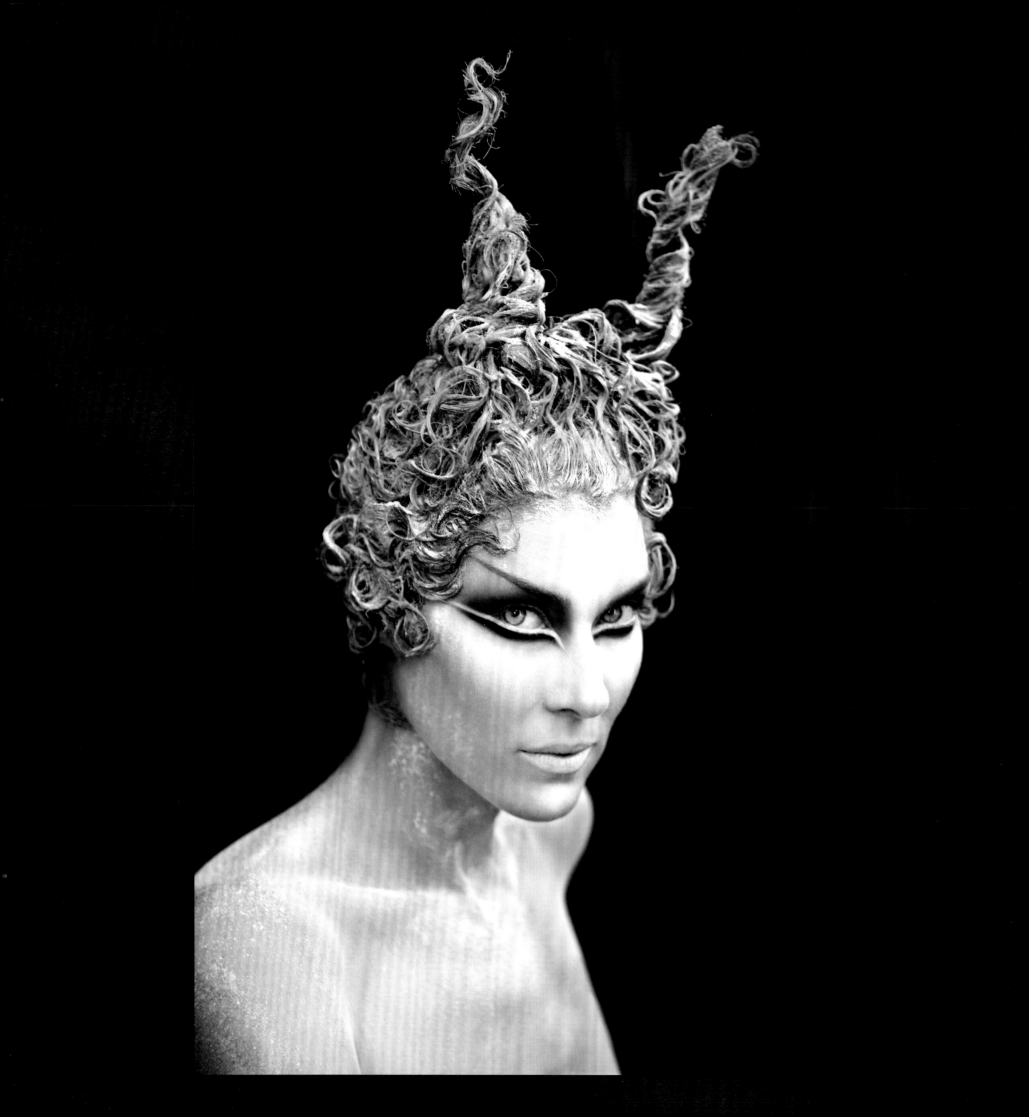

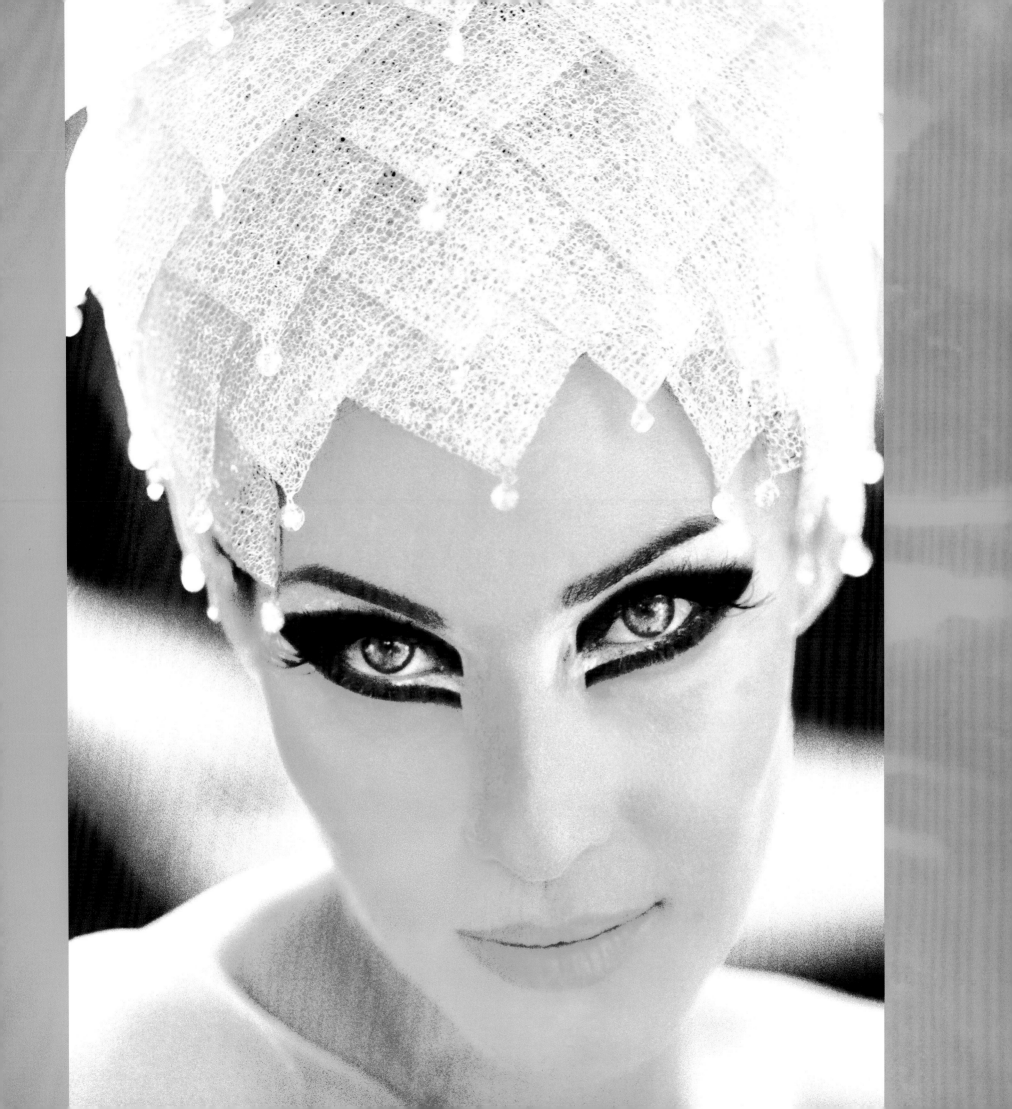

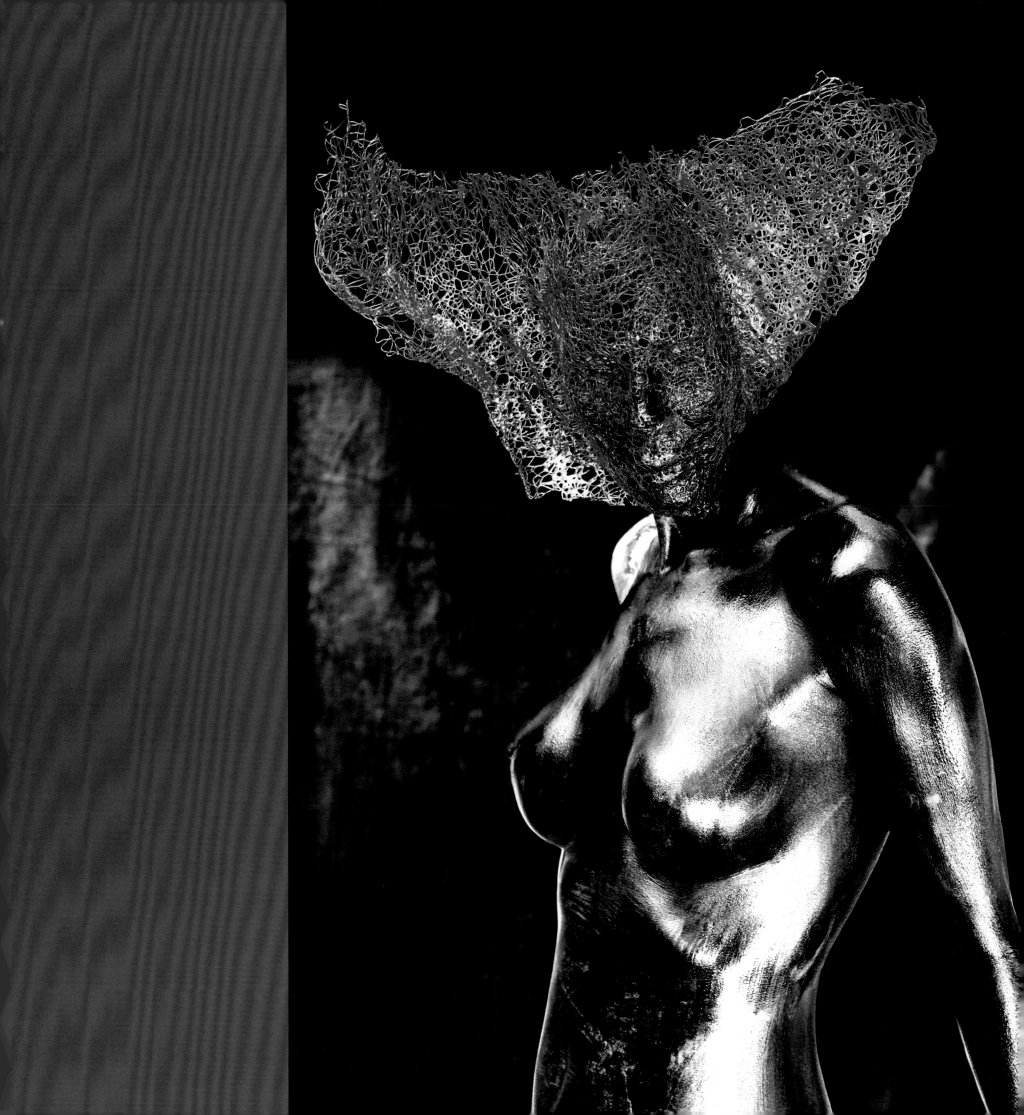

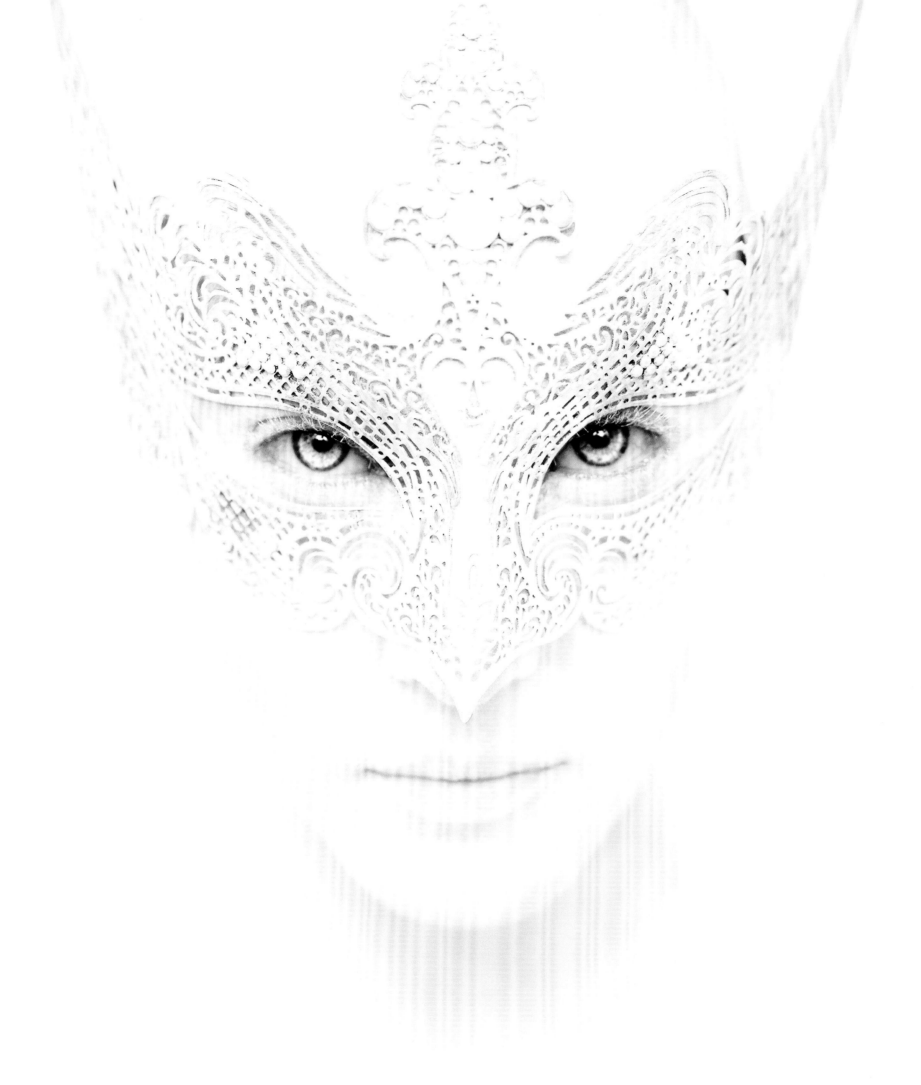

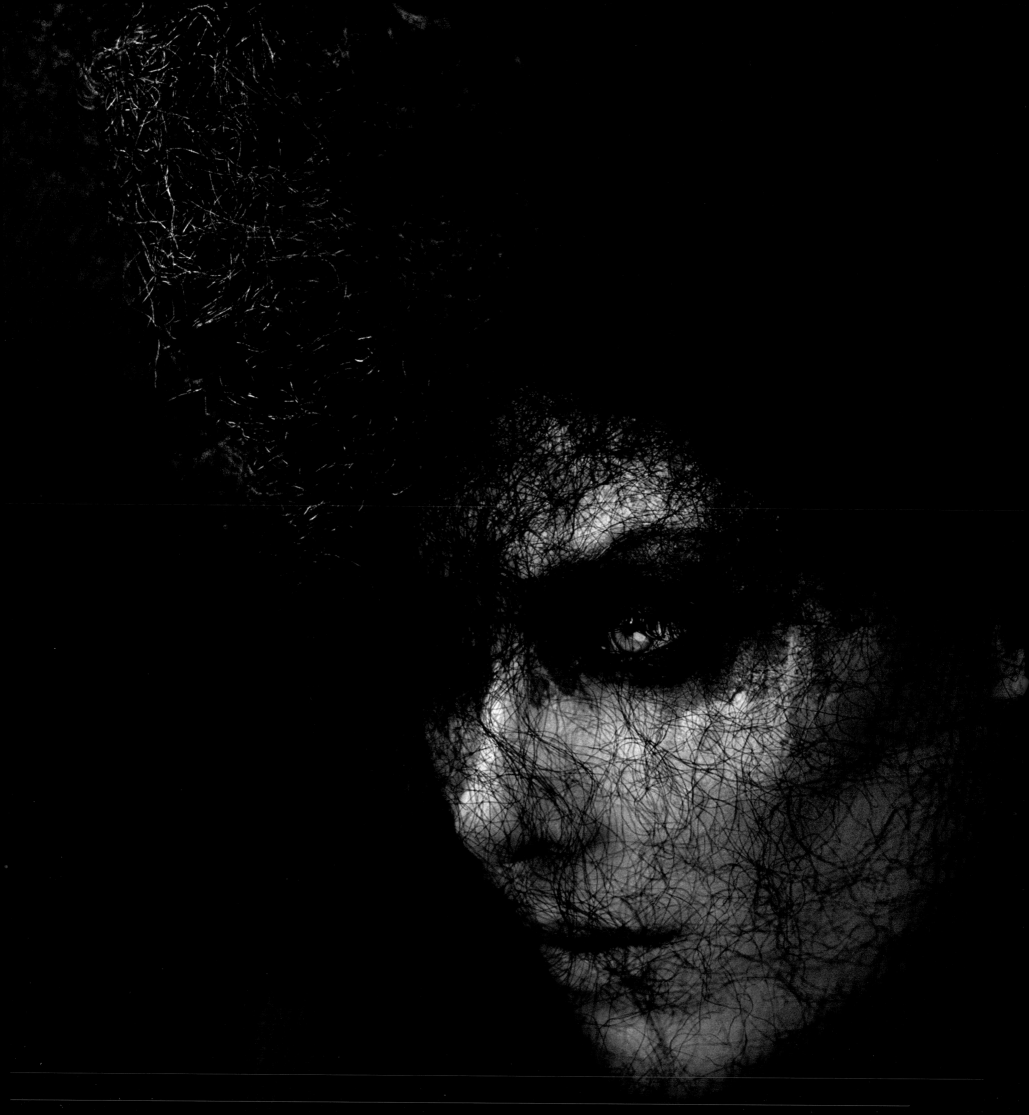

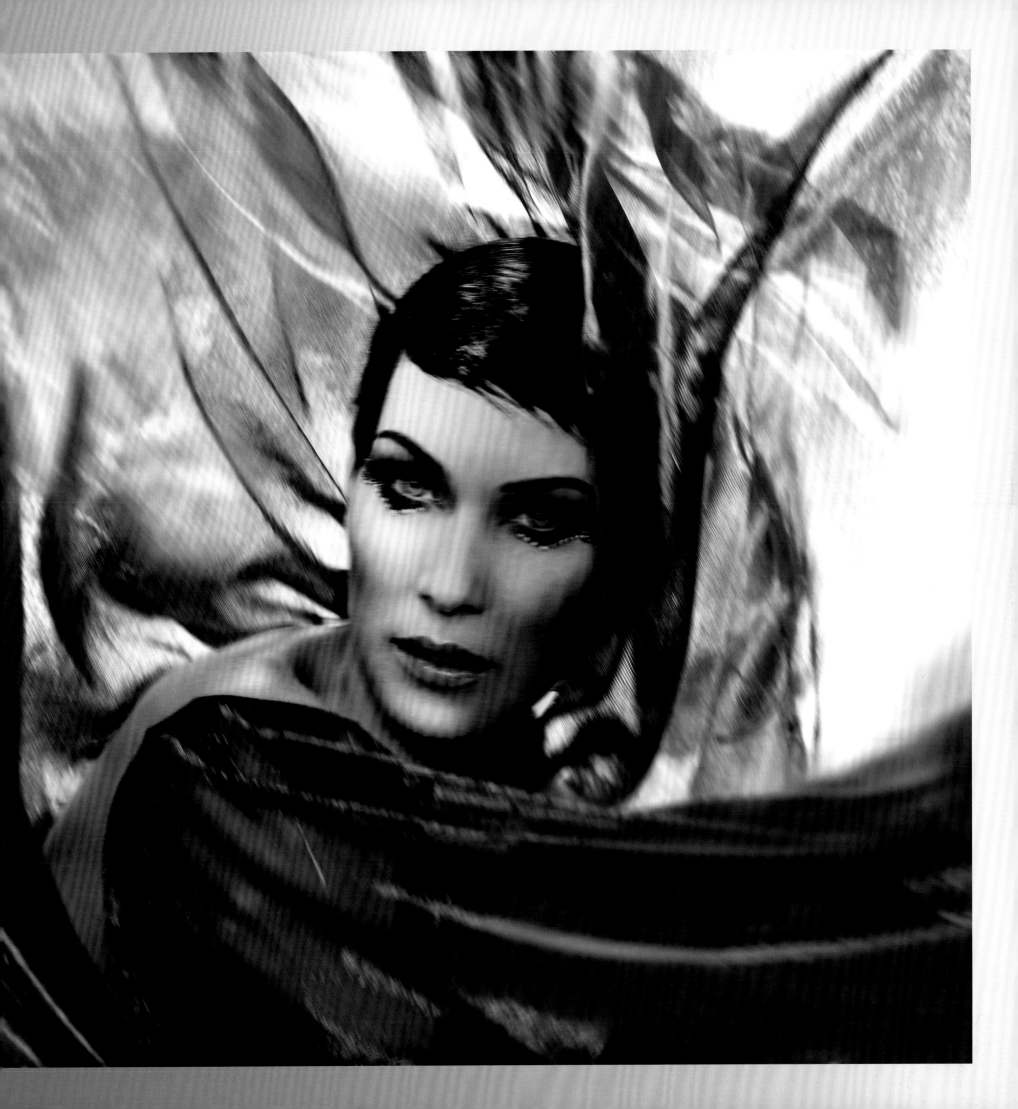

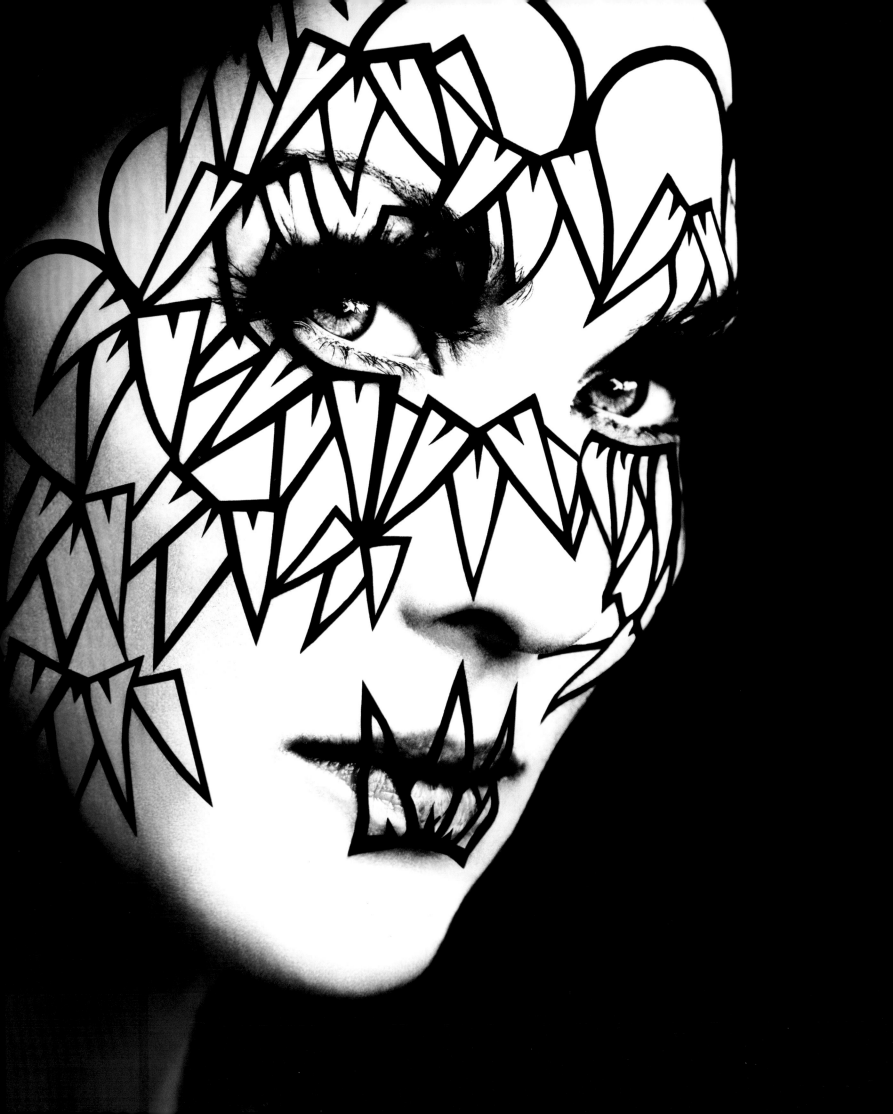

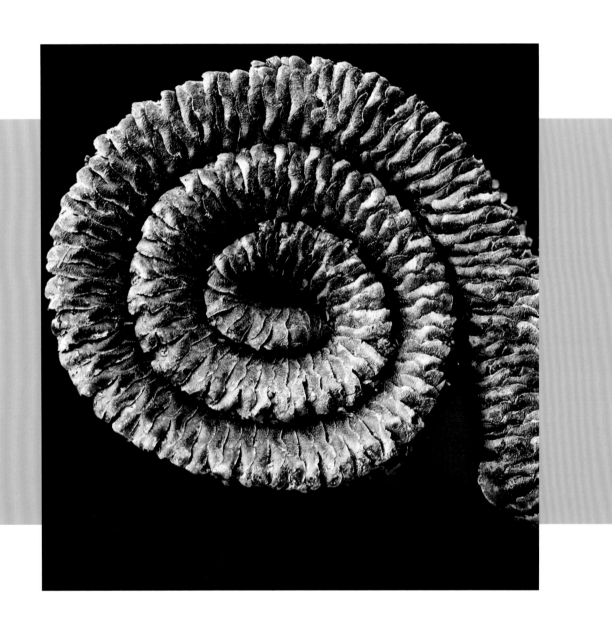

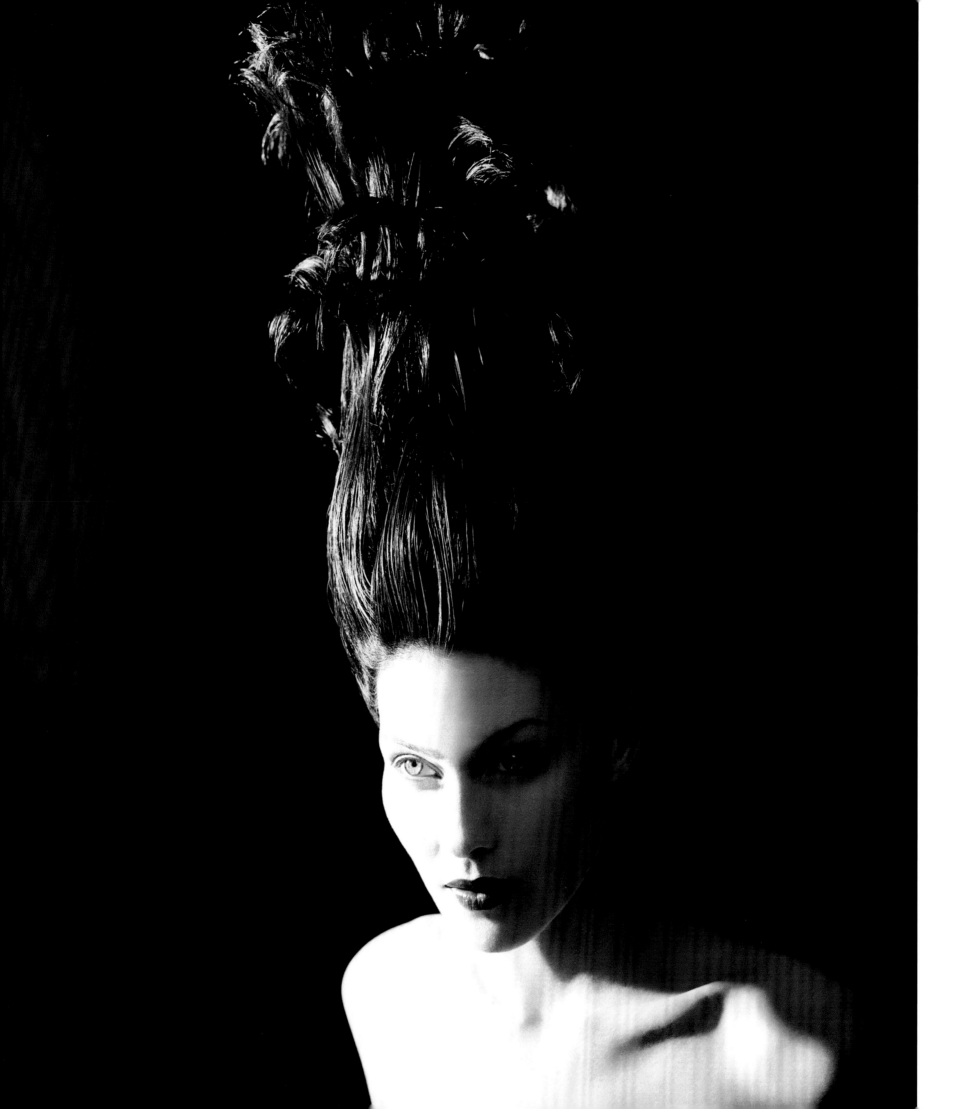

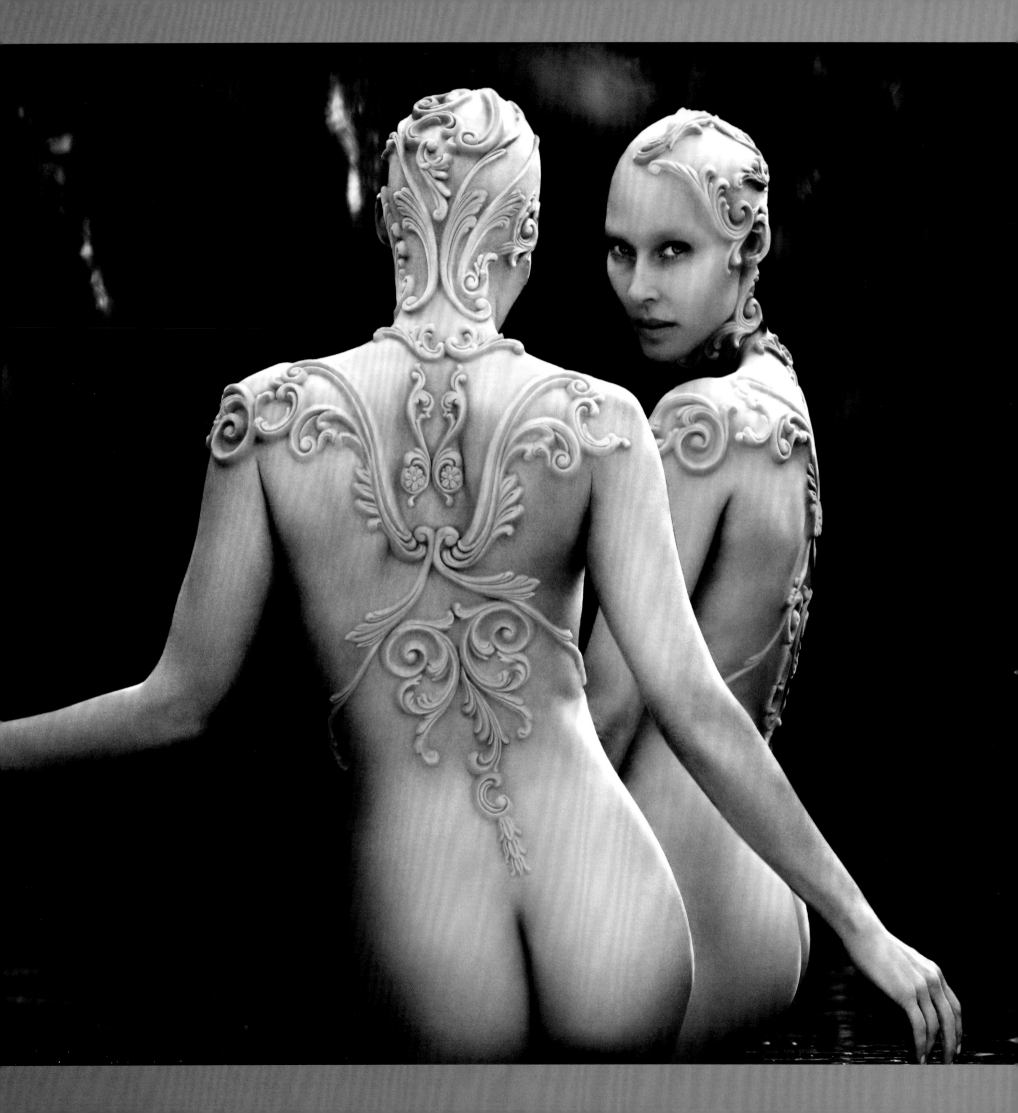

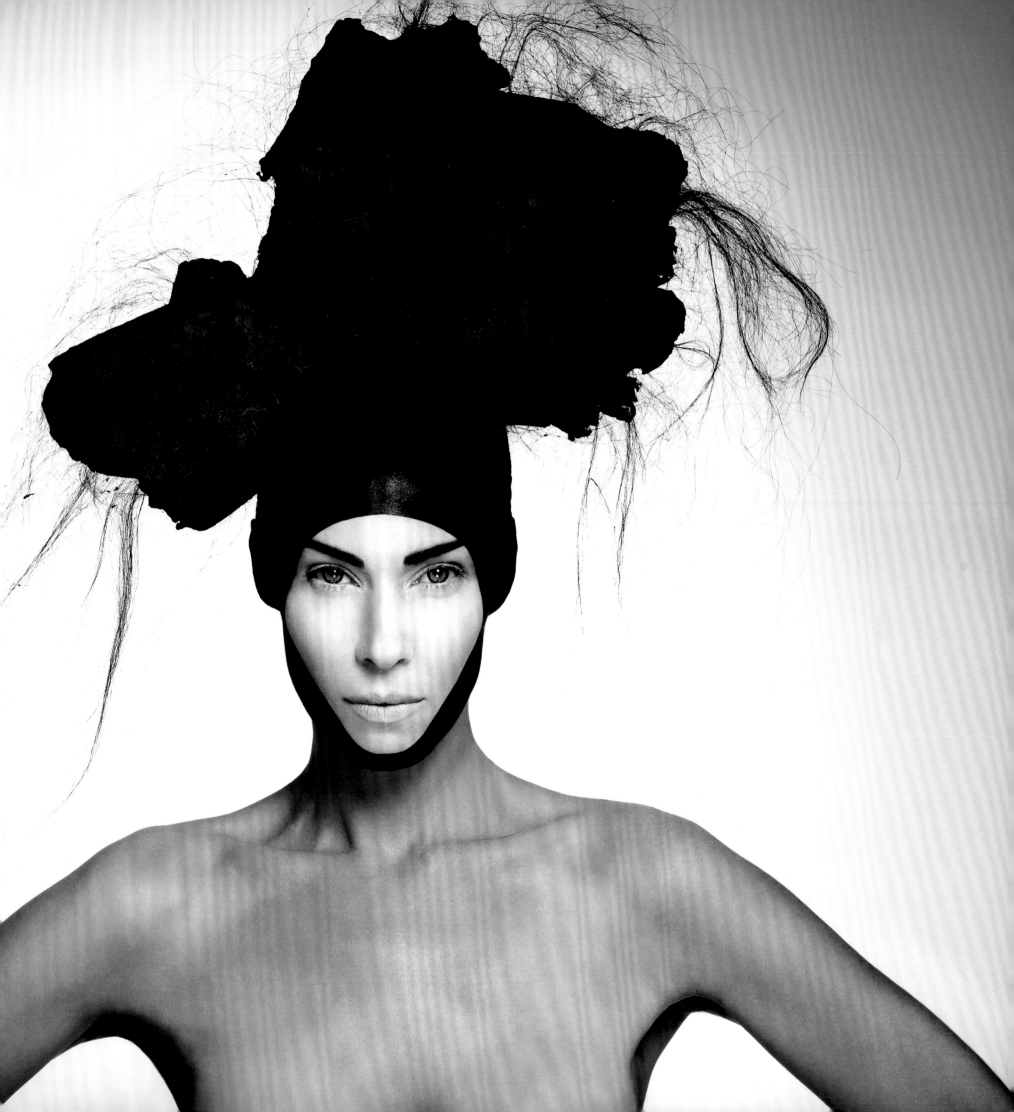

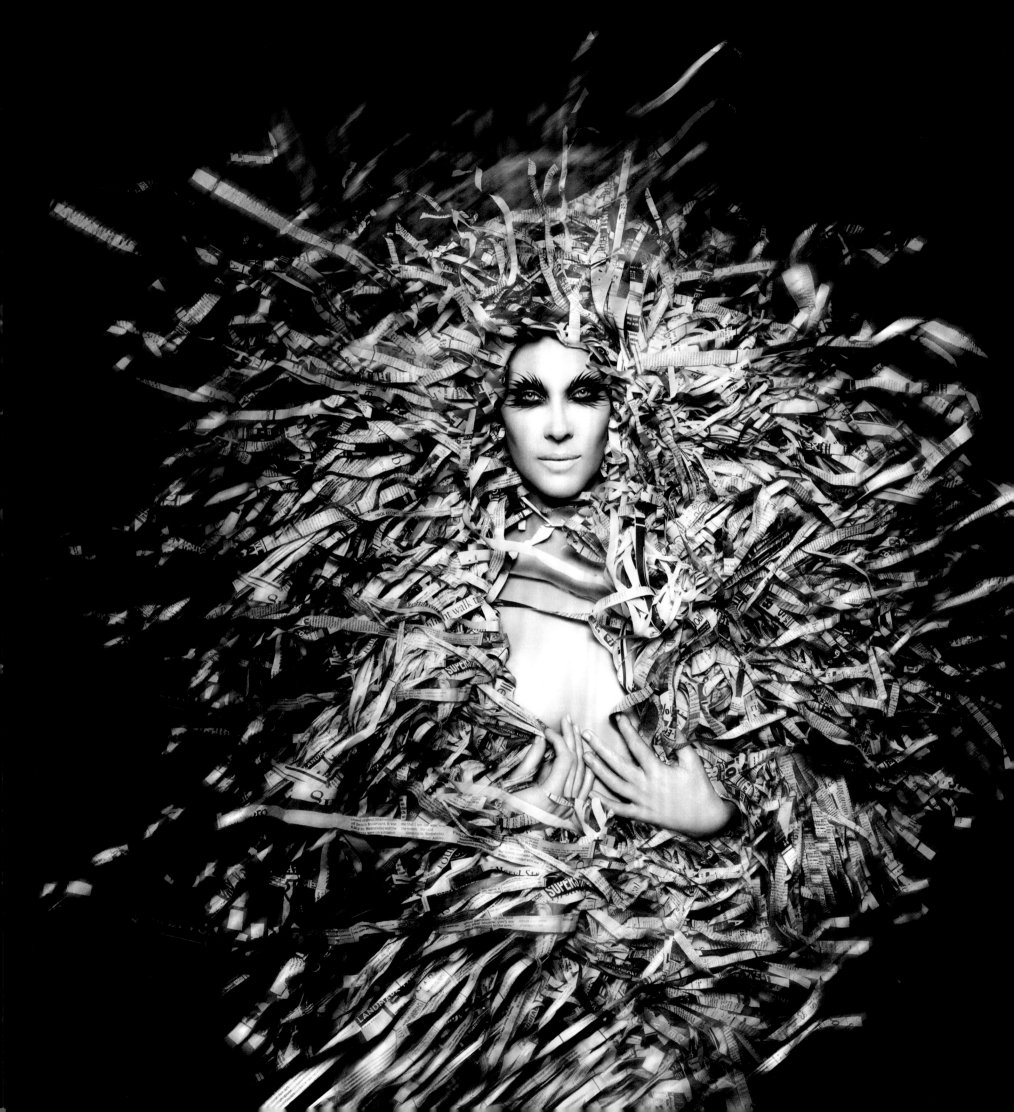

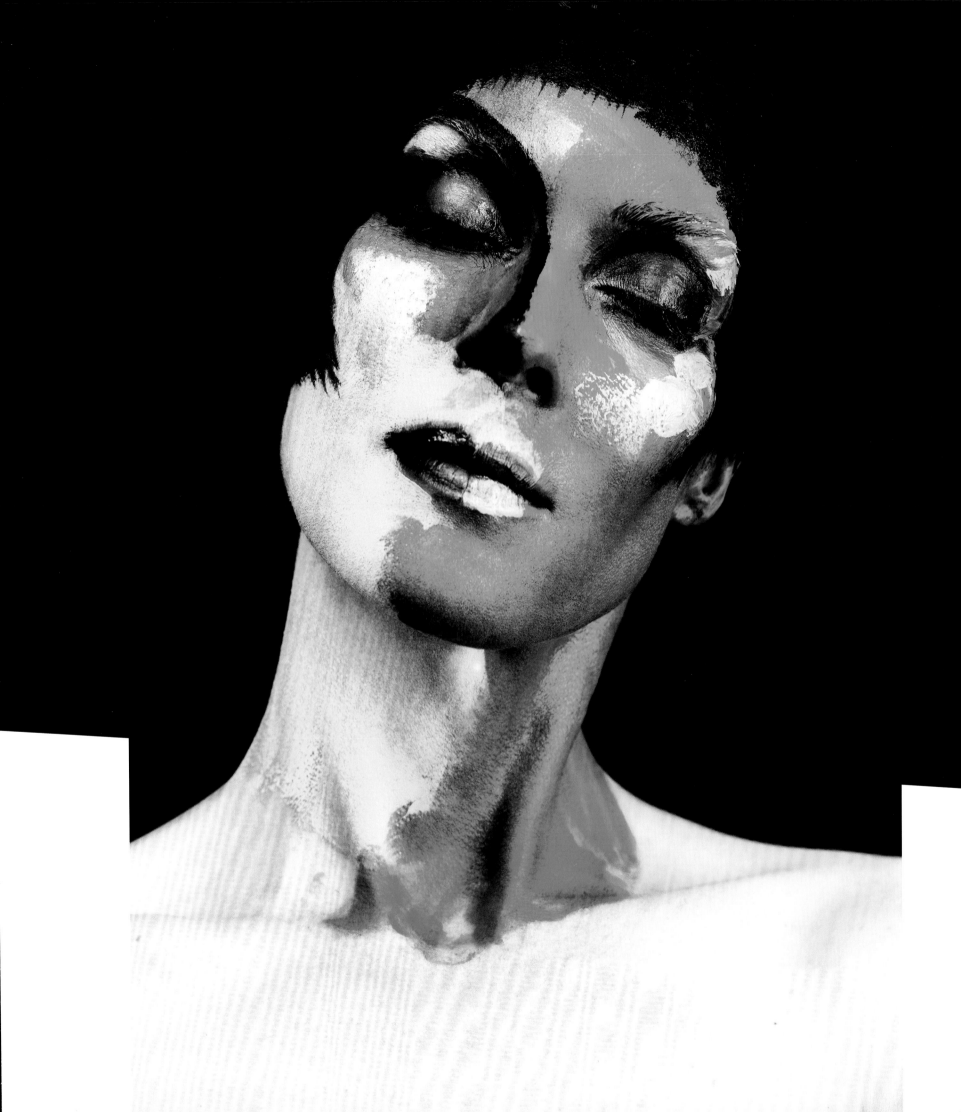

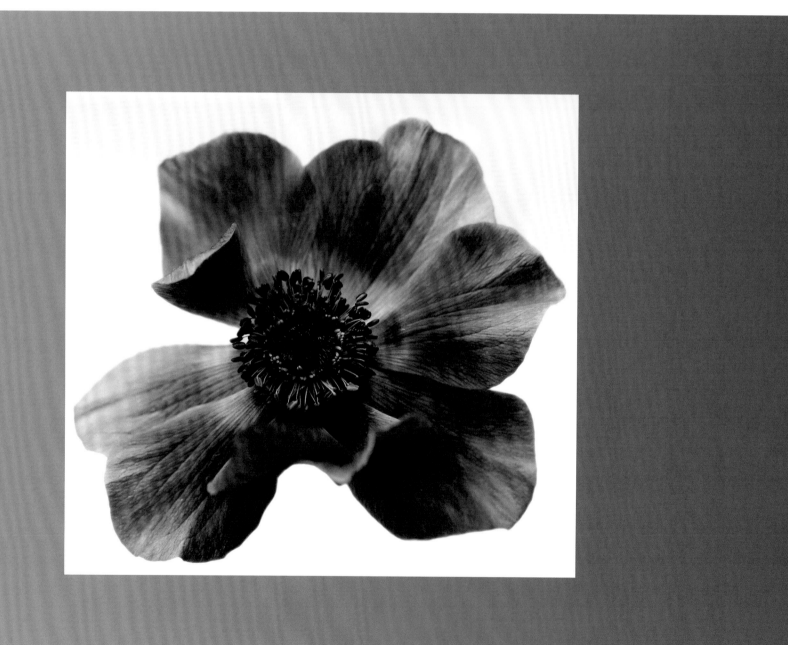

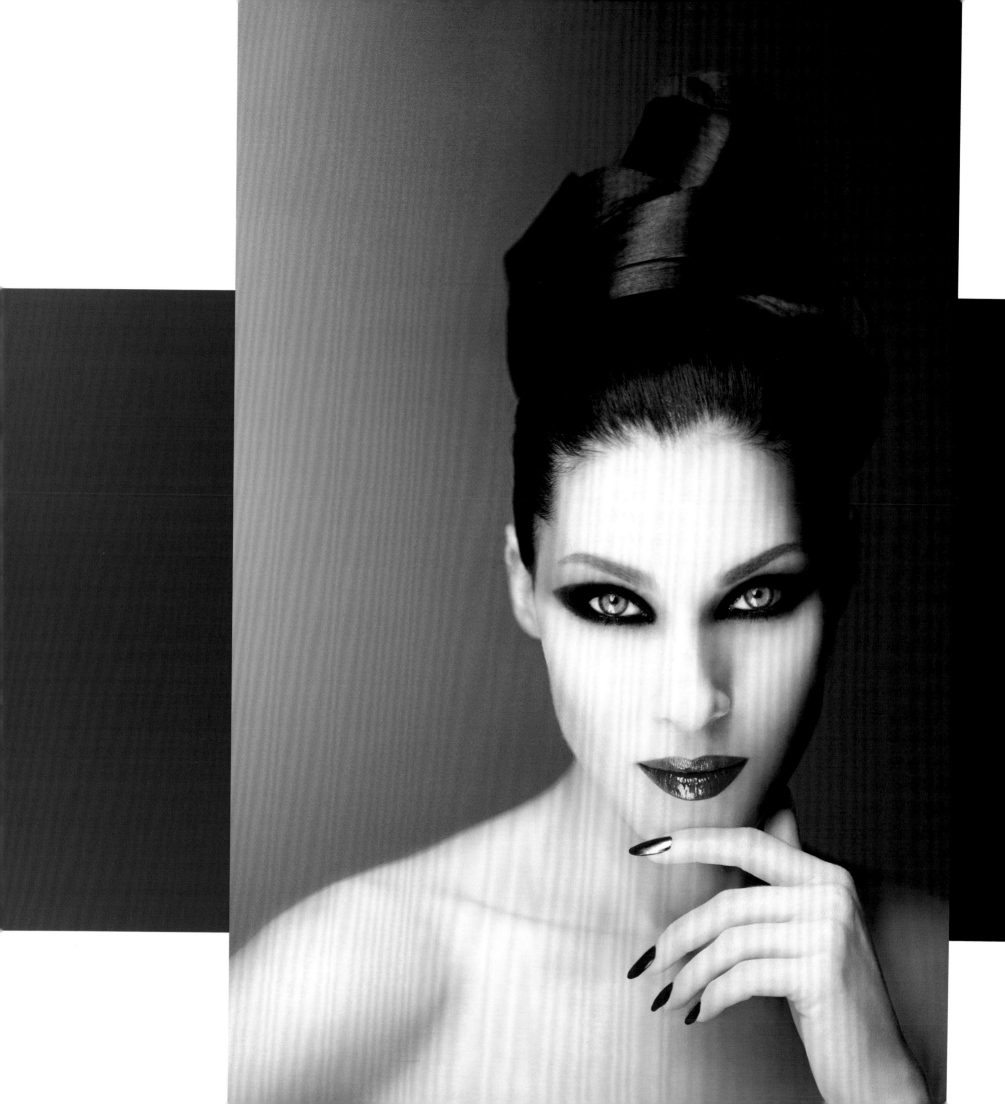

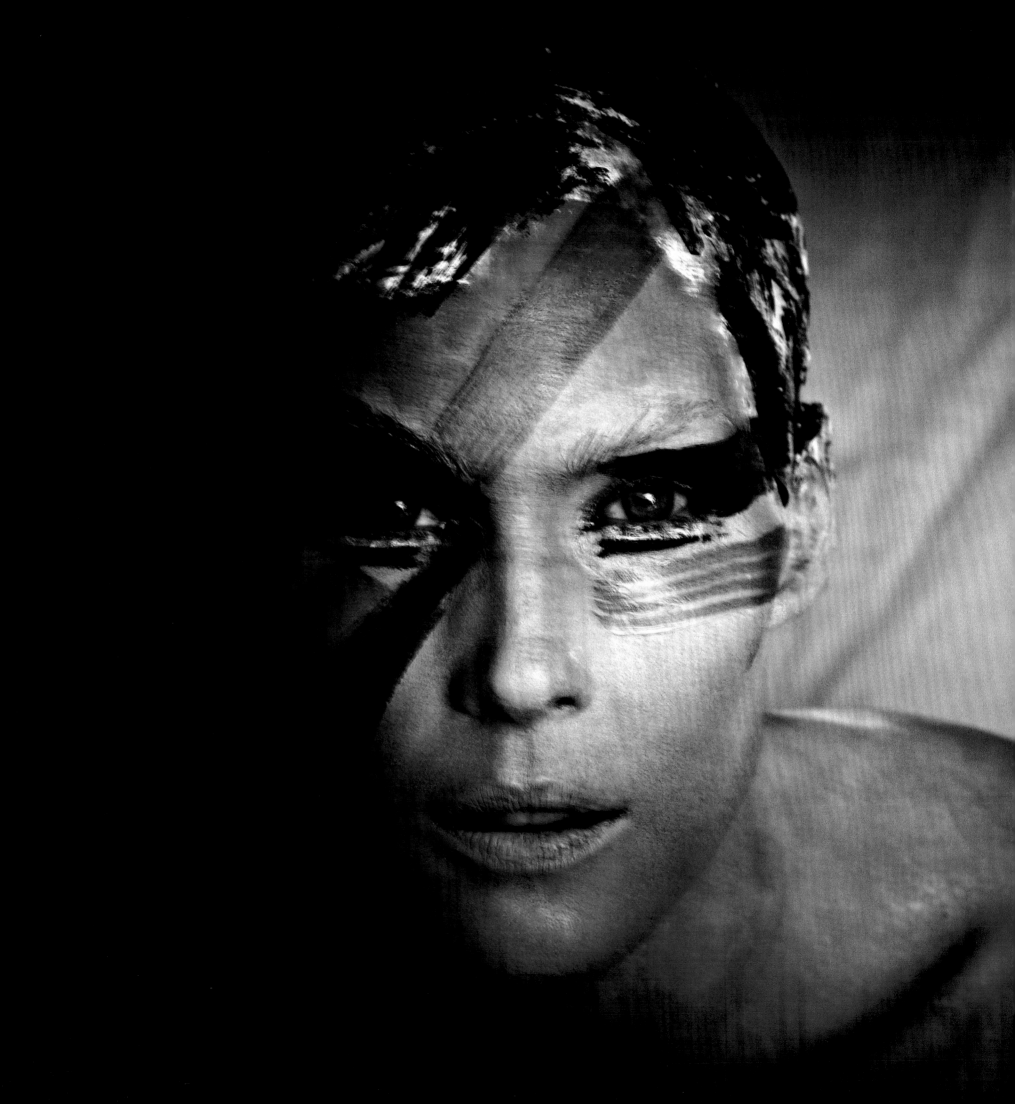

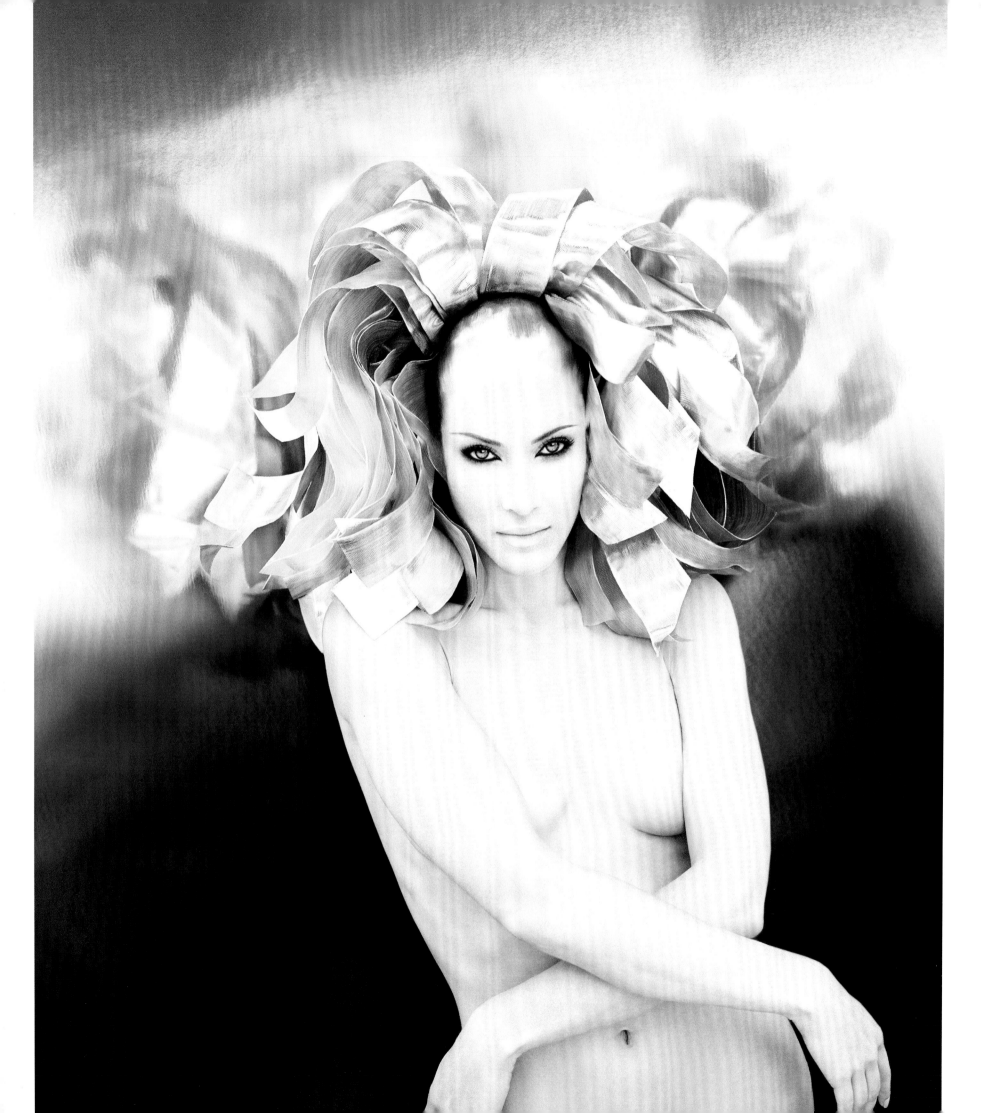

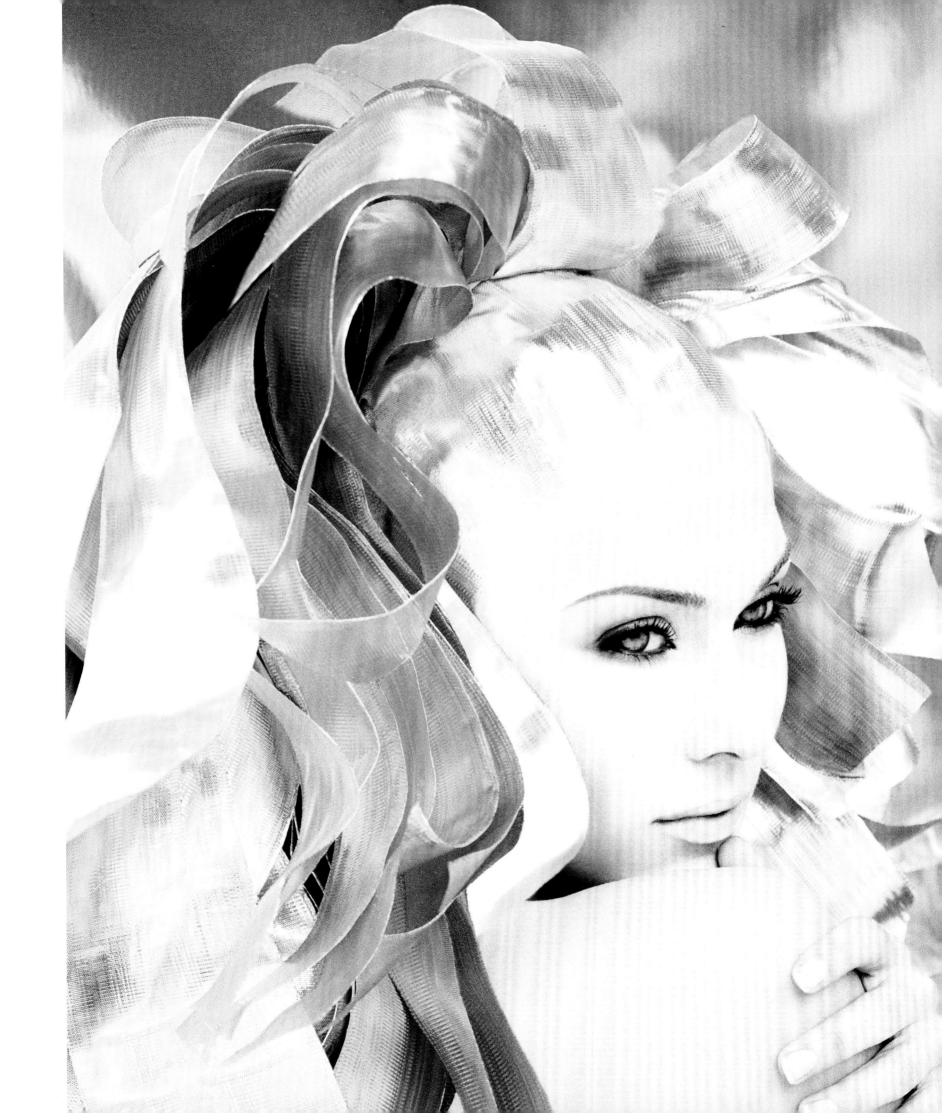

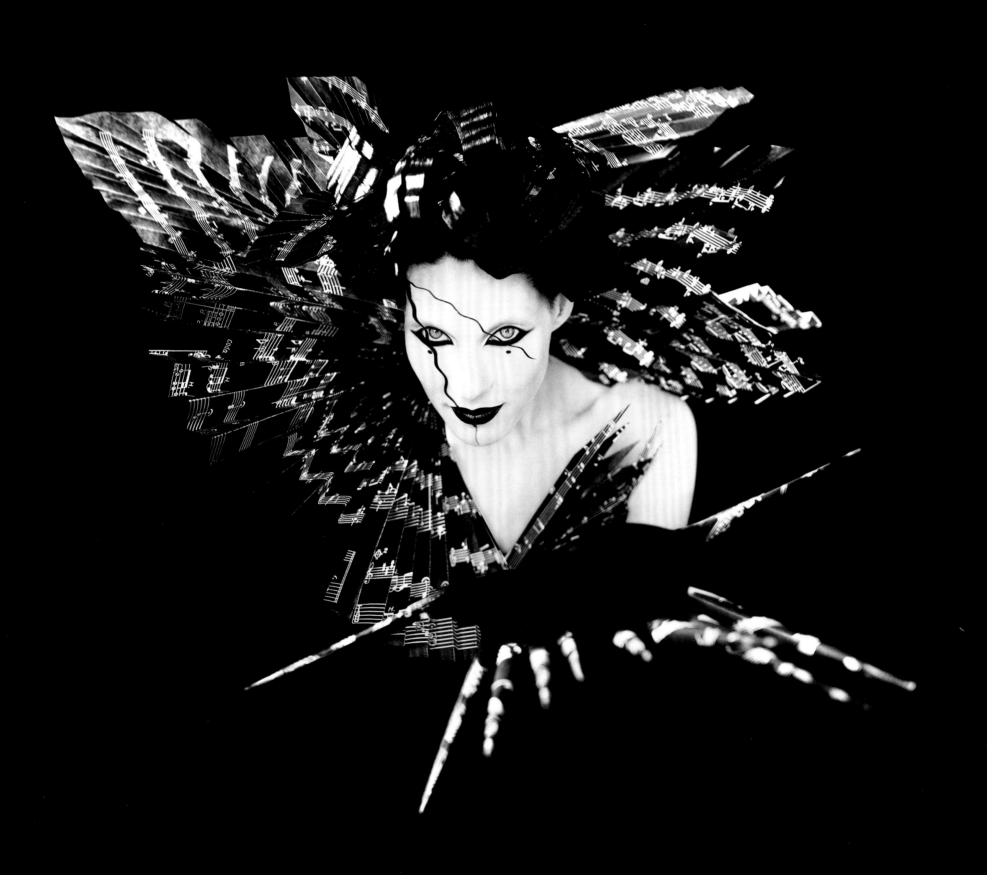

COLLABORATORS

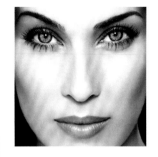

SERENA RADAELLI • 2007

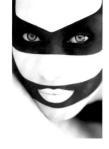

PETER SAVIC • 1998

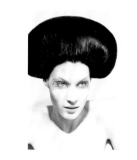

ENZO ANGILERI • 2000

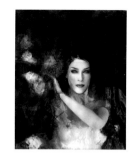

YUKI SHARONI • 2013

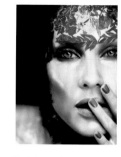

ENZO ANGILERI • 2001

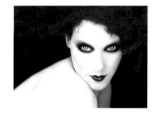

ENZO ANGILERI • 2001

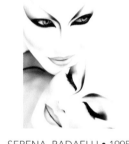

SERENA RADAELLI • 1995

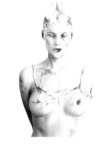

PETER SAVIC • 2013

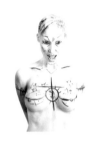

PETER SAVIC • 2013

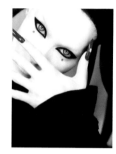

ENZO ANGILERI • 2000

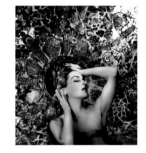

SERENA RADAELLI • 2013

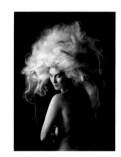

PETER SAVIC • 2004

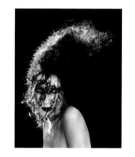

PETER SAVIC • 2003

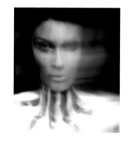

PETER SAVIC • 2013

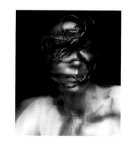

PETER SAVIC • 2013

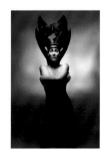

PETER SAVIC • 2011

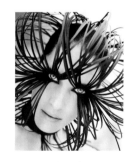

PETER SAVIC • 2002

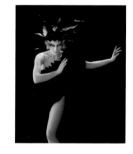

ENZO ANGILERI • 2000

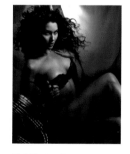

ENZO ANGILERI • 2004

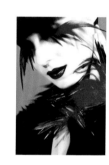

CHADWICK • 1993

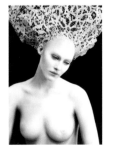

PETER SAVIC • 1986

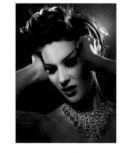

ROBERT VETICA • 2004

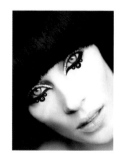

ENZO ANGILERI • 2001

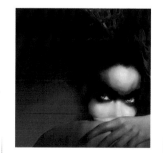

PETER SAVIC • 2004

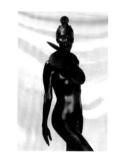

PETER SAVIC • 2013

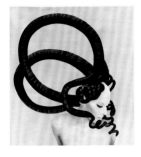

SERENA RADAELLI • 1997

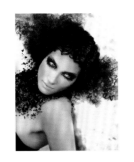

PETER SAVIC • 2004

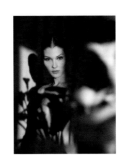

ENZO ANGILERI • 1996

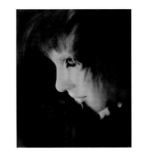

ENZO ANGILERI • 2000

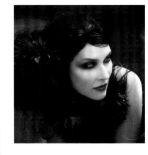

YUKI SHARONI • 2004

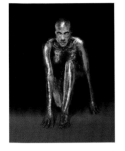

PETER SAVIC • 2013

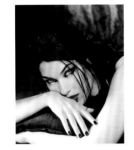

ENZO ANGILERI • 2000

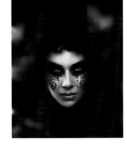

PETER SAVIC • 2004

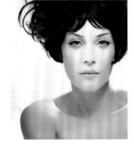

ENZO ANGILERI • 2004

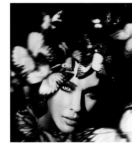

PETER SAVIC • 2004

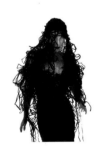

PETER SAVIC • 2012

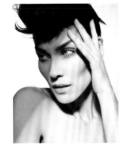

ROBERT VETICA • 2013

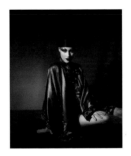

PETER SAVIC • 2012

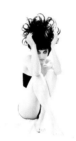

ENZO ANGILERI • 2004

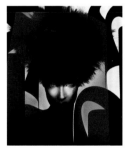

PETER SAVIC • 2008

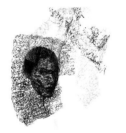

PETER SAVIC • 2013

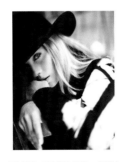

ENZO ANGILERI • 2004

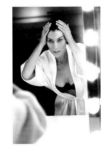

PETER SAVIC • 2012

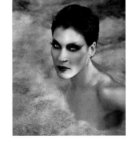

YUKI SHARONI • 2013

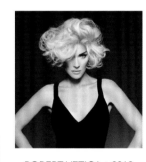

ROBERT VETICA • 2012

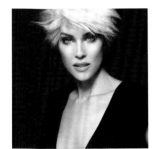

ROBERT VETICA • 2012

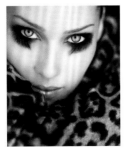

ENZO ANGILERI • 2002

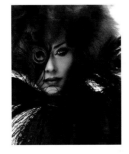

ROBERT VETICA • 2002

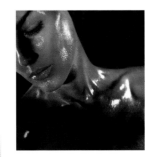

PETER SAVIC • 2012

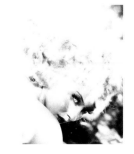

PETER SAVIC • 2005

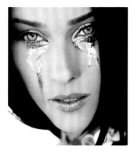

ENZO ANGILERI • 2002

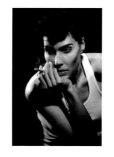

ROBERT VETICA • 2013

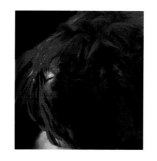

PETER SAVIC • 2003

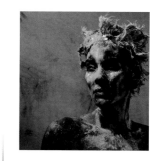

PETER SAVIC • 2013

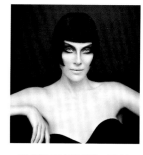

ENZO ANGILERI • 2013

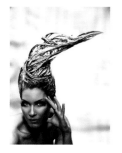

PETER SAVIC • 2004

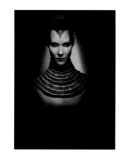

PETER SAVIC • 2008

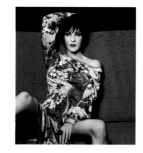

SERENA RADAELLI • 2013

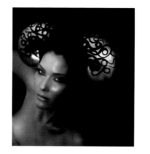

PETER SAVIC • 2004

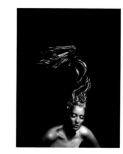

PETER SAVIC • 2004

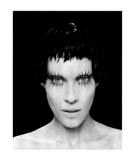

PETER SAVIC • 2013

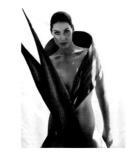

PETER SAVIC • 2003

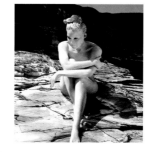

PETER SAVIC • 2013

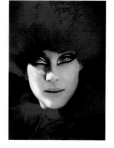

PETER SAVIC • 2003

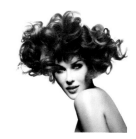

PETER SAVIC • 2006

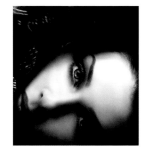

ROBERT VETICA • 2005

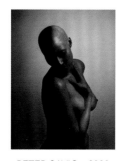

PETER SAVIC • 2008

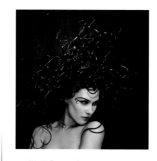

ENZO ANGILERI • 2004

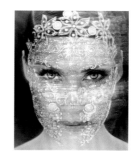

PETER SAVIC • 2007

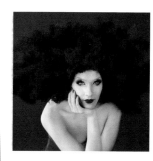

ENZO ANGILERI • 2003

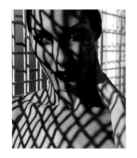

ROBERT VETICA • 2012

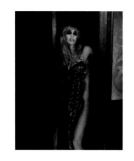

SERENA RADAELLI • 2013

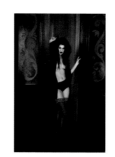

SERENA RADAELLI • 2013

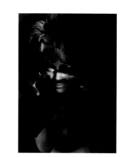

PETER SAVIC • 2003

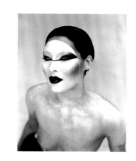

SERENA RADAELLI • 1995

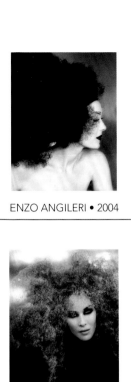

ENZO ANGILERI • 2004

PETER SAVIC • 2004

PETER SAVIC • 2004

ENZO ANGILERI • 1990

ENZO ANGILERI • 2004

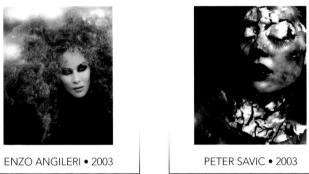

ENZO ANGILERI • 2003

PETER SAVIC • 2003

PETER SAVIC • 2009

ENZO ANGILERI • 2002

PETER SAVIC • 2012

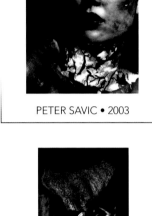

ROBERT VETICA • 2003

PETER SAVIC • 2013

PETER SAVIC • 2008

PETER SAVIC • 1999

PETER SAVIC • 2007

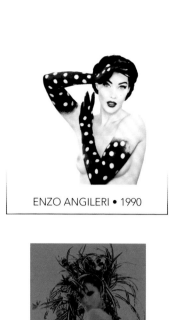

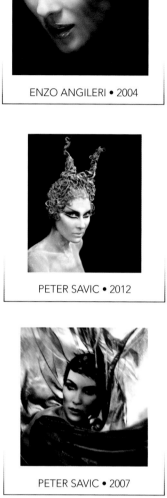

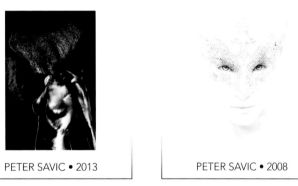

ENZO ANGILERI • 2012

ENZO ANGILERI • 2000

PETER SAVIC • 2013

PETER SAVIC • 2013

SERENA RADAELLI • 2013

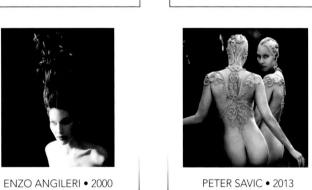

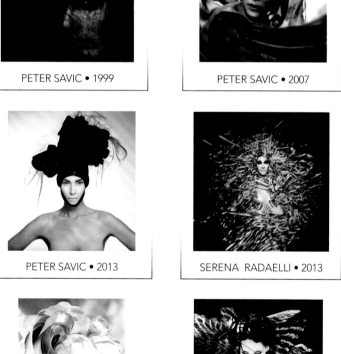

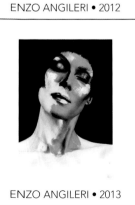

ENZO ANGILERI • 2013

ENZO ANGILERI • 1999

PETER SAVIC • 2013

ROBERT VETICA • 2001

ENZO ANGILERI • 2000

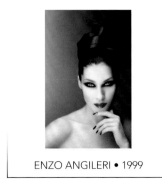

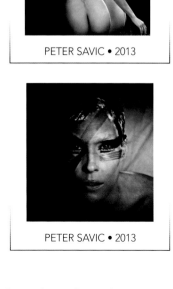

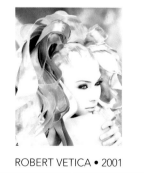

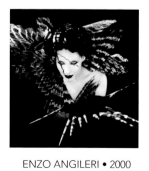

BOOK DESIGN by CRISTIANO A. TOLOT

THANKS

FROM ALBERTO & FRANCESCA

MITZI MARTIN
The muse.
A mother, a wife, a friend, a daughter, a sister, an actress, a model. But above all a woman. A woman gifted with beauty, intelligence, character, humor, compassion and generosity.
A muse.
Thank you MITZI and as redundant and repetitive as it might sound, we have to say;
This book would not be possible without you!
Thank you.

ENZO ANGILERI
PETER SAVIC
ROBERT VETICA
SERENA RADAELLI
YUKI SHARONI
Our dream is becoming a reality thanks to all of you, incredibly creative, passionate, generous artists and friends.
You have been an integral part in the making of this book by sharing with us your gift, your vision, your imagination, your time and your craft with infinite generosity.
It is a blessing to be a part of each other's lives, thank you.
Peter, you really gave to this project as if it was your own.

CRISTIANO TOLOT
MARTINA TOLOT
Thank you.
Your professional and creative support means the world to us. The sense of accomplishment we feel being able to share the creative process with you is priceless and surpasses any other kind of success.

BEYONCÉ KNOWLES
Thank you for writing an amazing foreword with such
beautiful words about me. You touched my heart.

MADELINE LEONARD
Thank you for believing in this project and carrying it to
completion with your grace and determination.
You made it happen.

SUMITA BATRA
Thank you for your generous introduction to Carlton.

MO MEINHART
KC MUSSMAN
WENDY ANN ROSEN
CINEMA MAKEUP SCHOOL
Thank you for your generous collaboration.

ANGIE BEYINCE
LEE ANNE CALLAHAN
YVETTE NOEL SCHURE
TINA KNOWLES
Thank you for your continuous support.

LISA DYER & CARLTON PUBLISHING
Thank you for sharing the vision and supporting this
project.

CESARE ZUCCA
Thank you for your priceless advice and keeping my
spirits up.

ADAM MENKEN
ADC DIGITAL
ALESSANDRO MORODER
ANTONELLA BELFORTE
CARLO DALL A CHIESA
CHADWICK
CHANTAL CLOUTIER
CLOUTIERREMIX AGENCY
CREATIVE NAIL DESIGN
DIEGO DALLA PALMA
DAME ELIZABETH TAYLOR
DAVID R. FISHER
DOMENICA CAMPAGNA
ELIZABETH TAYLOR FOUDATION
FAITH HILL
GEORGE BLODWELL
GIORGIO BOSSO
GIUSEPPE RINALDI
GUNDI DIETZ
JAN ARNOLD
JOHN PAUL MITCHELL
JOSÉ EBER
LIGIA MORRIS
LINE-MAG.COM
LYNN TOLOT
MAGIA MEDIA
MAKEUP ARTIST MAGAZINE
MASSIMO CAMPANA
MERLE GINSBERG
MICHAEL KEY
NAN OSHIN
PETER CARAVOLIAS
QUIXOTE STUDIOS
RIKKIE FREUNDLIGH
ROBERT YATES
SALLY BEAUTY
SANDRA WESTERMAN
SARAH TOHL
SMASHBOX STUDIO
TOM BACHIK
VIVIAN TURNER
Thank you for being directly or indirectly involved
in this project. Your support, encouragement, love,
and actions helped us to achieve our dream.
Thank you.